Paintings in Proust

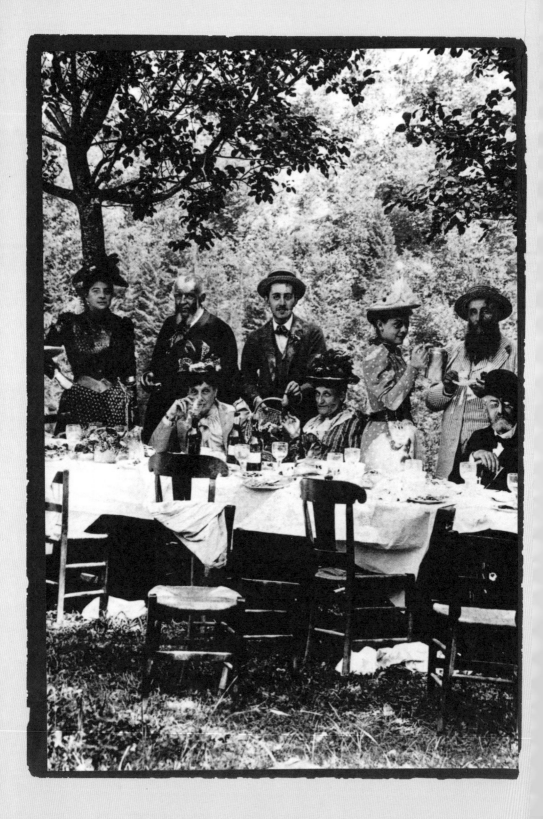

ERIC KARPELES

Paintings in Proust

A Visual Companion to
In Search of Lost Time

209 illustrations,
199 in color

 Thames & Hudson

To Michael Sell

…atque animum pictura pascit inani,
multa gemens, largoque umectat flumine voltum.

It was only a painting, but sighing deeply,
he let his thoughts feed on it, and his face was wet
with a stream of tears.

Virgil, *Aeneid*, 1.464–65

In memoriam
Rowland Rugeley Bachman

PAGE 3 Marcel Proust (standing, centre) at an open-air luncheon party.
Photo Mante-Proust Collection.

PAGE 4 Veronese, *The Wedding at Cana* (detail), 1562–63.

Paintings in Proust © 2008 Thames & Hudson Ltd, London
Text © 2008 Eric Karpeles
Quotations from *In Search of Lost Time* (Volume 1: *Swann's Way*, Volume 2: *Within A Budding Grove*,
Volume 3: *The Guermantes Way*, Volume 4: *Sodom and Gomorrah*, Volume 5: *The Captive and The Fugitive*,
Volume 6: *Time Regained*) by Marcel Proust, translated by C. K. Scott Moncrieff and Terence Kilmartin
and revised by D. J. Enright, translation © 1981 by Chatto & Windus and Random House Inc.,
with revisions to the translation © 1992 by D. J. Enright.
Used by permission of Modern Library, a division of Random House, Inc.

First published in 2008 in hardcover in the United States of America by
Thames & Hudson Inc., 500 Fifth Avenue, New York, New York 10110

www.thamesandhudsonusa.com

First paperback edition 2017

Library of Congress Control Number 2017931856

ISBN 978-0-500-29342-3

Printed and bound in China by C&C Offset Printing Co. Ltd

CONTENTS

INTRODUCTION 10

Mantegna · Botticelli · Manet · Chardin · Corot · Millais · Monet · Watteau · Ingres · Carpaccio · Whistler

VOLUME I *Swann's Way* 28

Lasinio · Robert · Turner · Morghen · Piranesi · Giotto · Bellini, Gentile · Gleyre · Carpaccio · De Hooch · Botticelli · Tintoretto · Ghirlandaio · Watteau · Rembrandt · Moreau · Sebastiano del Piombo · Mantegna · Dürer · Vermeer · Machard · Leloir · Fra Angelico · Poussin · Guys · Michelangelo

VOLUME II *Within a Budding Grove* 84

Titian · Leonardo · Gris · Fra Bartolommeo · Gozzoli · Winterhalter · Luini · Watteau · Botticelli · Veronese · Chardin · Whistler · Bourdichon · Moreau · Carrière · Guillaumin · Dürer · Rembrandt · Pisanello · Giotto · Hogarth · Manet · Carpaccio · Bellini, Giovanni · Michelangelo · Rubens

VOLUME III *The Guermantes Way* 144

Whistler · Rembrandt · Bruegel · Watteau · Decamps · Van Huysum · Hébert · Dagnan-Bouveret · Fantin-Latour · Fromentin · Renoir · Prud'hon · Van der Meulen · Perronneau · Chardin · Ingres · Manet · Carpaccio · Delaroche · Vibert · Moreau · Hals · Memling · Velázquez · Mignard · Turner · De Champaigne · Rigaud

VOLUME IV *Sodom and Gomorrah* 192

Detaille · Carpaccio · Veronese · Whistler · Rembrandt · Jacquet
· Giorgione · Nattier · Boucher · Bakst · Poussin · Monet · Manet
· Degas · Le Sidaner · Millet · Helleu

VOLUME V *The Captive* 226

Gozzoli · Leonardo · Fragonard · Mantegna · Vermeer · Tissot
· El Greco · Il Bronzino · Il Sodoma · Bellini, Giovanni · Couture
· Rousseau · De La Tour · Titian · Velázquez · Rembrandt
· Carpaccio · Munkácsy · Luini · Tiepolo

VOLUME VI *The Fugitive* 264

Van Dyck · Nattier · Dethomas · Titian · Carpaccio · Whistler
· Giotto · Turner

VOLUME VII *Time Regained* 286

Guardi · Saint-Aubin · Lawrence · Fantin-Latour · Cot
· Renoir · Pisanello · El Greco · Carpaccio · Whistler · Manet
· Delacroix · Fromentin · De La Tour · Watteau · Fouquet
· Chenavard · David · Rembrandt · Vermeer · Mantegna
· Michelangelo · Chardin

Notes 331
Index of Painters and Paintings 347
Acknowledgments and Picture Credits 354

Thanks to art, instead of seeing one world only, our own, we see that world multiply itself and we have at our disposal as many worlds as there are original artists...

Marcel Proust
—Time Regained

PAINTINGS IN PROUST

Introduction

My book is a painting

Marcel Proust to Jean Cocteau

'I assure you,' went on Mme de Guermantes...'that with
the palm-leaves and the golden crown on one side, it was
most moving, it was precisely the same composition as
Gustave Moreau's *Death and the Young Man*. (Your Highness
must know that masterpiece, of course.)'

The Princesse de Parme, who did not know so much
as the painter's name, nodded her head vehemently and
smiled ardently, in order to manifest her admiration for this
picture. But the intensity of her mimicry could not fill the
place of that light which is absent from our eyes so long as
we do not understand what people are talking to us about.

Like the labyrinthine galleries of the Louvre frequented by the young Marcel Proust
and his friends, *In Search of Lost Time* (*À la recherche du temps perdu*) houses a vast repository
of paintings. In the novel, over one hundred artists are named, spanning the history
of art from the trecento to the twentieth century, from primitivism to futurism, from
Giotto to Léon Bakst. Whether plunging into Proust for the first or the fifth time, each
reader encounters many esoteric and increasingly obscure pictorial references that keep
testing his mettle. These can leave him nodding his head, with a smile frozen on his
face just like the Princesse de Parme.

Paintings in Proust grew out of a curiosity about the paintings that this reader's
visual memory could not readily summon. Many of these were works by the society
artists who disappeared with *la belle époque*, but there were also a substantial number of
Renaissance pictures whose specific iconography remained elusive. Coming across
Mme Verdurin, 'who regarded *The Night Watch* as the supreme masterpiece of the uni-
verse', most readers can call forth a reasonable facsimile of Rembrandt's immense
canvas, but how many of us can visualize 'that purely decorative warrior whom one
sees in the most tumultuous of Mantegna's paintings, lost in thought, leaning upon his
shield'? Without the ability to conjure up these references – so revealing, so com-
pounded – their intended impact is considerably diminished. The paintings selected

St James Led to Execution, from *Martyrdom of St James*, Andrea Mantegna, 1450–54

by Proust to animate and expand the imaginative world of *In Search of Lost Time* func-
tion in significant ways – as descriptive analogies, as metaphors and symbols – recalling
the Narrator's grandmother and her desire to expose her grandson to 'several "thick-
nesses" of art'. In your hands is a companion guide to the pictures found along the
reader's way, conceived to illuminate the winding corridors of the novel.

Proust wrote primarily about paintings he knew from direct experience, works
thoughtfully studied for untold hours in the museums, galleries and private collec-

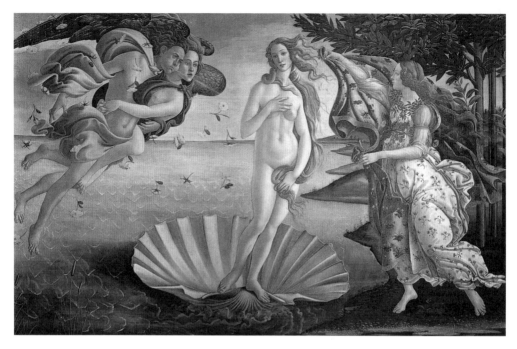

The Birth of Venus, Sandro Botticelli, 1482–86

tions of late nineteenth-century Paris. The long-held notion of a young life frittered away at parties does disservice to his early discipline and devotion to pictures. With friends such as Robert de Billy and Pierre Lavallée, Proust frequented the Louvre's collections, returning again and again. Climbing the social ladder certainly was a preoccupation of his formative years, but before successfully gaining entry to the salons of the Faubourg Saint-Germain he was at home in the Louvre, among the aristocrats of the visual world. There he bowed before the Titians and the Rubenses with their impeccable provenance, just as he would soon come to bow before princesses and dukes at the home of his friend Mme Straus. While still a *lycée* student, he wrote poems about van Dyck and Watteau, emulating Baudelaire's attempt to transpose the experience of pictures into words. Proust was slow to develop his own philosophy of art, yet while he may have been languid, he was also voracious. And although 'going to the Louvre to look at a Titian consoles us for not being able to go to Venice', Proust later travelled abroad, making complicated and often difficult journeys with the express intent of putting himself squarely in front of pictures he had previously known only by reputation. While working out the chamber music of his composer Vinteuil, Proust had it within his means to hire the Poulet Quartet; they performed the Franck quartet in his bedroom in the middle of the night. Arranging to have Carpaccio's *Patriarch of Grado* delivered to the boulevard Haussmann, however, was beyond even his reach. Once his failing health and the demands of his novel combined to put an end to travel, memories of earlier holidays in Italy and Holland provided a stockpile of richly observed details for his writing.

Even so, Proust never saw many of the actual paintings that came to be incorporated into the pages of his novel. He first came to know several of them in Paris, far from the collections that preserved them, in the form of artists' copies of masterworks, as was the case with Gustave Moreau's oil study of Botticelli's *Birth of Venus*. But for the most part, Proust supplemented his already impressive roster of pictures known first-hand with pictures seen in reproduction. The emergence at this time of elaborate art books and critical studies (such as the generously illustrated Library Edition of John Ruskin and biographical volumes on Carpaccio by Molmenti and by Gabrielle and Léon Rosenthal) added breadth and depth to his range of knowledge. He fleshed out his 'database' of images and ideas by actively reading contemporary publications devoted to art of the past and present.

The *fin de siècle* was an unusually heady time for the exchange of ideas between writers and painters in Paris. In a subtle shift in the balance of artistic power, visual artists began to emerge from the tyranny of literary and historical narrative. The struggle and hard-won freedoms of a handful of painters impressed many writers, who were fascinated by their new ways of seeing. Henry James confessed, 'what the verbal artist would like to do would be to find out the secret of the pictorial, to drink at the same fountain'. Proust swanned about town, looking, listening and learning. He knew many painters, and within the confines of their inner sanctums he discussed their work with them. He knew art critics. He read reviews. He went to exhibitions and dropped in at the galleries. The art collector and dealer René Gimpel, who owned twelve Rembrandts and was Duveen's son-in-law, was a friend. Charles Ephrussi, publisher and editor of the influential *Gazette des Beaux-Arts*, granted Proust *carte blanche* to peruse the magazine's extensive library, where the novelist pored over the lavish *Burlington Magazine* and browsed through auction catalogues.

Ephrussi (with whom socialite and amateur scholar Charles Swann shares more than just a first name) was a collector of Japanese prints and a patron of painters. He and his friend Édouard Manet figure in a parable that found its way into the pages of *In Search of Lost Time*, revealing Proust's appetite for historical material that could be remade into fiction. Ephrussi admired a small painting of a bunch of asparagus and wished to purchase it directly from Manet. Learning that the asking price was 800 francs, he generously sent 1000 francs in payment. In response, Manet promptly selected a very small canvas, dashed off a picture of a single stalk of asparagus, signed it with only an 'M', and sent it off to his friend Ephrussi with a note that proclaimed, 'There was one missing from your bunch.' With a wry sleight of hand, Proust fashioned a tiny morality play from this charming vignette that involved a painting, also of asparagus, by Elstir. In his sumptuous dining room, the Duc de

Asparagus, Édouard Manet, 1880

Guermantes is eating asparagus served with a *sauce mousseline*. He expresses indignation to the Narrator because Swann has had the nerve to suggest that he and his wife buy a painting of a bunch of asparagus from Elstir. The Duc is outraged, claiming that an extortionate price is being asked. 'Three hundred francs for a bundle of asparagus! A louis, that's as much as they're worth, even early in the season.' Proust transformed an anecdote about largesse into a tale of arrogant refusal, using a beautiful small painting as a touchstone to expose the unpredictable behaviour of *le beau monde*.

From the pantheon of masters, Proust selected painters for his novel: Velázquez, Bellini, Ingres. Just twenty or so pages into the book Corot is the first painter mentioned, while thousands of pages later Chardin is the last, only five pages from the end. In between, far less renowned painters such as Detaille, Munkácsy and Winterhalter appear. Proust cited particular historical works (Giotto's *Charity*, El Greco's *Burial of the Count of Orgaz*, Manet's *Olympia*) but other paintings he merely suggested more generally: the handsome violinist Morel resembles 'a sort of Bronzino'. And there are fictional paintings that existed only in the *atelier* of Proust's mind, such as a provocative watercolour study by Elstir of the young Odette de Crécy *in travesti*. Throughout his magnum opus, Proust introduced and intermingled imaginary and actual paintings.

Naturally, he had favourite artists: Mantegna, Rembrandt, Titian. There was Chardin and his subtle transcendence of the mundane: Proust's transformative icons, a madeleine and a paving stone, are direct literary corollaries of the humble objects found in Chardin's still lifes. Perhaps the most revered painter was Vermeer, whose now-indelible images were then only slowly emerging from obscurity. Odette's ignorance about the subject of her lover's essay ('I've never even heard of him; is he still alive?') should not be interpreted as an indication of deficient cultural awareness. In the era of *Swann's Way*, only a very small circle of cognoscenti would have recog-

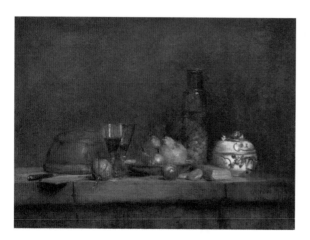

Still Life with Jar of Olives, Jean-Baptiste-Siméon Chardin, 1760

nized the name, let alone been able to identify a work from the hand of Vermeer. Writing about the Dutch painter, art historian Lawrence Gowing discerned 'a poetry of brick and vapour, resistance and penetration, a complex pattern of feeling in which the attraction of the tangible world and a rejection of it were at last reconciled'. With equal conviction, he could have been describing the work of Marcel Proust.

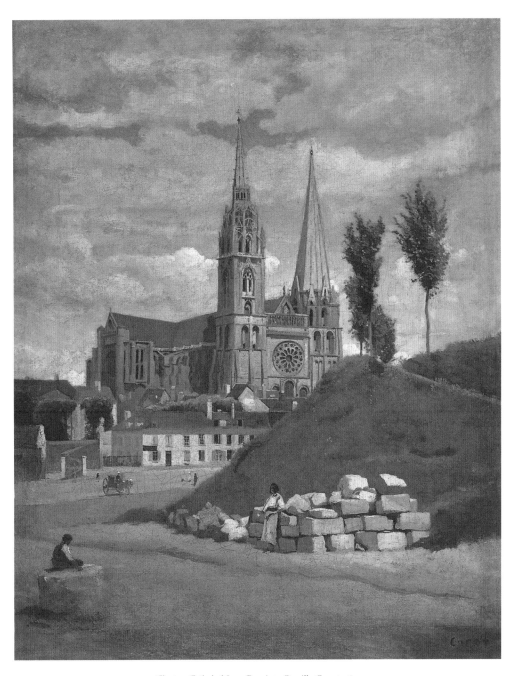

Chartres Cathedral, Jean-Baptiste-Camille Corot, 1830

The death of the novelist Bergotte in the room where Vermeer's *View of Delft* hung presents the single most palpable collaboration of word and image in the novel – arguably in any novel. Proust fiddled with the crafting of this scene until the last day of his life. His prose is rhapsodic, but keyed down, in awe of the painting's elusive, haunting quietude. The luminous townscape, with its ineffable 'little patch of yellow wall', surprises Bergotte into thinking that maybe his books had been too dry, that maybe he should have done as Vermeer had done and layered more colours into his writing. Overwhelmed by the consummate perfection of the Dutch painter's art shimmering before him, he diffidently holds his own life's work in abeyance. At that moment, the picture occasions an epiphany. Merciless but empathetic, Proust extracted from his character a final self-critical judgment. 'In a celestial pair of scales there appeared to him, weighing down one of the pans, his own life, while the other contained the little patch of wall so beautifully painted in yellow. He felt that he had rashly sacrificed the former for the latter.' Bergotte staggers back onto a settee and dies. It may be asserted that the painting is what killed him. In the presence of *View of Delft*, so profound an expression of humanity, Proust's unequivocal, brutal credo – life is nothing, art is all – is given full force.

Proust wanted no such anxiety of influence in his own writing life. As he gained confidence as an artist, he needed fewer mentors. Once their lessons had been taught, his teachers (whose confidences he had so elaborately cultivated) would be purged. The novelist Anatole France, upon whom the budding writer lavished the extravagant gift of a Rubens drawing, was an early role model whose influence he later renounced. For a time, Proust sat at the feet of 'the professor of beauty', Count Robert de Montesquiou, who strove to make a work of art out of a life lived. This self-aggrandizing posturing finally became abhorrent to Proust, who developed, in the story of Swann and especially in that of Charlus, cautionary tales about the price of such confusion of realities. The single greatest influence upon Proust's aesthetic development was John Ruskin, a man he never met but through whose work was revealed a new collaboration of eyes, mind and heart. Ruskin's philosophical treatises explored new ways of thinking that made Proust even more sensitive to the world around him. In Ruskin's books Proust was first introduced to many of the painters whose works would come to mean so much to him. He clung to Ruskin's books as talismans; he was never far from them. He made himself into an expert on the subject of Ruskin. Proust claimed to know by heart Ruskin's portrait of his early development, a volume called *Praeterita* (which could be loosely translated as 'Lost Time' or 'Things Past'). The degree to which this memoir's tone of voice would today be called 'Proustian' is an indication of how much Ruskin's writing influenced him.

However, the mentor–disciple relationship once again became strained. As Proust dug deeper into Ruskin's world view, he understood that for the English critic great art and morality were one and the same. This belief had exploded into Ruskin's public condemnation of Whistler, a painter Proust admired enormously, and who believed that art and morality were clearly separate and distinct entities. Proust

ultimately came to reconcile the differences between these two uncompromising figures, finding truth in each of their opposing essences. But his apprenticeship was over. Proust's project of translating into French Ruskin's *Bible of Amiens* languished. Finally, in the postscript to the translation, he brought himself to elaborate upon what he understood as Ruskin's undoing. Proust felt that the great critic was unable to see that the seductive wonders of the external world distracted from necessary truths hidden below. It was this 'idolatry' toward surface beauties on the part of the author of *The Stones of Venice* that convinced Proust to remove his acolyte's robe. Although the English critic's influence is everywhere to be found in *In Search of Lost Time*, it is muted and filtered. Proust's rejection of Ruskin was an act of will that helped free him to face the consuming challenge that lay ahead.

Ruskin died in 1900. Proust gradually emerged from under his considerable influence, and with the new century a slow flowering of his own aesthetic began. The development of his mature writing style was powerfully affected by many trends in painting, especially impressionism, referred to by the critic John Berger as 'the triumphal arch through which European art passed to enter the twentieth century'. Impressionist paintings seemed to trigger something in Proust's nervous system. Studying them carefully, and their impact upon him, he began to analyse 'the essence

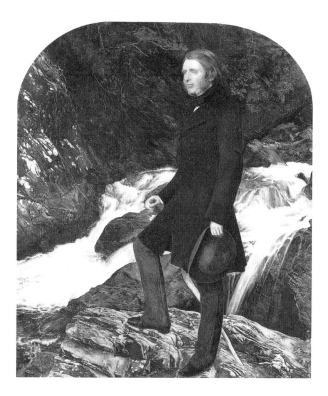

John Ruskin, John Everett Millais, 1853–54

of the impression that an object produces, an essence that remains impenetrable unless genius reveals it to us'. The genius in question, for a time, was Claude Monet, who was born thirty years before Proust and robustly outlived him by four years. 1900, the year of Ruskin's death, saw the first of two memorable exhibitions of Monet's water-lily paintings at the Galerie Durand-Ruel in Paris. Proust tried to imagine a writer who could achieve what Monet had done as a painter. He wrote what was to be a description of himself; 'Imagine today a writer to whom the idea would occur to treat twenty times under different lights the same theme, and who would have the sensation of creating something profound, subtle, powerful, overwhelming, original, startling like the fifty cathedrals or forty water-lily ponds of Monet.' As editor and biographer Jean-Yves Tadié observed, 'when Proust felt passionate about somebody else's creation, it was a sign that he was foreseeing his own work'. There is much territory shared between these two great French artists, including the critical primacy of scale. The expansive, sustained gesture each developed could not be contained within the conventional bounds of their respective crafts – a painting unfolded across not one canvas but a whole series; a novel was composed not of a single volume but of many. Surrounded by Monet's lily ponds and cathedral fronts, Proust was among

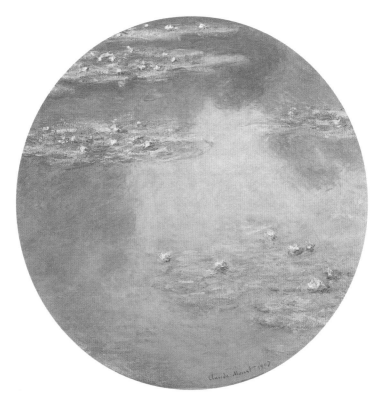

Water Lilies (Nymphéas), Claude Monet, 1907

the first to internalize their misty mastery not only of space but of time as well. From a close scrutiny of these impressionist masterworks, Proust formulated the vindication – the triumph – of effect over cause. One finds in *In Search of Lost Time* a good deal of clinical objectivity, but no narrative omniscience. Like the viewer getting his bearings in front of Monet's monumental surround of water lilies, the reader enters the universe of Proust's novel almost exclusively through the subjective perceptions of the Narrator.

For his burgeoning novel, Proust had character needs greater than any single painter, living or historical, could provide, so he fashioned a trio of heroic artists to meet his own exacting specifications. The writer Bergotte, the composer Vinteuil, and the painter Elstir form a trinity, three kings whose gifts of creative genius inspire and enrich the young Narrator's spirit. In Elstir's studio, the Narrator experiences his first mature interactions with art. He is moved to realize that Elstir lives his life as an absorbing stroll down a long gallery hung with eternal works of art that existed before us and that will continue to live long after we are gone. Elstir's studio becomes the crucible for the Narrator's metamorphosis from attentive observer to nascent artist. The Narrator often comes to watch the painter at work and to listen to the painter speak. As opposed to the reticence encouraged by his contemporary Paul Valéry ('We should apologize for daring to speak about painting'), Proust has his characters speak about painting at some length.

As is true for all of Proust's character pastiches, there are genealogical clues to link the painter Elstir to various inspirational models. Alexander Harrison, an American impressionist, remained a lingering presence in Proust's mind after they met in Brittany in 1895, and soon afterwards he appeared disguised as a writer in *Jean Santeuil*. Harrison was transferred from this abandoned work into the pages of Proust's new novel, changed back into a painter. One can also distinguish in Elstir the personality traits and painterly concerns of Moreau, Degas, Turner, Renoir and Monet. Some of Elstir's slangy speechifying was lifted directly from Vuillard, whom Proust had met as a co-contributor to *La Revue Blanche*. The very name Elstir is itself a partial anagram of the names of the painters Helleu and Whistler, each of whom deepened Proust's understanding of the act of painting and the mystery of what it was to be a painter. Elstir has a lengthy and complicated pedigree. And although he created a substantial *œuvre* – a whole studio full of brilliantly coloured canvases spanning a lengthy career – these works have only ever been painted in the pages of Proust's book. Not one Elstir canvas is reproduced in the pages of *Paintings in Proust* as they do not, so to speak, exist.

The Narrator remembers the boyhood turmoil of waiting for his mother's kiss 'as a painter prepares his palette for a subject he can only have for short sittings and does in advance everything that can be done in the sitter's absence'. Proust's inclination to identify with painters was a considerable force. In his early, brief essays, later collected as *Portraits de peintres*, he made an attempt at articulating a philosophy of art that subsequently informed the development of characters in his novel. Before Elstir

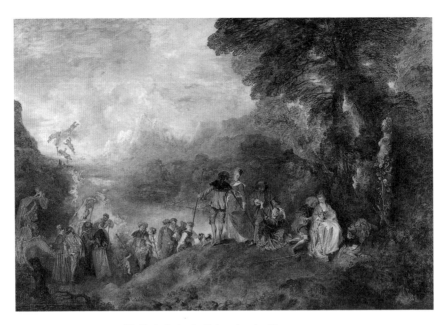

The Embarkation for Cythera, Antoine Watteau, 1717

came into being, Proust had, with equal affection and bravado, linked himself to Watteau: 'I often think with a mixture of sympathy and pity about the life of the painter Watteau, in whose work lives the painting, the allegory, the apotheosis of love and pleasure.…It has been said that he was the first to have painted modern love, meaning by this, no doubt, a love where conversation, the pleasures of the table, promenading, the sadness of masquerading, fleeting water and time, all hold a higher place than pleasure itself, a sort of gilded impotence.' What better foreshadowing is there for the ubiquitous sexual melancholia in *In Search of Lost Time*? Proust was the progeny of Watteau, embarking on his own literary pilgrimage to the isle of modern love. As work on *In Search of Lost Time* slowly coalesced, Watteau – like Monet, like Whistler, like Moreau – dissolved into Elstir, narrowing even further the divide between painter and writer. To invert Ruskin's comment about the Venetians, for whom 'painting is the way they write', writing was the way Proust painted.

The sibling relationship between painting and writing, the 'sister arts', has been acknowledged as far back as criticism goes in both disciplines. In a balanced, harmonious simile – *ut pictura poesis* – Horace referred to a written text that aspires to the condition of a picture. *Ekphrasis* is the term of classical rhetoric for this pairing of words and pictures, a state of imitation that the poet and critic John Hollander refers to as 'mimesis of mimesis'. There are two basic modes of *ekphrasis* and Proust employed both. Notional *ekphrasis* involves a writer's creation and description of an imagined work of art. Homer's shield of Achilles in the *Iliad* is among the earliest examples of literary word-painting in the Western tradition. Elstir's great

atmospheric canvas, *Le Port de Carquethuit*, is an entirely notional construct conceived by Marcel Proust. Actual *ekphrasis* involves the evocation of an existing work of art. W. H. Auden's poem 'Musée des Beaux-Arts' observes and comments upon Icarus falling out of the sky in a Breugel painting in Brussels. Swann's musings on the sultan portrayed in Bellini's *The Sultan Mehmet II* derive from a very real painting. Yet when Saint-Loup speaks of a portrait of his aunt, the Duchesse de Guermantes, being by Carrière, 'as fine as Whistler or Velasquez', Proust is being characteristically sly, holding up a notional picture in comparison to actual ones, blurring the distinctions.

In nineteenth-century Europe, the anti-classical Romantics willingly made much use of the classical convention of *ekphrasis*. Paintings figure prominently in novels by Zola, James, Balzac, Melville and Wilde. In *The Idiot*, Dostoevsky (subject of a protracted conversation between the Narrator and Albertine in *The Captive*) presents Holbein's *Christ Taken from the Cross* as a frightening portent and symbol. However, in Dostoevsky's narrative, the painting itself remains securely hung on the wall, unintegrated into the life of the book. By comparison, certain paintings singled out by Proust, whether by Elstir or Botticelli, penetrate into the very life of his story.

'I believe that all true art is classical,' Proust wrote in an essay, 'though it is rarely permitted to be recognized as such.' Nowhere else is the turf war between classicism, romanticism and modernism as joyfully and profoundly celebrated as in the pages of *In Search of Lost Time*. In order to miss nothing, Proust looked backward and forward; he was a link to the past and a man of his own time. Just as his knowledge of Racine and Mme de Sévigné served to expand his appreciation of Mallarmé and Nerval, so his familiarity with van Dyck and Carpaccio helped to intensify his embrace of Renoir and Picasso. Reading *Sodom and Gomorrah* when it was published, just a few months before Proust died in 1922, a friend wrote to him: 'One thing that struck me for the first time is your relationship to the cubist movement, and deeper, your profound immersion in the contemporary aesthetic reality.' Proust, the swaddled writer in his cork-lined cocoon, managed not only to remain vitally connected to current trends in twentieth-century art, but to arrive somehow right on the cultural doorstep of the twenty-first century. At the dawn of modernism, Proust was already a postmodernist. His affectionate borrowings from earlier writers and painters pushed the boundaries of pastiche with a process that we now call 'appropriation'. He legitimized the mixture of highbrow and low: Proust was 'a Persian poet in a porter's lodge' (Maurice Barrès); 'he was so intensely responsive to the ordinary that a girl on a bicycle could overshadow a princess' (Anatole Broyard). And his pioneering use of psychosexual insight in the development of epicene characters established him as a founding father of 'queer studies'. From the vantage point of painters and paintings, Proust's formidable fluency with various historical styles is clearly manifest. Taken as a writer who embodies multiple, often contrary, disciplines, Proust can appear as much a composite character as one of his own creations.

Distributed throughout *In Search of Lost Time*, allusions to paintings and painters are presented in varying guises and serve multiple purposes. Although abstract

philosophical ideas held little appeal for him, the Lycée Condorcet graduate never lost sight of the potential for creative dialectic and the struggle between universals and particulars. The novel has many layers of reference whose borders are continually transgressed, where art and reality, painting and life, subtly transform and meld. At times Proust used painting references simply to 'accessorize' his text with a visual window-dressing of sorts, to capture a fleeting association, as when he observed that, in one of the grimier neighbourhoods of the city, the dome of Saint-Augustin gave 'this view of Paris the character of some of the Piranesi views of Rome'. (The reader occasionally senses the writer stimulating himself by offering up an effusion of visual analogies. In response to her observation of this persistent impulse, Colette, Proust's contemporary, created a Marcel-like character in an early novel who was clearly 'excited by his own evocations'.) Often more than one layer is incorporated in an association, and a pentimento effect begins to develop from a deeper ground: Swann is likened by the Narrator to 'the charming Mage with the arched nose and fair hair in Luini's fresco'. Although the explicit comparison is one of physical likenesses, it is not only Swann's handsome face that is called forth, but also his generosity, a reference to his magus-like giving of gifts.

In Proust's even more sustained integration of painted image and written text, characters and pictures seem to melt into each other. Charlus, snob and aesthete, has an amusing way of projecting himself into the rarefied company of aristocrats in portraits hanging on the walls of the homes of the French nobility. In less elevated surroundings, his more lascivious appetites are exposed, as when a *tableau vivant* of

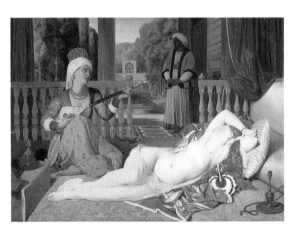

Odalisque and Slave, Jean-Auguste-Dominique Ingres, 1842

references to orientalism spills forth from him – Fromentin, Decamps, Delacroix, Ingres – behind which he believes his sexual hunger for a passing Senegalese soldier is safely hidden. Put in the position of voyeur, the reader observes Charles Swann as he shifts his ardent attentions between his mistress Odette and his fetishistic ur-Odette, Zipporah, a figure from Botticelli's Sistine Chapel frescoes. Swann keeps on his work table a photograph not of his lover, but of the girl in the fresco, and clutching the photograph of Zipporah close to him, 'he would imagine that he was holding Odette against his heart'.

Paintings in *In Search of Lost Time* fulfil an extremely complex role as transitional objects. They are formidable enough to be imbued with conjuring and validating powers. From Botticelli's Zipporah, Swann extracts permission and benediction for

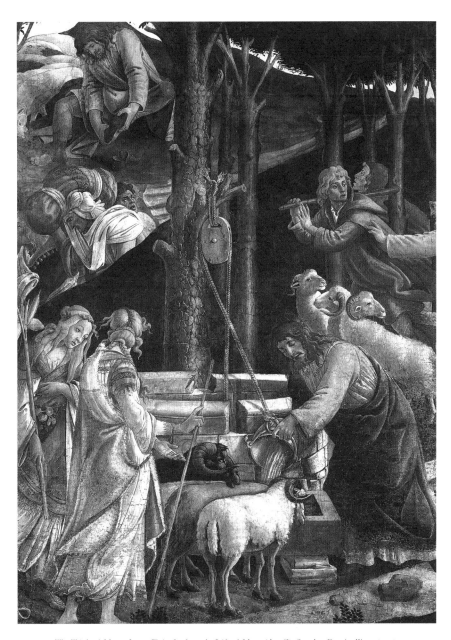

The Trials of Moses, from *Episodes from the Life of Moses* (detail), Sandro Botticelli, 1481–82

his obsessive love of the untutored Odette; the painting could be said to have inspired his love – something Odette's own physical allure had failed to do. It cast a spell of enchantment over Swann strong enough to nurture him with an aesthetic sustenance she could not possibly provide. The picture of the girl in the Sistine fresco is used by Swann almost optically, as a prism, to spread upon the figure of Odette the broadest spectrum of colours and possibilities. In the painting's reflected glow the orchid-loving courtesan emerges transfigured into someone good, someone biblical. Swann's erotic dementia is spiritually pacified as he holds to his lips the picture of the daughter of Jethro.

Later in the novel, in Venice, within the Byzantine walls of the San Marco Baptistry, the Narrator is intensely aware of being inside a work of art; paintings vaporize into a palpable reality. Studying an image of Christ immersed in water, he thinks of the gondola awaiting him outside. His long-suffering mother, who has shared this gondola with him, is nearby. Suddenly she is indistinguishable from the figure of a woman kneeling in prayer in a painting he has recently seen at the Accademia: Carpaccio! Instantly Albertine, resurrected from the Grand Canal of the febrile young man's imagination, is called forth by the memory of another Carpaccio. One night at Versailles, Albertine had worn a Fortuny cape whose design derived from a cloak worn by a Venetian nobleman in *The Patriarch of Grado*. The very thought of this painting re-ignites a smouldering passion in the Narrator. It is just a painting, but a painting that 'almost succeeded one day in reviving my love for Albertine'. All these charged particles of art-assisted memory flood the Narrator's mind with such a force and speed that both writer and reader strain to contain and absorb them.

Charting this flow of associational formation and disjunction requires an exacting methodology. Proust's Narrator understood that the possibilities for the imaginative expansion of life were available to everyone if only they would allow themselves to be open to them. But he feared for the complacency of most people. At a luxurious restaurant on the coast of Normandy, the Narrator could see 'the round tables whose innumerable assemblage filled the restaurant like so many planets'. At the same time, 'I rather pitied all the diners because I felt that for them the round tables were not planets and that they had not cut through the scheme of things in such a way as to be delivered from the bondage of habitual appearances and enabled to perceive analogies.' In the creation theory of Proust's cosmology, the ability to perceive analogies is critical. He who cannot fathom restaurant tables as planetary orbs cannot expect to look upon Vermeer's *View of Delft* and discover the eternal.

Marcel Proust himself had a complex relationship with paintings as tangible objects. They did not figure in his own intimate surroundings. Much in the way that the Narrator dismisses friendship as being a distraction from an artist's necessary focus, Proust seems to have dismissed the companionship of paintings. In *Within a Budding Grove*, a tirade is launched against the fashionable display of pictures as a betrayal of the artist's essential, isolated act: 'A picture is nowadays "presented"

Apotheosis of St Ursula, Vittore Carpaccio, 1491

in the midst of furniture, ornaments, hangings of the same period, stale settings...
the masterpiece we contemplate as we dine does not give us that exhilarating delight
which we can expect from it only in a public gallery, which symbolizes far better, by
its bareness and by the absence of all irritating detail, those innermost spaces into
which the artist withdrew to create it.' Photographs of Proust's last, modest bedroom
at 44 rue Hamelin in Paris show unadorned walls hung in a dingy striped fabric, bereft
of anything approximating the vibrant, animated images in the writer's head. He may
have found that the sustenance domestic pictures provide to the eyes and mind was
a false comfort and creative dead-end for the working artist. Struggling with his
Ruskin translation, he had confessed to his collaborator, Marie Nordlinger, that pic-
tures had been banished from his field of vision: 'my room contains in its intentional
nudity only a single reproduction of a work of art – Whistler's *Carlyle*'. Soon even
Carlyle would be withdrawn. In two words, 'intentional nudity', two disparate, co-
existing essences are succinctly conjoined, the sensualist rubbing up against the
ascetic. Proust and his fictional self were both victims of seduction, both the poorer
for their inability to possess what their gaze desired. The visual and the erotic are
hopelessly entwined – what one sees, one cannot possess. At the end of *Time Regained*,
this revelation precipitates the Narrator's withdrawal to the solitary confines of art.

Travelling restlessly from Paris to Balbec for the first time, the Narrator glimpses
through the train window the first soft glimmers of dawn. The next moment, the
train turns away from the east and his window plunges again into nocturnal dark.
Soon it turns once more, and the window opposite him reveals a further effect
of sunrise on cloud and sky. 'I spent my time running from one window to the other
to reassemble, to collect on a single canvas the intermittent, antipodean fragments of
my fine, scarlet, ever-changing morning, and to obtain a comprehensive view and
a continuous picture of it.' Just as the Narrator grapples with the visual fracturing
of his idea of morning and longs to unify the multiplicity of disconnected observa-
tions, so *Paintings in Proust* attempts to reassemble in a single volume the fleeting
paintings weaving in and out of a moving narrative, to offer for the first time to the
reader of *In Search of Lost Time* 'a comprehensive view and a continuous picture'.

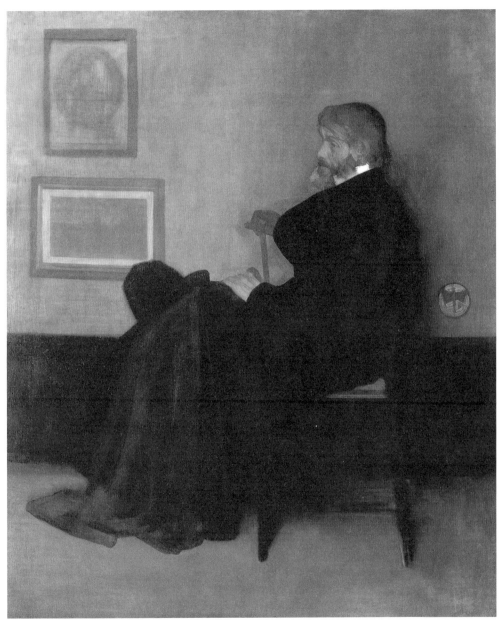

Arrangement in Grey and Black No. 2: Portrait of Thomas Carlyle, James Abbott McNeill Whistler, 1872–73

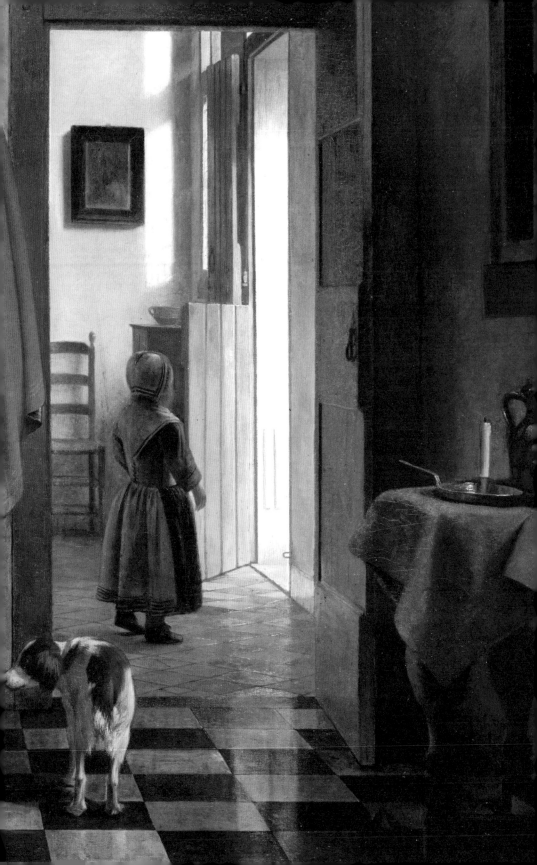

VOLUME I

Swann's Way

The Mother (detail), Pieter de Hooch, *c.* 1670

The young Narrator is on an annual Easter holiday with his family, staying at the home of his aunt Léonie in the small town ('a trifle depressing') of Combray. After dinner, he has been sent off to bed without the usual good-night kiss from his mother. He waits upstairs for her anxiously, knowing that being found out of bed could incite the wrath of his parents. Unexpectedly, his father responds benevolently:

I t was impossible for me to thank my father; he would have been exasperated by what he called mawkishness. I stood there, not daring to move; he was still in front of us, a tall figure in his white nightshirt, crowned with the pink and violet cashmere scarf which he used to wrap around his head since he had begun to suffer from neuralgia, standing like Abraham in the engraving after Benozzo Gozzoli which M. Swann had given me, telling Sarah she must tear herself away from Isaac.

The Sacrifice of Abraham, Carlo Lasinio (after Benozzo Gozzoli), *c.* 1806

The Narrator's grandmother has bought the young boy the pastoral novels of George Sand as a birthday gift, claiming that she could not bring herself to give him 'anything that was not well written'. She feels keenly the moral responsibility to expose her grandson only to elevated ideals:

S he would have liked me to have in my room photographs of ancient buildings or of beautiful places. But at the moment of buying them, and for all that the subject of the picture had an aesthetic value, she would find that vulgarity and utility had too prominent a part in them, through the mechanical nature of their reproduction by photography. She attempted by a subterfuge, if not to eliminate altogether this commercial banality, at least to minimise it, to supplant it to a certain extent with what was art still, to introduce, as it were, several 'thicknesses' of art: instead of photographs of Chartres Cathedral, of the Fountains of Saint-Cloud, or of Vesuvius, she would inquire of Swann whether some great painter had not depicted them, and preferred to give me photographs of 'Chartres Cathedral' after Corot, of the 'Fountains of Saint-Cloud' after Hubert Robert, and of 'Vesuvius' after Turner, which were a stage higher in the scale of art.

View of a Park with a Water Fountain,
Hubert Robert, 1783

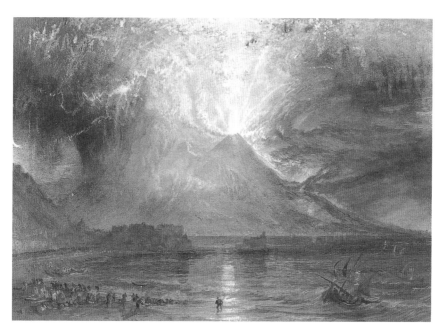

Vesuvius Erupting, Joseph Mallord William Turner, 1817

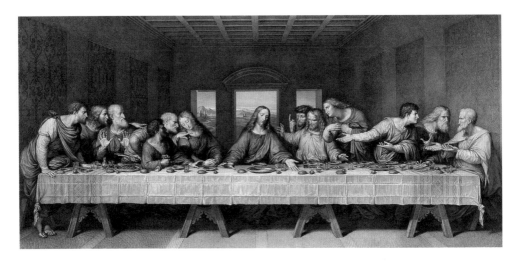

The Last Supper, Raphael Morghen (after Leonardo da Vinci), 1800

Determined to uphold high standards in her grandson's education, the Narrator's grandmother enlists the help of her neighbour and friend, the cultured and debonair Charles Swann:

Accordingly, having to reckon again with vulgarity, my grandmother would endeavour to postpone the moment of contact still further. She would ask Swann if the picture had not been engraved, preferring, when possible, old engravings with some interest of association apart from themselves, such, for example, as show us a masterpiece in a state in which we can no longer see it today (like Morghen's print of Leonardo's 'Last Supper' before its defacement).

While running errands with his mother, the young Narrator is struck by the way the church steeple of Saint-Hilaire appears, disappears, then reappears as they make their way through the small town square after mass. Into this remembered scene the voice of the adult Narrator intrudes, offering another observation of shifting visual perspectives:

Even in Paris, in one of the ugliest parts of the town, I know a window from which one can see, across a first, a second, and even a third layer of jumbled roofs, street beyond street, a violet dome, sometimes ruddy, sometimes too, in the finest 'prints' which the atmosphere makes of it, of an ashy solution of black, which is, in fact, none other than the dome of Saint-Augustin, and which imparts to this view of Paris the character of some of the Piranesi views of Rome.

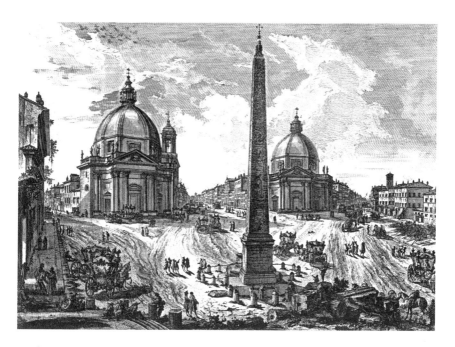

View of the Piazza del Popolo, from *Views of Rome (Vedute di Roma)*, Giovanni Battista Piranesi, 1750

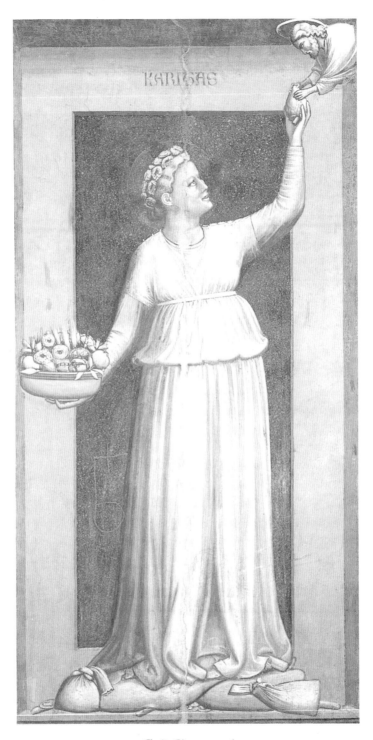

Charity, Giotto, 1304–6

At Combray, the Narrator's aunt, who is virtually bedridden, has her house run by the imposing housekeeper Françoise. At Easter each year, with the additional burden of the Narrator's family to care for, a supplementary servant is hired to assist:

I n the year in which we ate such quantities of asparagus, the kitchen-maid whose duty it was to prepare them was a poor sickly creature, some way 'gone' in pregnancy when we arrived at Combray for Easter, and it was indeed surprising that Françoise allowed her to run so many errands and to do so much work, for she was beginning to find difficulty in bearing before her the mysterious basket, fuller and larger every day, whose splendid outline could be detected beneath the folds of her ample smock. This last recalled the cloaks in which Giotto shrouds some of his allegorical figures, of which M. Swann had given me photographs. He it was who pointed out the resemblance, and when he inquired after the kitchen-maid he would say: 'Well, how goes it with Giotto's Charity?' And indeed the poor girl, whose pregnancy had swelled and stoutened every part of her, even including her face and her squarish, elongated cheeks, did distinctly suggest those virgins, so sturdy and mannish as to seem matrons rather, in whom the virtues are personified in the Arena Chapel. And I can see now that those Vices and Virtues of Padua resembled her in another aspect as well. For just as the figure of this girl had been enlarged by the additional symbol which she carried before her, without appearing to understand its meaning, with no awareness in her facial expression of its beauty and spiritual significance, as if it were an ordinary, rather heavy burden, so it is without any apparent suspicion of what she is about that the powerfully built housewife who is portrayed in the Arena Chapel beneath the label 'Caritas,' and a reproduction of whose portrait hung upon the wall of my schoolroom at Combray, embodies that virtue, for it seems impossible that any thought of charity can ever have found expression in her vulgar and energetic face.

Finding both the aptness and the irony in Swann's reference to 'Charity',
the Narrator reconsiders the other figures among Giotto's Vices and Virtues:

The 'Invidia,' again, should have had some look of envy on her face. But in this fresco, too, the symbol occupies so large a place and is represented with such realism, the serpent hissing between the lips of Envy is so huge, and so completely fills her wide-opened mouth, that the muscles of her face are strained and contorted, like those of a child blowing up a balloon, and her attention – and ours too for that matter – is so utterly concentrated on the activity of her lips as to leave little time to spare for envious thoughts.

Despite all the admiration M. Swann professed for these figures of Giotto, it was a long time before I could find any pleasure in contemplating on the walls of our schoolroom (where the copies he had brought me were hung) that Charity devoid of charity, that Envy who looked like nothing so much as a plate in some medical book, illustrating the compression of the glottis or the uvula by a tumour of the tongue or by the introduction of the operator's instrument, a Justice whose greyish and meanly regular features were identical with those which characterized the faces of certain pious, dessicated ladies of Combray whom I used to see at mass and many of whom had long been enrolled in the reserve forces of Injustice.

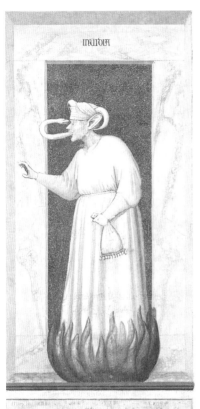

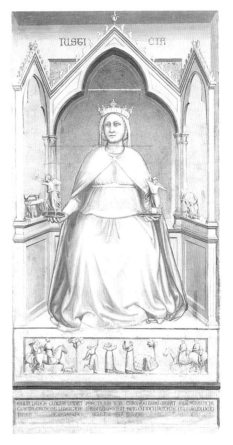

Envy, Giotto, 1304–6

Justice, Giotto, 1304–6

The Narrator is deeply impressed by the literary sophistication of a slightly older boy called Bloch, whom he befriends. His grandfather is full of remorse, not because Bloch is a Jew, but rather not a Jew 'of the best type' like Charles Swann, his grandfather's friend, who possesses a wholly more acceptable social standing:

O ne Sunday, while I was reading in the garden, I was interrupted by Swann, who had come to call upon my parents.

'What are you reading? May I look? Why, it's Bergotte! Who has been telling you about him?'

I said it was Bloch.

'Oh, yes, that boy I saw here once, who looks so like the Bellini portrait of Mahomet II. It's an astonishing likeness; he has the same arched eyebrows and hooked nose and prominent cheekbones. When he has a little beard he'll be Mahomet himself.'…

Swann felt a very cordial sympathy with the sultan Mahomet II whose portrait by Bellini he admired, who, on finding he had fallen madly in love with one of his wives, stabbed her to death in order, as his Venetian biographer artlessly relates, to recover his peace of mind.

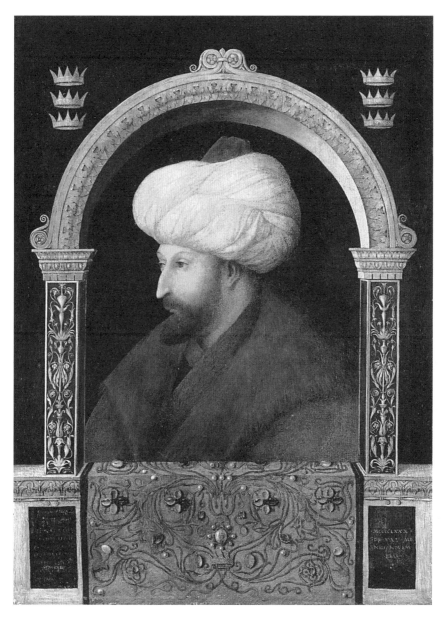

The Sultan Mehmet II, Gentile Bellini, 1480

On warm, moonlit evenings in Combray, the young Narrator and his father and mother would often stroll through the town, admiring the lime trees and the houses:

We would return by way of the Boulevard de la Gare, which contained the most attractive villas in the town. In each of their gardens the moonlight, copying the art of Hubert Robert, scattered its broken staircases of white marble, its fountains, its iron gates temptingly ajar. Its beams had swept away the telegraph office. All that was left of it was a column, half shattered but preserving the beauty of a ruin which endures for all time.

The Cenotaph of Jean-Jacques Rousseau in the Tuileries, Paris, Hubert Robert, 1794

Walking along the 'Méséglise way' in Combray, the Narrator expands upon the beauties of the landscape – the apple trees with their circular shadows, the fields, the spires of churches in distant towns:

Sometimes in the afternoon sky the moon would creep up, white as a cloud, furtive, lustreless, suggesting an actress who does not have to come on for a while, and watches the rest of the company for a moment from the auditorium in her ordinary clothes, keeping in the background, not wishing to attract attention to herself. I enjoyed finding its image reproduced in books and paintings, though these works of art were very different – at least in my earlier years, before Bloch had attuned my eyes and mind to more subtle harmonies – from those in which the moon would seem fair to me today, but in which I should not have recognized it then. It might, for instance, be some novel by Saintine, some landscape by Gleyre, in which it is silhouetted against the sky in the form of a silver sickle, one of those works as naïvely unformed as were my own impressions, and which it enraged my grandmother's sisters to see me admire.

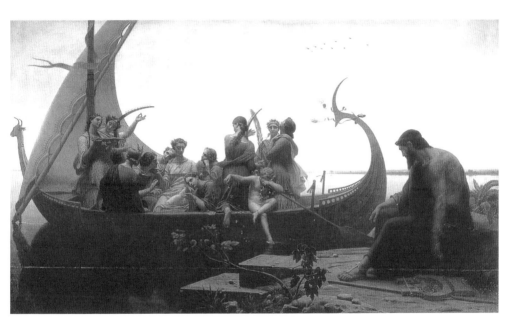

Lost Illusions (Le Soir), Charles Gleyre, 1843

The Narrator remembers his walks along the 'Guermantes way', a path that began just beyond his aunt Léonie's little garden gate, in the narrow, bent lane called the Rue des Perchamps. A village school has been built on the spot in the years since his childhood, but it does not stand in his way as he retraces the route in his memory:

But in my dreams of Combray...I leave not a stone of the modern edifice standing, but pierce through it and 'restore' the Rue des Perchamps. And for such reconstruction memory furnishes me with more detailed guidance than is generally at the disposal of restorers: the pictures which it has preserved – perhaps the last surviving in the world today, and soon to follow the rest into oblivion – of what Combray looked like in my childhood days; pictures which, because it was the old Combray that traced their outlines upon my mind before it vanished, are as moving – if I may compare a humble landscape with those glorious works, reproductions of which my grandmother was so fond of bestowing on me – as those old engravings of the Last Supper or that painting by Gentile Bellini, in which one sees, in a state in which they no longer exist, the masterpiece of Leonardo and the portico of Saint Mark's.

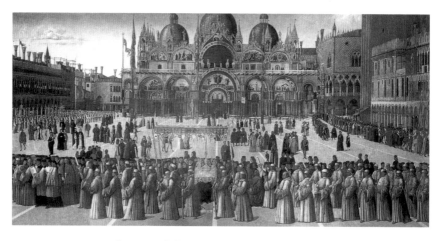

Procession in the Piazza San Marco, Gentile Bellini, 1496

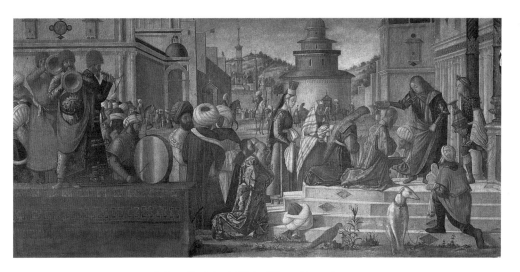

St George Baptizing the Selenites, Vittore Carpaccio, 1507

The Narrator catches a glimpse of the Duchesse de Guermantes at the wedding of Dr Percepied's daughter in Combray, and he is overwhelmed to be seeing a flesh and blood incarnation of the 'Guermantes way'. He believes their eyes meet; he falls in love and convinces himself that the Duchesse cares for him:

Her eyes waxed blue as a periwinkle flower, impossible to pluck, yet dedicated by her to me; and the sun, bursting out again from behind a threatening cloud and darting the full force of its rays on to the Square and into the sacristy, shed a geranium glow over the red carpet laid down for the wedding, across which Mme de Guermantes was smilingly advancing, and covered its woollen texture with a nap of rosy velvet, a bloom of luminosity, that sort of tenderness, of solemn sweetness in the pomp of a joyful celebration, which characterise certain pages of *Lohengrin*, certain paintings by Carpaccio, and make us understand how Baudelaire was able to apply to the sound of the trumpet the epithet 'delicious.'

To his surprise, the erudite Charles Swann has become infatuated with Odette de Crécy, a flirtatious courtesan he cannot seem to live without. Together they attend the informal evenings at the home of M. and Mme Verdurin, where they first hear the music of Vinteuil:

He would enter the drawing-room; and there, while Mme Verdurin, pointing to the roses which he had sent her that morning, said: 'I'm furious with you,' and sent him to the place kept for him beside Odette, the pianist would play to them – for their two selves – the little phrase by Vinteuil which was, so to speak, the national anthem of their love. He would begin with the sustained tremolos of the violin part which for several bars are heard alone, filling the whole foreground; until suddenly they seemed to draw aside, and – as in those interiors by Pieter de Hooch which are deepened by the narrow frame of a half-opened door, in the far distance, of a different colour, velvety with the radiance of some intervening light – the little phrase appeared, dancing, pastoral, interpolated, episodic, belonging to another world.

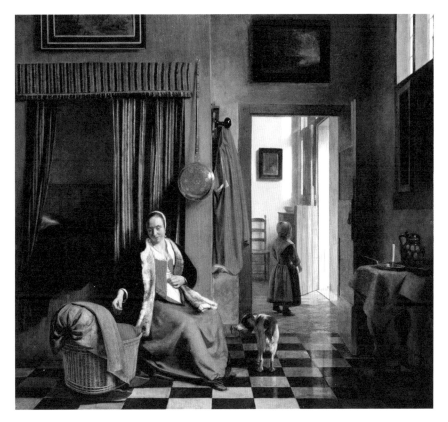

The Mother, Pieter de Hooch, 1670

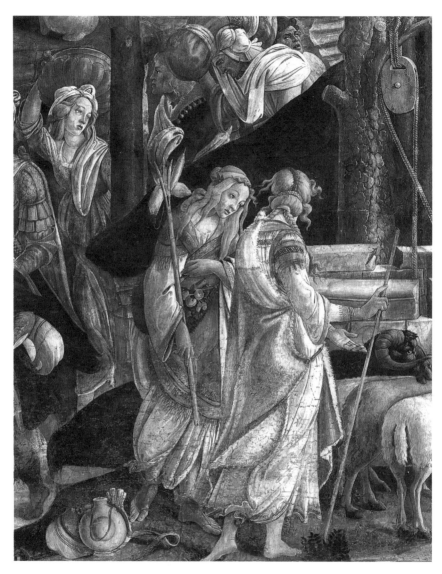

The Trials of Moses (detail), from *Episodes from the Life of Moses*,
Sandro Botticelli, 1481–82

Confident in his sense of himself as a man of the world, Swann takes pleasure in the company of a young seamstress during the early hours of the evening, while escorting Odette later at night to the Verdurin salon. On his second visit to Odette's house, he finds her unwell and not dressed for going out. Suddenly Swann is struck by her resemblance to a woman in a painting, and he loses his heart to her:

She was not very well, and she received him in a dressing gown of mauve crêpe de Chine, drawing its richly embroidered material over her bosom like a cloak. Standing there beside him, her loosened hair flowing down her cheeks, bending one knee in a slightly balletic pose in order to be able to lean without effort over the picture at which she was gazing, her head on one side, with those great eyes of hers which seemed so tired and sullen when there was nothing to animate her, she struck Swann by her resemblance to the figure of Zipporah, Jethro's daughter, which is to be seen in one of the Sistine frescoes....

He stood gazing at her; traces of the old fresco were apparent in her face and her body, and these he tried incessantly to recapture thereafter, both when he was with Odette and when he was only thinking of her in her absence; and, although his admiration for the Florentine masterpiece was doubtless based upon his discovery that it had been reproduced in her, the similarity enhanced her beauty also, and made her more precious. Swann reproached himself with his failure, hitherto, to estimate at her true worth a creature whom the great Sandro would have adored, and was gratified that his pleasure in seeing Odette should have found a justification in his own aesthetic culture....

He placed on his study table, as if it were a photograph of Odette, a reproduction of Jethro's daughter. He would gaze in admiration at the large eyes, the delicate features in which the imperfection of the skin might be surmised, the marvellous locks of hair that fell along the tired cheeks; and, adapting to the idea of a living woman what he had until then

felt to be beautiful on aesthetic grounds, he converted it into a series of physical merits which he was gratified to find assembled in the person of one whom he might ultimately possess. The vague feeling of sympathy which attracts one to a work of art, now that he knew the original in flesh and blood of Jethro's daughter, became a desire which more than compensated, thenceforward, for the desire which Odette's physical charms had at first failed to inspire in him. When he had sat for a long time gazing at the Botticelli, he would think of his own living Botticelli, who seemed even lovelier still, and as he drew towards him the photograph of Zipporah he would imagine that he was holding Odette against his heart....

Or else she would look at him sulkily, and he would see once again a face worthy to figure in Botticelli's 'Life of Moses'; he would place it there, giving to Odette's neck the necessary inclination; and when he had finished her portrait in tempera, in the fifteenth century, on the wall of the Sistine, the idea that she was none the less in the room with him still, by the piano, at that very moment, ready to be kissed and enjoyed, the idea of her material existence, would sweep over him with so violent an intoxication that, with eyes starting from his head and jaws tensed as though to devour her, he would fling himself upon this Botticelli maiden and kiss and bite her cheeks.

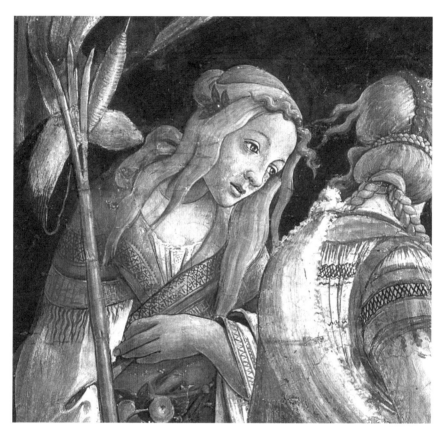

The Trials of Moses (detail), from *Episodes from the Life of Moses*,
Sandro Botticelli, 1481–82

A great connoisseur of fine art, Swann has a penchant for identifying, in the paintings of the past, the faces of individuals who inhabit his present world:

He had always found a peculiar fascination in tracing in the paintings of the old masters not merely the general characteristics of the people whom he encountered in his daily life, but rather what seems least susceptible of generalisation, the individual features of men and women whom he knew: as, for instance, in a bust of the Doge Loredan by Antonio Rizzo, the prominent cheekbones, the slanting eyebrows, in short, a speaking likeness to his own coachman Rémi; in the colouring of a Ghirlandaio, the nose of M. de Palancy; in a portrait by Tintoretto, the invasion of the cheek by an outcrop of whisker, the broken nose, the penetrating stare, the swollen eyelids of Dr du Boulbon.

Self-Portrait,
Jacopo Tintoretto, 1588

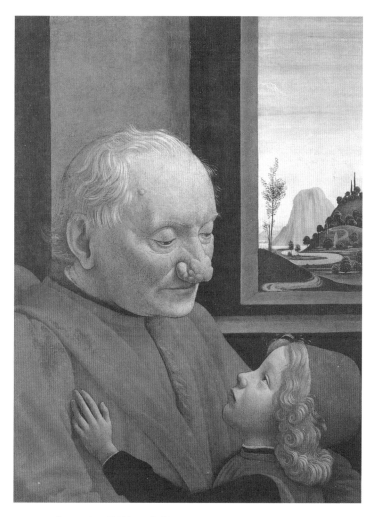

Portrait of an Old Man and a Young Boy, Domenico Ghirlandaio, 1490

Swann knows nothing of Odette's past, nor how she spends her daytime hours. During their courtship, Swann would see her only in the evenings. On rare occasions she would call on him at home in the afternoon:

His servant would come to in to say that Mme de Crécy was in the small drawing-room. He would go and join her, and when he opened the door, on Odette's rosy face, as soon as she caught sight of Swann, would appear – changing the curve of her lips, the look in her eyes, the moulding of her cheeks – an all-absorbing smile. Once he was alone he would see that smile again, and also her smile of the day before, and another with which she had greeted him sometime else, and the smile which had been her answer, in the carriage that night, when he had asked her whether she objected to his rearranging her cattleyas; and the life of Odette at all other times, since he knew nothing of it, appeared to him, with its neutral and colourless background, like those sheets of sketches by Watteau upon which one sees here, there, at every corner and at various angles, traced in three colours upon the buff paper, innumerable smiles.

Five Studies of the Face and Bust of a Woman, Antoine Watteau, *c.* 1713

Swann and Odette have become regulars at the Verdurin soirées. Mme Verdurin prides herself on the quality of intelligent conversation in her drawing room and around her table. Another member of this 'little circle' is a painter who is given to elaborate posturing. In this instance, he is carrying on about an exhibition of the work of a recently deceased artist who was an old friend:

'I went up to one of them,' he began, 'just to see how it was done. I stuck my nose into it. Well, it's just not true! Impossible to say whether it was done with glue, with rubies, with soap, with sunshine, with leaven, with cack! …It looks as though it was done with nothing at all,' resumed the painter; 'no more chance of discovering the trick than there is in *The Night Watch* or *The Female Regents*, and technically it's even better than either Rembrandt or Hals. It's all there – but really, I swear it.'…

Except at the moment when he had called it 'better than *The Night Watch*,' a blasphemy that had called forth an instant protest from Mme Verdurin, who regarded *The Night Watch* as the supreme masterpiece in the universe (conjointly with the *Ninth* and the *Winged Victory*), and at the word 'cack,' which had made Forcheville throw a sweeping glance round the table to see whether it was 'all right,' before he allowed his lips to curve in a prudish and conciliatory smile, all the guests (save Swann) had kept their fascinated and adoring eyes fixed upon the painter.

See page 181 for a reproduction of *The Women Regents of the Old Men's Almshouses.*

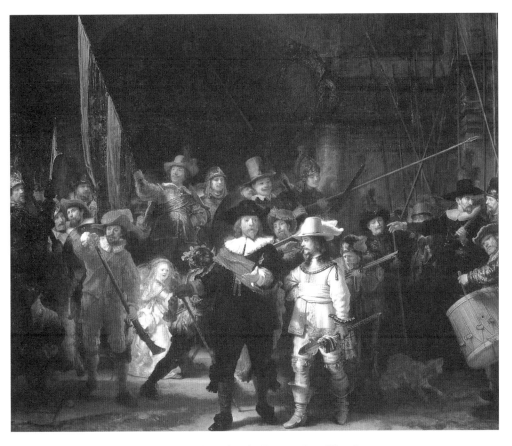

The Night Watch, Rembrandt (Harmensz.) van Rijn, 1642

The pleasure Swann takes in having Odette in his life is intensified by his awareness of what this pleasure is costing him. Still he is gratified to recognize in her sentiments displayed by other people close to him:

One day, when reflections of this sort had brought him back to the memory of the time when someone had spoken to him of Odette as of a kept woman, and he was amusing himself once again with contrasting that strange personification, the kept woman – an iridescent mixture of unknown and demoniacal qualities embroidered, as in some fantasy of Gustave Moreau, with poison-dripping flowers interwoven with precious jewels – with the Odette on whose face he had seen the same expressions of pity for a sufferer, revolt against an act of injustice, gratitude for an act of kindness, which he had seen in earlier days on his own mother's face and on the faces of his friends...

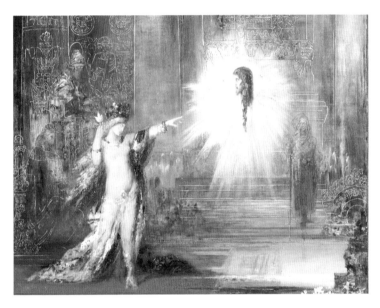

The Apparition (detail), Gustave Moreau, 1876

One afternoon, Swann pays an unannounced call upon Odette. He believes her to be at home – indeed he hears her footstep just behind the door – but when he knocks, there is no response. When he realizes that she is lying to him he is not especially troubled. However, Odette begins to appear remorseful:

All the same, it was a matter of so little importance that her air of unrelieved sorrow began at length to astonish him. She reminded him, even more than usual, of the faces of some of the women created by the painter of the 'Primavera.' She had at this moment their downcast, heart-broken expression, which seems ready to succumb beneath the burden of a grief too heavy to be borne when they are merely allowing the Infant Jesus to play with a pomegranate or watching Moses pour water into a trough....

Indeed he would have devoted to the reconstruction of the petty details of social life on the Côte d'Azur in those days, if it could have helped him to understand something of Odette's smile and the look in her eyes – candid and simple though they were – as much passion as the aesthete who ransacks the extant documents of fifteenth-century Florence in order to penetrate further into the soul of the Primavera, the fair Vanna or the Venus of Botticelli.

Venus Offering Gifts to a Youth Accompanied by the Graces (detail), Sandro Botticelli, 1486

See page 12 for Botticelli's *Birth of Venus.*
See page 23 for Botticelli's *Episodes from the Life of Moses.*

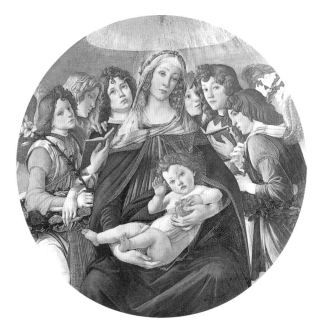

Madonna of the Pomegranate, Sandro Botticelli, c. 1487

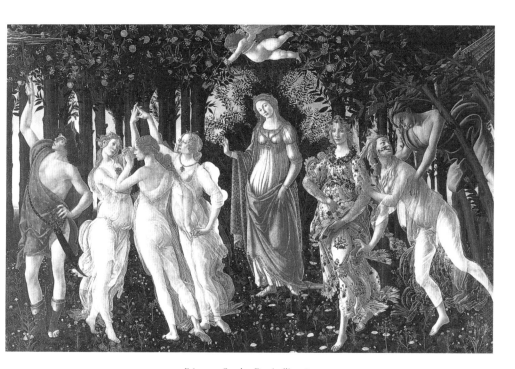

Primavera, Sandro Botticelli, 1482

Swann, distracted by thoughts of Odette, arrives at the home of the Marquise de Saint-Euverte for a musical evening. Descending from the carriage that has brought him, Swann is immediately attended to by a swarm of liveried footmen:

T he tendency he had always had to look for analogies between living people and the portraits in galleries reasserted itself here, but in a more positive and more general form; it was society as a whole, now that he was detached from it, which presented itself to him as a series of pictures. In the hall, which in the old days, when he was still a regular attender at such functions, he would have entered swathed in his overcoat to emerge from it in his tails, without noticing what had happened during the few moments he had spent there, his mind having been either still at the party which he had just left or already at the party into which he was about to be ushered, he now noticed for the first time, roused by the unexpected arrival of so belated a guest, the scattered pack of tall, magnificent, idle footmen who were drowsing here and there upon benches and chests and who, pointing their noble greyhound profiles, now rose to their feet and gathered in a circle round about him.

One of them, of a particularly ferocious aspect, and not unlike the headsman in certain Renaissance pictures which represent executions, tortures and the like, advanced upon him with an implacable air to take his things. But the harshness of his steely glare was compensated by the softness of his cotton gloves, so that, as he approached Swann, he seemed to be exhibiting at once an utter contempt for his person and the most tender regard for his hat.

The Martyrdom of St Agatha, Sebastiano del Piombo, 1520

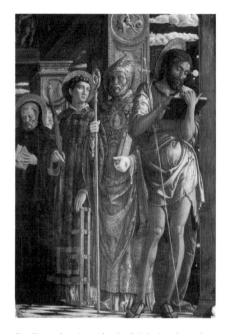

St George, Paumgartner
altar, Albrecht Dürer, 1503

San Zeno altarpiece (detail of right-hand panel),
Andrea Mantegna, 1457–60

Swann makes his way into the Marquise de Saint-Euverte's party, buoyed along
by a team of manservants who see to his every need. His mind races with historical
visual associations culled from paintings:

A few feet away, a strapping great fellow in livery stood musing, motionless, statuesque, useless, like that purely decorative warrior whom one sees in the most tumultuous of Mantegna's paintings, lost in thought, leaning upon his shield, while the people around him are rushing about slaughtering one another; detached from the group of his companions who were thronging about Swann, he seemed as determined to remain aloof from that scene, which he followed vaguely with his cruel glaucous eyes, as if it had been the Massacre of the Innocents or the Martyrdom of St James. He seemed precisely to have sprung from that vanished race – if, indeed, it had ever existed, save in the reredos of San Zeno and the frescoes of the Eremitani, where Swann had come in contact with it, and where it still dreams – fruit of the impregnation of a classical statue by one of the Master's Paduan models or an Albrecht Dürer Saxon.

St James Led to Execution (detail), from *Martyrdom of St James*,
Andrea Mantegna, 1450–54

Once inside, surrounded by party guests, Swann begins to assess his fellow socialites. He finds them far less attractive than the servants outside. A parade of men sporting monocles passes by him:

Meanwhile, behind him, M. de Palancy, who with his huge carp's head and goggling eyes moved slowly through the festive gathering, periodically unclenching his mandibles as though in search of his orientation, had the air of carrying about upon his person only an accidental and perhaps purely symbolical fragment of the glass wall of his aquarium, a part intended to suggest the whole, which recalled to Swann, a fervent admirer of Giotto's Vices and Virtues at Padua, that figure representing Injustice by whose side a leafy bough evokes the idea of the forests that enshroud his secret lair.

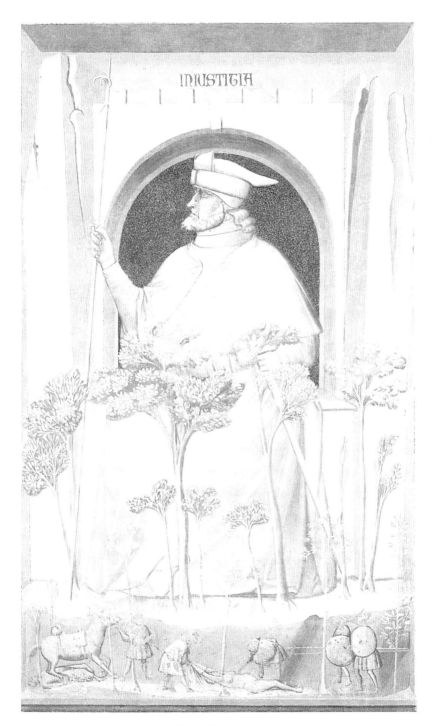

Injustice, Giotto, 1304–6

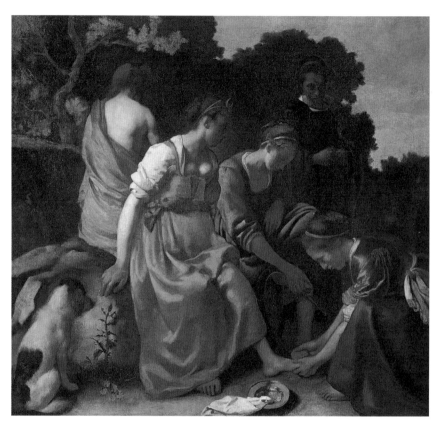

Diana and her Companions, Jan Vermeer, 1653–54

Odette's love for Swann has cooled and he must acknowledge to himself that his hopes for happiness with her are beyond realization. Defeated and dispirited, he returns to his scholarly work:

Now that he was once again at work upon his essay on Vermeer, he needed to return, for a few days at least, to The Hague, to Dresden, to Brunswick. He was convinced that a picture of 'Diana and her Companions' which had been acquired by the Mauritshuis at the Goldschmidt sale as a Nicholas Maes was in reality a Vermeer. And he would have liked to be able to examine the picture on the spot, in order to buttress his conviction. But to leave Paris while Odette was there, and even when she was not there – for in strange places where our sensations have not been numbed by habit, we revive, we resharpen an old pain – was for him so cruel a project that he felt capable of entertaining it incessantly in his mind only because he knew he was determined never to put it into effect.

Aboard a bus heading to the Luxembourg Gardens in Paris, Swann encounters another member of the Verdurin set, Mme Cottard, journeying about town to pay social calls. She is brimming over with enthusiasm for her subject of the day and Swann, a temporary hostage, listens with his usual polite attention:

'I needn't ask you, M. Swann, whether a man so much in the swim as yourself has been to the Mirlitons to see the portrait by Machard which the whole of Paris is rushing to see. Well and what do you think of it? Whose camp are you in, those who approve or those who don't? It's the same in every house in Paris now, no one talks about anything else but Machard's portrait. You aren't smart, you aren't really cultured, you aren't up-to-date unless you give an opinion on Machard's portrait....I have another friend who insists that she'd rather have Leloir. I'm only a wretched Philistine, and for all I know Leloir may be technically superior to Machard. But I do think that the most important thing about a portrait, especially when it's going to cost ten thousand francs, is that it should be like, and a pleasant likeness if you know what I mean.'

A Portrait of Two Boys With a Sketchbook,
Jean-Baptiste Auguste Leloir, 1847

Young Woman in an Evening Dress with Hydrangeas,
Jules Machard, 1896

The Narrator, in poor health and convalescing in his Paris apartment, nevertheless sets sail in his mind. First dreaming of the storms along the Normandy coast, he is soon imagining a Tuscan paradise:

But at the approach of the Easter holidays, when my parents had promised to let me spend them for once in the North of Italy, suddenly, in place of those dreams of tempests by which I had been entirely possessed…was substituted in me the converse dream of the most colourful of springs, not the spring of Combray, which still pricked sharply with all the needle-points of the winter's frost, but that which already covered the meadows of Fiesole with lilies and anemones, and gave Florence a dazzling golden background like those in Fra Angelico's pictures.

Coronation of the Virgin, Fra Angelico, 1434

With no experience of foreign cities, the Narrator is reduced to feeding his travel fever with imagery from paintings:

When my father had decided, one year, that we should go for the Easter holidays to Florence and Venice, not finding room to introduce into the name of Florence the elements that ordinarily constitute a town, I was obliged to evolve a supernatural city from the impregnation by certain vernal scents of what I supposed to be, in its essentials, the genius of Giotto. At most – and because one cannot make a name extend much further in time than in space – like some of Giotto's paintings themselves which show us at two separate moments the same person engaged in different actions, here lying in his bed, there getting ready to mount his horse, the name of Florence was divided into two compartments....That (even though I was still in Paris) was what I saw, and not what was actually round about me. Even from the simplest, the most realistic point of view, the countries which we long for occupy, at any given moment, a far larger place in our actual life than the country in which we happen to be.

The Sacrifice of Joachim, Giotto, 1304–6

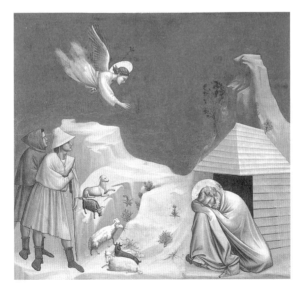

The Dream of Joachim, Giotto, 1304–6

Whenever it is felt that he is strong enough to venture out-of-doors, the young Narrator is sent to play in the park of the Champs-Élysées. He goes out in the company of the family servant, Françoise, sent to monitor his exertions. One day, straying a bit further than their usual haunts, the Narrator is struck by the first of love's random arrows:

The name Gilberte passed close by me...forming, on its celestial passage through the midst of the children and their nursemaids, a little cloud, delicately coloured, resembling one of those clouds that, billowing over a Poussin landscape, reflect minutely, like a cloud in the opera teeming with chariots and horses, some apparition of the life of the gods – casting, finally, on that ragged grass, at the spot where it was at once and the same time a scrap of withered lawn and a moment in the afternoon of the fair battledore player (who continued to launch and retrieve her shuttlecock until a governess with a blue feather in her hat had called her away) a marvellous little band of light, the colour of heliotrope, impalpable as a reflection and superimposed like a carpet on which I could not help but drag my lingering, nostalgic and desecrating feet, while Françoise shouted: 'Come on, do up your coat and let's clear off!' and I remarked for the first time how common her speech was, and that she had, alas, no blue feather in her hat.

Spring, or The Earthly Paradise, Nicolas Poussin, 1660

Charles Swann (highly esteemed and much deferred to at Combray by the Narrator's aunts) marries Odette, a woman of questionable moral character, thereby jeopardizing his longstanding connections with the exacting beau monde. The Swanns have a daughter, Gilberte, to whom the Narrator has lost his heart. When he cannot expect to see Gilberte in the park of the Champs-Élysées, he leads Françoise to the Bois de Boulogne in hope of catching a glimpse of Gilberte's mother:

I saw at length emerging from the Porte Dauphine – figuring for me a royal dignity, the passage of a sovereign, an impression such as no real queen has ever since been able to give me, because my notion of their power has been less vague, more founded upon experience – borne along by the flight of a pair of fiery horses, slender and shapely as one sees them in the drawings of Constantin Guys, carrying on its box an enormous coachman furred like a Cossack, and by his side a diminutive groom like 'the late Beaudenord's tiger,' I saw – or rather I felt its outlines engraved upon my heart by a clean and poignant wound – a matchless victoria, built rather high, and hinting, through the extreme modernity of its appointments, at the forms of an earlier day, in the depths of which Mme Swann negligently reclined, her hair, now blond with one grey lock, encircled with a narrow band of flowers, usually violets, from which floated down long veils, a lilac parasol in her hand, on her lips an ambiguous smile in which I read only the benign condescension of Majesty, though it was pre-eminently the provocative smile of the courtesan, which she graciously bestowed upon the men who greeted her.

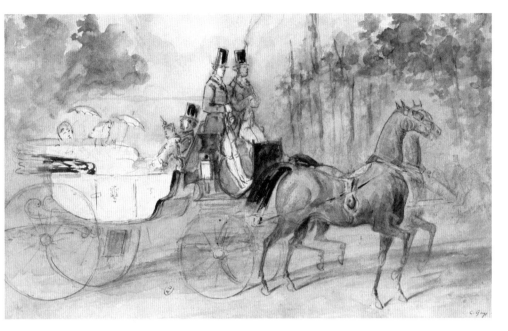

Promenade in the Woods, Constantin Guys, after 1860

On autumn days in Paris, the Bois de Boulogne exerts a transcendent power over the besotted Narrator. Amongst its groves of trees, he languishes in his 'obscure desire':

I walked towards the Allée des Acacias…the trees continued to live by their own vitality, which, when they had no longer any leaves, gleamed more brightly still on the nap of green velvet that carpeted their trunks, or in the white enamel of the globes of mistletoe that were scattered among the topmost boughs of the poplars, rounded like the sun and the moon in Michelangelo's *Creation*.

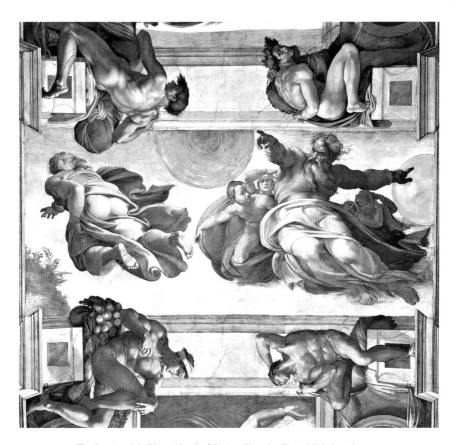

The Creation of the Planets (detail of Sistine Chapel ceiling), Michelangelo, 1511

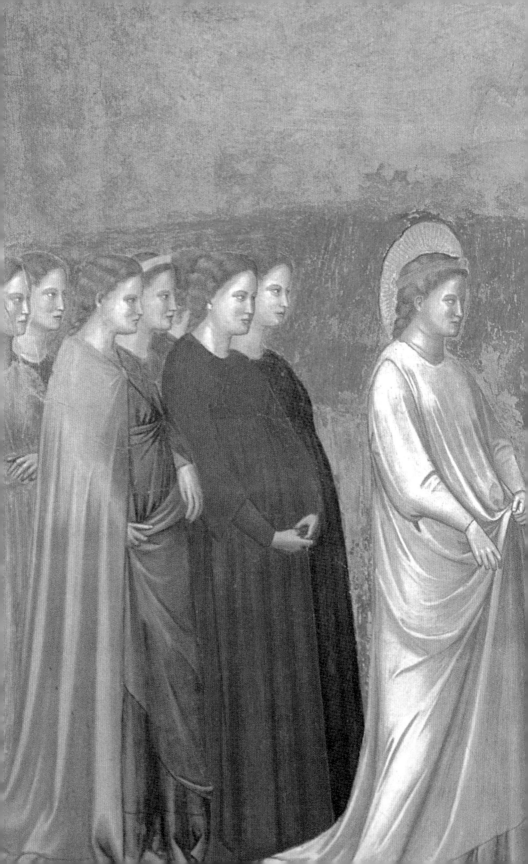

VOLUME II

Within a Budding Grove

As a result of the approval expressed by his parents' distinguished friend M. de Norpois, the Narrator has finally been granted permission to attend a performance in which the actress Berma will appear. His expectations are enormous; he equates the impact of her artistry with that of the Venetian masters:

For when it is in the hope of making a priceless discovery that we desire to receive certain impressions from nature or from works of art, we have qualms lest our soul imbibe inferior impressions which might lead us to form a false estimate of the value of Beauty. Berma in *Andromaque*, in *Les Caprices de Marianne*, in *Phèdre*, was one of those famous spectacles which my imagination had long desired. I should enjoy the same rapture as on the day when a gondola would deposit me at the foot of the Titian of the Frari or the Carpaccios of San Giorgio dei Schiavoni, were I ever to hear Berma recite the lines beginning,

They say a prompt departure takes you from us, Prince…

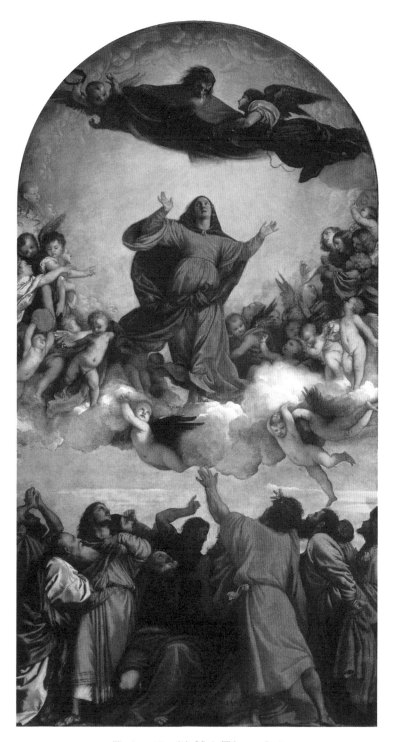

The Assumption of the Virgin, Titian, 1516–18

The Narrator is smitten with Gilberte, daughter of Charles and Odette Swann. He takes advantage of the connection between his family and hers to position himself in her world. On occasion they play in her room and, when a little air is needed, they lean out of her window together:

At such moments Gilberte's plaits used to brush my cheek. They seemed to me, in the fineness of their grain, at once natural and supernatural, and in the strength of their skilfully woven tracery, a matchless work of art in the composition of which had been used the very grass of Paradise. To a section of them, however infinitesimal, what celestial herbarium would I not have given as a reliquary? But since I never hoped to obtain an actual fragment of those plaits, if at least I had been able to have a photograph of them, how far more precious than one of a sheet of flowers drawn by Leonardo!

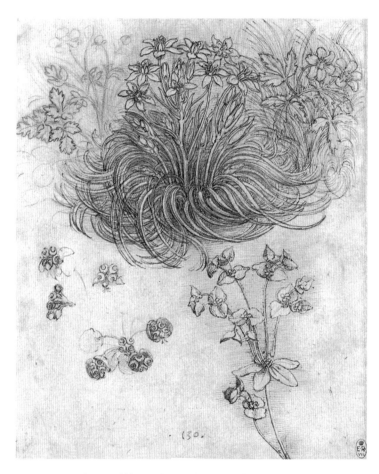

A 'Star of Bethlehem' and Other Plants, Leonardo da Vinci, 1505

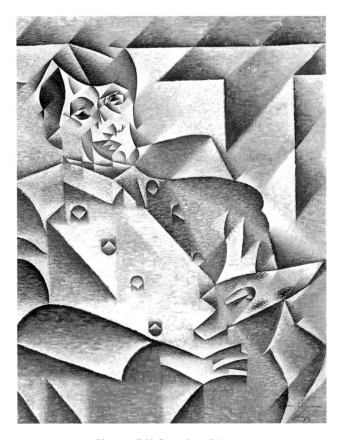

Homage to Pablo Picasso, Juan Gris, 1912

Listening to Mme Swann playing a passage from the Vinteuil sonata, the Narrator begins to analyse its impact upon him. He realizes that when he hears music that is familiar to him, he finds it less beautiful, less moving than when he hears music that is unknown to him. His thoughts then expand to include all manifestations of what is initially unfamiliar, or new, in art:

And so it is essential that the artist (and this is what Vinteuil had done), if he wishes his work to be free to follow its own course, should launch it, there where there is sufficient depth, boldly into the distant future.... No doubt it is easy to imagine, by an illusion similar to that which makes everything on the horizon appear equidistant, that all the revolutions which have hitherto occurred in painting or in music did at least respect certain rules, whereas that which immediately confronts us, be it impressionism, the pursuit of dissonance, an exclusive use of the Chinese scale, cubism, futurism or what you will, differs outrageously from all that has occurred before.

Odette and Swann receive the young Narrator in their home and make him welcome as a friend of their daughter. While the precocious mind and impeccable manners of this young man are duly acknowledged, his hosts also occasionally tease him:

'Which reminds me, talking of the Zoo, do you know, this young man thought that we were devotedly attached to a person whom I cut as a matter of fact whenever I possibly can, Mme Blatin. I think it's rather humiliating for us that she should be taken for a friend of ours. Just fancy, dear Dr Cottard, who never says a harsh word about anyone, declares that she's positively repellant!' 'A frightful woman! The one thing to be said for her is that she's exactly like Savonarola. She's the very image of that portrait of Savonarola by Fra Bartolommeo.'

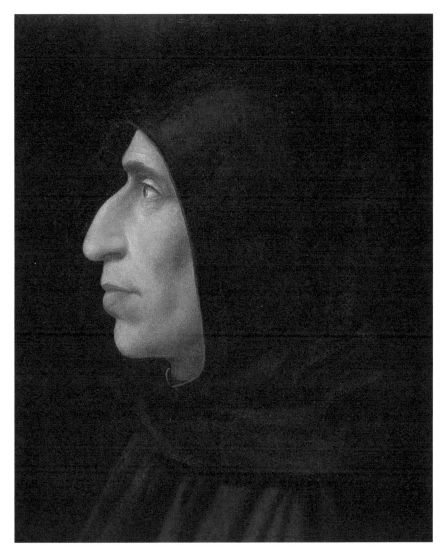

Portrait of Savonarola, Fra Bartolommeo, 1498

Swann takes refuge from the world around him by crossing over into the world of paintings. He surrounds himself with painted figures who are as dear to him as his friends:

This mania of Swann's for finding likenesses to people in pictures was defensible, for even what we call individual expression is – as we so painfully discover when we are in love and would like to believe in the unique reality of the beloved – something diffused and general, which can be found existing at different periods. But if one had listened to Swann, the retinues of the Magi, already so anachronistic when Benozzo Gozzoli introduced in their midst various Medicis, would have been even more so, since they would have included the portraits of a whole crowd of men, contemporaries not of Gozzoli but of Swann, subsequent, that is to say, not only by fifteen centuries to the Nativity but by four to the painter himself. There was not missing from those cortèges, according to Swann, a single living Parisian of note, any more than there was from that act in one of Sardou's plays, in which, out of friendship for the author and for the leading lady, and also because it was the fashion, all the notabilities of Paris, famous doctors, politicians, barristers, amused themselves, each on a different evening, by 'walking on'.

Journey of the Magi (detail), Benozzo Gozzoli, 1459

Having been so thoroughly instructed by her husband in the manners of polite society, Mme Swann is now entirely the equal of any great lady. Out of deference to Swann's long and intimate friendships with the elite of the Faubourg Saint-Germain, many grandes dames condescend to accept greetings from the couple as they meet out-of-doors:

T he day on which we went to inspect the Singhalese, on our way home we saw coming in our direction, and followed by two others who seemed to be acting as her escort, an elderly but still handsome lady enveloped in a dark overcoat and wearing a little bonnet tied beneath her chin with a pair of ribbons. 'Ah! Here's someone who will interest you!' said Swann. The old lady, who was now within a few yards of us, smiled at us with a caressing sweetness. Swann doffed his hat. Mme Swann swept to the ground in a curtsey, and made as if to kiss the hand of the lady, who, standing there like a Winterhalter portrait, drew her up again and kissed her cheek. 'Come, come, will you put your hat on, you!' she scolded Swann in a thick and almost growling voice…

Empress Maria Aleksandrovna, Franz Xavier Winterhalter, 1857

Once again, Swann offers to introduce the Narrator to his favourite writer, the novelist Bergotte. The young man is enthralled by the prospect of meeting his literary idol and feels intensely grateful to Swann for making this happen. In a pictoral association worthy of Swann himself, the Narrator acknowledges this generous gesture:

I seemed to remember having heard once at Combray that he had suggested to them that, in view of my admiration for Bergotte, he should take me to dine with him, and that my parents had declined, saying that I was too young and too highly-strung to 'go out.' My parents doubtless represented to certain other people (precisely those who seemed to me the most wonderful) something quite different from what they were to me, so that, just as when the lady in pink had paid my father a tribute of which he had shown himself so unworthy, I should have wished them to understand what an inestimable present I had just received and, to show their gratitude to that generous and courteous Swann who had offered it to me, or to them rather, without seeming any more conscious of its value than the charming Mage with the arched nose and fair hair in Luini's fresco, to whom, it was said, Swann had at one time been thought to bear a striking resemblance.

Adoration of the Magi, Bernardino Luini, 1520–25

What was once 'chic' is now 'trashy'. Mme Swann is a creature of fashion. She is passionately devoted to her aesthetic ideals, even if they are continually changing:

Nowadays it was rarely in Japanese kimonos that Odette received her intimates, but rather in the bright and billowing silk of a Watteau housecoat whose flowering foam she would make as though to rub gently over her bosom, and in which she basked, lolled, disported herself with such an air of well-being, of cool freshness, taking such deep breaths, that she seemed to look on these garments not as something decorative, a mere set-

ting for herself, but as necessary, in the same way as her 'tub' or her daily 'constitutional,' to satisfy the requirements of her physiognomy and the niceties of hygiene. She used often to say that she would go without bread rather than give up art and cleanliness, and that the burning of the 'Gioconda' would distress her infinitely more than the destruction, by the same element, of the 'millions' of people she knew.

Mona Lisa (La Gioconda),
Leonardo da Vinci, 1503–6

The Italian Serenade, Antoine Watteau, 1715

As Mme Swann gains stature in certain circles of society, she takes on a 'winning and enigmatic expression'. This conceals her less confident nature, the diffident comportment of Odette de Crécy, with whom Swann had originally fallen in love:

For he still liked to see his wife as a Botticelli figure. Odette, who on the contrary sought not to bring out but to compensate for, to cover and conceal the points about her looks that did not please her, what might perhaps to an artist express her 'character' but in her woman's eyes were blemishes, would not have that painter mentioned in her presence. Swann had a wonderful scarf of oriental silk, blue and pink, which he had bought because it was exactly that worn by the Virgin in the *Magnificat*. But Mme Swann refused to wear it. Once only she allowed her husband to order her a dress covered all over with daisies, cornflowers, forget-me-nots and bluebells, like that of the Primavera. And sometimes in the evening, when she was tired, he would quietly draw my attention to the way in which she was giving, quite unconsciously, to her pensive hands the uncontrolled, almost distraught movement of the Virgin who dips her pen into the inkpot that the angel holds out to her, before writing upon the sacred page on which is already traced the word 'Magnificat'. But he added: 'Whatever you do, don't say anything about it to her; if she knew she was doing it, she would change her pose at once.'

See page 63 for Botticelli's *Primavera*.

Madonna of the Magnificat, Sandro Botticelli, 1480–81

The Narrator contemplates the nature of travel as he prepares for his long-desired departure for the seaside at Balbec. He elaborates upon the difference between imagined journeys and actual ones. When we travel in our imagination, he muses, we are miraculously borne 'from the place in which we were living right to the very heart of a place we longed to see':

Unhappily those marvellous places, railway stations, from which one sets out for a remote destination, are tragic places also, for if in them the miracle is accomplished whereby scenes which hitherto have had no existence save in our minds are about to become the scenes among which we shall be living, for that very reason we must, as we emerge from the waiting room, abandon any thought of presently finding ourselves once more in the familiar room which but a moment ago still housed us. We must lay aside all hope of going home to sleep in our own bed, once we have decided to penetrate into the pestiferous cavern to which we gain access to the mystery, into one of those vast glass-roofed sheds, like that of Saint-Lazare into which I went to find the train for Balbec, and which extended over the eviscerated city one of those bleak and boundless skies, heavy with an accumulation of dramatic menace, like certain skies painted with an almost Parisian modernity by Mantegna or Veronese, beneath which only some terrible and solemn act could be in process, such as a departure by train or the erection of the Cross.

The Crucifixion, Veronese, 1580–88

Self-Portrait Wearing Spectacles, Jean-Baptiste-Siméon Chardin, 1771

The day of departure has arrived, and the Narrator is distraught at the imminent separation from his beloved mother. In his mind, this represents parting not only in the present instance, but also in a future sense, as it marks the beginning of an inevitable estrangement brought on by time:

Then Mamma sought to distract me by asking what I thought of having for dinner and drawing my attention to Françoise, whom she complimented on a hat and coat which she did not recognize, although they had horrified her long ago when she first saw them, new, upon my great-aunt, the one with an immense bird towering over it, the other decorated with a hideous pattern and jet beads. But the cloak having grown too shabby to wear, Françoise had had it turned, exposing an 'inside' of plain cloth and quite a good colour. As for the bird, it had long since come to grief and been discarded. And just as it is disturbing, sometimes, to find the effects that the most conscious artists have to strive for in a folk song or on the wall of some peasant's cottage where above the door, at precisely the right spot in the composition, blooms a white or yellow rose – so with the velvet band, the loop of ribbon that would have delighted one in a portrait by Chardin or Whistler, which Françoise had set with simple but unerring taste upon the hat, which was now charming.

Harmony in Pink and Grey: Valerie, Lady Meaux (detail), James Abbott McNeill Whistler, 1881

The sight of the modest but elegantly turned out Françoise, who is to travel with the Narrator and his grandmother, temporarily comforts the anxieties of the traveller, who derives from her moral simplicity a picture of inner tranquillity and solace:

To take a parallel from an earlier age, the modesty and integrity which often gave an air of nobility to the face of our old servant having extended also to the clothes which, as a discreet but by no means servile woman, who knew how to hold her own and to keep her place, she had put on for the journey so as to be fit to be seen in our company without at the same time seeming or wishing to make herself conspicuous, Françoise, in the faded cherry-coloured cloth of her coat and the discreet nap of her fur collar, brought to mind one of those miniatures of Anne of Brittany painted in Books of Hours by an old master, in which everything is so exactly in the right place, the sense of the whole is so evenly distributed throughout the parts, that the rich and obsolete singularity of the costume expresses the same pious gravity as the eyes, the lips and the hands.

Anne with Patron Saints, from the *Great Hours of Anne of Brittany, Queen of France*,
Jean Bourdichon, 1500–8

At Balbec, the Narrator is introduced to his grandmother's old friend Mme de Villeparisis. Unassuming and yet worldly, a friend of the Princesse de Luxembourg, she surprises the Narrator with information about his father, who, as Permanent Secretary of the Ministry, has been on a diplomatic errand in Spain:

And I wondered by what strange accident, in the impartial telescope through which Mme de Villeparisis considered, from a safe distance, the minuscule, perfunctory, vague agitation of the host of people whom she knew, there had come to be inserted at the spot through which she observed my father a fragment of glass of prodigious magnifying power which made her see in such high relief and in the fullest detail everything that was agreeable about him, the contingencies that obliged him to return home, his difficulties with the customs, his admiration for El Greco, and, altering the scale of her vision, showed her this one man, so large among all the rest so small, like that Jupiter to whom Gustave Moreau, when he portrayed him by the side of a weak mortal, gave a superhuman stature.

Jupiter and Semele, Gustave Moreau, 1895

Mme de Villeparisis proves to be an invaluable companion to the Narrator's grandmother, making all the resources she has to offer available to her old friend. Increasingly she is subjected to the Narrator's scrutiny. He is surprised and impressed by her pedigree and her erudition:

O ne got the impression that for her there were no other pictures than those that have been inherited. She was pleased that my grandmother liked a necklace which she wore, and which hung over her dress. It appeared in a portrait of an ancestress of hers, by Titian, which had never left the family. So that one could be certain of its being genuine.

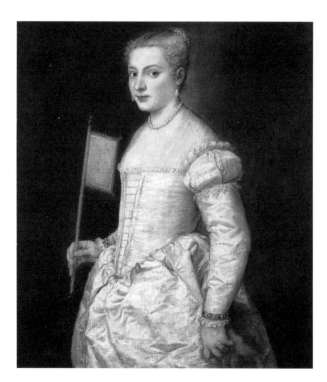

Portrait of a Lady in White, Titian, 1555

Lady Leaning her Elbows on a Table, Eugène Carrière, 1893

After lavishing on them such devoted attention, Mme de Villeparisis announces she will see less of the Narrator and his grandmother in the coming weeks, as she has a nephew coming to stay with her. And so Robert, the Marquis de Saint-Loup-en-Bray enters their lives and reveals his direct connection to the Guermantes family:

'But what they have got at Guermantes, which is a little more interesting, is quite a touching portrait of my aunt by Carrière. It's as fine as Whistler or Velasquez,' went on Saint-Loup, who in his neophyte zeal was not always very exact about degrees of greatness.

Though initially dazzled by Saint-Loup's appearance and the immaculate tailoring of his clothes, the Narrator finds he has as a new friend an extremely attentive young nobleman. Unlike his older relatives, Saint-Loup prefers to live in the modern world:

I f Saint-Loup's strivings towards sincerity and emancipation could not but be regarded as extremely noble, to judge by their visible result, one could still be thankful that they had failed to bear fruit in M. de Charlus, who had transferred to his own home much of the admirable furniture from the Hôtel Guermantes instead of replacing it, like his nephew, with Art Nouveau furniture, pieces by Lebourg or Guillaumin.

Environs of Paris, Armand Guillaumin, *c.* 1890

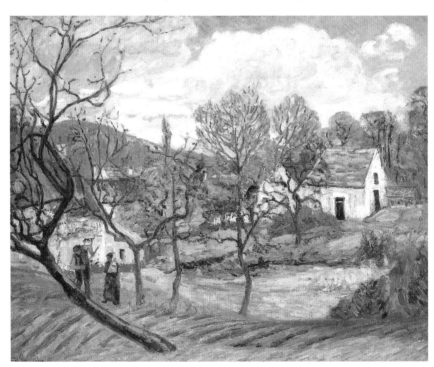

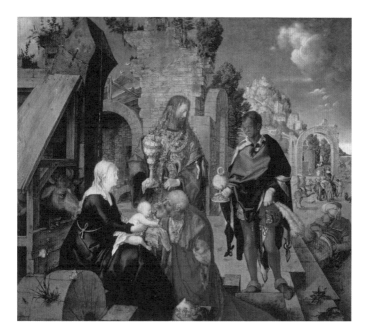

The Adoration of the Magi, Albrecht Dürer, 1504

Taking leave of his new friend, Saint-Loup returns to his soldier's life. The Narrator feels his absence at Balbec. One day, however, he has his first glimpse of a group of young girls and he, 'going through one of those phases of youth', is enormously attracted to them:

They were now quite near me. Although each was of a type absolutely different from the others, they all had beauty; but to tell the truth I had seen them for so short a time, and without venturing to look hard at them, that I had not yet individualized any of them. Except for one, whose straight nose and dark complexion singled her out from the rest, like the Arabian king in a Renaissance picture of the Epiphany, they were known to me only by a pair of hard, obstinate and mocking eyes, for instance, or by cheeks whose pinkness had a coppery tint reminiscent of geraniums; and even these features I had not yet indissolubly attached to any one of these girls rather than to another.

Having become a fixed presence in the life of the hotel at Balbec, the Narrator falls into an insular state, making fewer efforts to be sociable to the staff. However, he is still receptive to intense sensations drawn from his immediate surroundings:

But as a rule, for my zeal and timidity of the first evening were now things of the past, I no longer spoke to the lift-boy. It was he now who stood there and received no answer during the short journey on which he threaded his way through the hotel, which, hollowed out inside like a toy, deployed around us, floor by floor, the ramifications of its corridors in the depths of which the light grew velvety, lost its tone, blurred the communicating doors or the steps of the service stairs which it transformed into that amber haze, unsubstantial and mysterious as a twilight, in which Rembrandt picks out here and there a window-sill or a well-head.

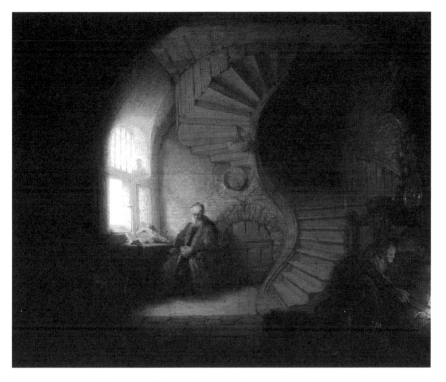

Philosopher in Meditation, Rembrandt (Harmensz.) van Rijn, 1632

The summer is passing and the transformation from one season to the next makes itself felt. The seaside resort quietens down as more hotel guests depart and the days begin to draw in:

I went into my room. Gradually, as the season advanced, the picture that I found there in my window changed. At first it was broad daylight, and dark only if the weather was bad: and then, in the greenish glass which it distended with the curve of its rounded waves, the sea, set between the iron uprights of my casement window like a piece of stained glass in its leads, ravelled out over all the deep rocky border of the bay little plumed triangles of motionless foam etched with the delicacy of a feather or a downy breast from Pisanello's pencil...

Female Winter Duck Swimming, Pisanello, 1434–45

Comfortably ensconced in his hotel room, the Narrator studies the expanse of sea and sky beyond the window. An ongoing drama of panoramic proportions, ever changing and eternal, parades before him outside:

Sometimes the ocean filled almost the whole of my window, raised as it was by a band of sky edged at the top only by a line that was of the same blue as the sea, so that I supposed it to be still sea, and the change in colour due only to some effect of lighting. Another day the sea was painted only in the lower part of the window, all the rest of which was filled with so many clouds, packed one against another in horizontal bands, that its panes seemed, by some premeditation or predilection on the part of the artist, to be presenting a 'Cloud Study,' while the fronts of the various bookcases showing similar clouds but in another part of the horizon and differently coloured by the light, appeared to be offering as it were the repetition – dear to certain contemporary masters – of one and the same effect caught at different hours but able now in the immobility of art to be seen altogether in a single room, drawn in pastel and mounted under glass. And sometimes to a sky and sea uniformly grey a touch of pink would be added with an exquisite delicacy, while a little butterfly that had gone to sleep at the foot of the window seemed to be appending with its wings at the corner of this 'Harmony in Grey and Pink' in the Whistler manner the favourite signature of the Chelsea master. Then even the pink would vanish; there was nothing now left to look at.

Crepuscule in Opal, Trouville, James Abbott McNeill Whistler, 1865

Taking an interest in all the comings and goings of the resort, the Narrator has the hotel's major-domo, Aimé, bring him the latest list of guests. A name there catches his eye and he enters into a reverie:

It was not without a slight pang that on the first page of the list I caught sight of the words 'Simonet and family.' I had in me a store of old dream-memories dating from my childhood, in which all the tenderness that existed in my heart but, being felt by my heart, was not distinguishable from it, was brought to me by a being as different as possible from myself. Once again I fashioned such a being, utilizing for the purpose the name Simonet and the memory of the harmony that had reigned between the young bodies which I had seen deployed on the beach in a sportive procession worthy of Greek art or of Giotto. I did not know which of these girls was Mlle Simonet, if indeed any of them was so named, but I did know that I was loved by Mlle Simonet and that with Saint-Loup's help I was going to try to get to know her.

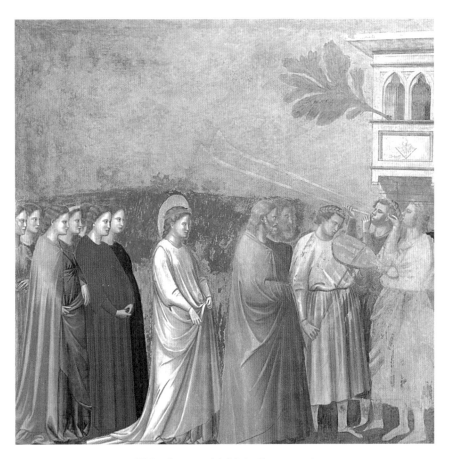

Wedding Procession of the Virgin, Giotto, 1304–6

Dining in the fashionable restaurant at Rivebelle one night with his friend Saint-Loup, the Narrator is informed that the great painter Elstir is at a nearby table. A note of introduction is quickly written and delivered to him. Before leaving the restaurant, the famous artist comes to present himself to the young men:

Elstir did not stay talking to us for long. I made up my mind that I would go to his studio during the next few days, but on the following afternoon, after I had accompanied my grandmother to the far end of the sea-front, near the cliffs of Canapville, on the way back, at the corner of one of the little streets which ran down at right angles to the beach, we passed a girl who, hanging her head like an animal that is being driven reluctant to its stall, and carrying golf-clubs, was walking in front of an authoritarian-looking person, in all probability her or one of her friends' 'Miss,' who suggested a portrait of Jeffreys by Hogarth, with a face as red as if her favourite beverage were gin rather than tea, on which a dried smear of tobacco at the corner of her mouth prolonged the curve of a moustache that was grizzled but abundant.

John and Elizabeth Jeffreys and their Children (detail),
William Hogarth, 1730

Paying a visit to Elstir's studio, the Narrator comes to a deeper understanding of the phases of an artist's life. He also begins to see Mme Elstir as more than just a woman who 'might have been beautiful at twenty', and to recognize in her the powerful presence of a muse:

Elstir at this period was no longer at that youthful age in which we look only to the power of the mind for the realization of our ideal. He was nearing the age at which we count on bodily satisfactions to stimulate the force of the brain, at which mental fatigue, by inclining us towards materialism, and the diminution of our energy, towards the possibility of influences passively received, begin to make us admit that there may indeed be certain bodies, certain callings, certain rhythms that are specially privileged, realizing so naturally our ideal that even without genius, merely by copying the movement of a shoulder, the tension of a neck, we can achieve a masterpiece; it is the age at which we like to caress Beauty with our eyes objectively, outside ourselves, to have it near us, in a tapestry, in a beautiful sketch by Titian picked up in a second-hand shop, in a mistress as lovely as Titian's sketch. When I understood this I could no longer look at Mme Elstir without a feeling of pleasure, and her body began to lose its heaviness, for I filled it with an idea, the idea that she was an immaterial creature, a portrait by Elstir.

Landscape with a Dragon and a Nude Woman Sleeping, Titian, date unknown

Portrait of a Venetian Lady (La Belle Nani), Veronese, 1560

Under the guise of strolling with him to look at some beach motifs, the Narrator hopes to use the presence of Elstir to draw a group of young women like a magnet. In this endeavour he is disappointed, and with a momentary exchange of glances with Albertine, the 'Mlle Simonet' whom he has been admiring from a distance, a 'whole series of agonies' opens before him:

What did I know of Albertine? One or two glimpses of a profile against the sea, less beautiful, assuredly, than those of Veronese's women whom I ought, had I been guided by purely aesthetic reasons, to have preferred to her. By what other reasons could I be guided, since, my anxiety having subsided, I could recapture only those mute profiles, possessing nothing else?

Having the privileged opportunity of observing Elstir at work in his studio enables the Narrator to understand more fully how an artist sees. Meanwhile, on his own, he composes complex portraits using time instead of paint as his medium:

I n a portrait, it is not only the manner the woman then had of dressing that dates her, it is also the manner the artist had of painting. And this, Elstir's earliest manner, was the most devastating of birth certificates for Odette because it not only established her, as did her photographs of the same period, as the younger sister of various well-known courtesans, but made her portrait contemporary with the countless portraits that Manet or Whistler had painted of all those vanished models, models who already belonged to oblivion or to history.

Woman with Fans (Nina de Callais), Édouard Manet, 1873

Tormented about whether to pursue Andrée or Albertine from among the group of young girls at Balbec, the Narrator vacillates and anguishes in his indecision. First one girl appeals, then the other. The prospect of being rejected only excites him further, while any sign of familiarity worries him. He and Albertine walk out together:

One morning, not long after Andrée had told me that she would be obliged to stay beside her mother, I was taking a short stroll with Albertine, whom I had found on the beach tossing up and catching again at the end of a string a weird object which gave her a look of Giotto's 'Idolatry'; it was called, as it happened, a 'diabolo,' and has so fallen into disuse now that, when they come upon a picture of a girl playing with one, the commentators of future generations will solemnly discuss, as it might be in front of the allegorical figures in the Arena Chapel, what it is that she is holding.

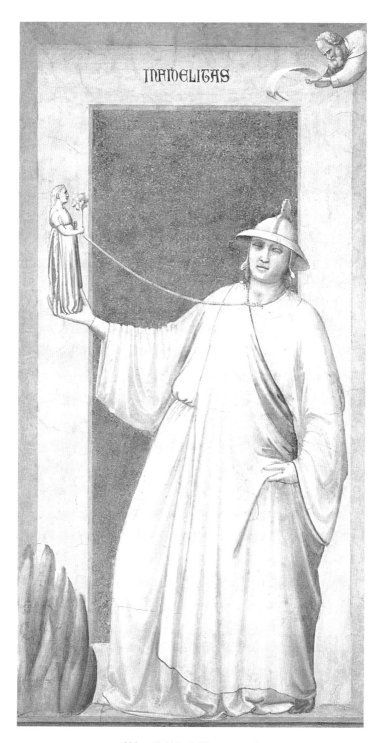

Idolatry (Infidelitas), Giotto, 1304–6

The Narrator, having previously dismissed the ritual aspects of seaside society in favour of contemplating the elemental forces of nature, responds to the beauty of marine pageantry in the light of Elstir's lyrical celebrations of such scenes:

He waxed more enthusiastic still over the yacht-races, and I realized that regattas, and race-meetings where well-dressed women might be seen bathed in the greenish light of a marine race-course, might be for a modern artist as interesting a subject as the festivities which they so loved to depict were for a Veronese or a Carpaccio. When I suggested this to Elstir, 'Your comparison is all the more apt,' he replied, 'since because of the nature of the city in which they painted, those festivities were to a great extent aquatic.... They had water-tournaments, as we have here, held generally in honour of some Embassy, such as Carpaccio shows us in his *Legend of Saint Ursula*. The ships were massive, built like pieces of architecture, and seemed almost amphibious, like lesser Venices set in the heart of the greater, when, moored to the banks by gangways decked with crimson satin and Persian carpets, they bore their freight of ladies in cerise brocade and green damask close under the balconies incrusted with multi-coloured marble from which other ladies leaned to gaze at them, in gowns with black sleeves slashed with white, stitched with pearls or bordered with lace.... I must confess that I prefer the fashions of today to those of Veronese's and even of Carpaccio's time.'

Meeting of the Betrothed Couple and Departure of the Pilgrims (detail), from *The Life of St Ursula* cycle,
Vittore Carpaccio, 1495

*At the end of the season at Balbec, the Narrator can think of little but the band
of young girls he has befriended and for whom he longs. He equates watching their
'play of young unstable forces' with the experience of looking out at the sea. He allows
his friendship with Saint-Loup to languish, unwilling to risk missing an outing
with the girls:*

I t was with delight that I listened to their pipings.
Loving helps us to discern, to discriminate. The bird-
lover in a wood at once distinguishes the twittering of
the different species, which to ordinary people sound the
same. The devotee of girls knows that human voices vary
even more....Just as infants have a gland the secretion of
which enables them to digest milk, a gland which is not
found in adults, so there were in the twitterings of these girls
notes which women's voices no longer contain. And on this
more varied instrument they played with their lips, with
all the application and the ardour of Bellini's little angel
musicians, qualities which also are an exclusive appanage
of youth.

Mary with Angels Making Music, central panel of *Madonna* tryptych
(detail), Giovanni Bellini, 1488

The Narrator is intoxicated by the possibilities of love; whether his thoughts are focused upon Andrée or Rosemonde or Albertine seems almost an irrelevance. 'We are not exclusively attached to the object', he convinces himself, but rather to 'the desire to love'. He is continually astonished to find himself amongst the girls:

N o doubt this astonishment is to some extent due to the fact that the other person on such occasions presents some new facet; but so great is the multiformity of each individual, so abundant the wealth of lines of face and body, so few of which leave any trace, once we are no longer in the presence of the other person, on the arbitrary simplicity of our recollection, since the memory had selected some distinctive feature that had struck us, has isolated it, exaggerated it, making of a woman who has appeared to us tall a sketch in which her figure is elongated out of all proportion, or of a woman who has seemed to be pink-cheeked and golden-haired a pure 'Harmony in Pink and Gold', that the moment this woman is once again standing before us, all the other forgotten qualities which balance that one remembered feature at once assail us, in their confused complexity, diminishing her height, paling her cheeks, and substituting for what we came exclusively to seek other features which we remember having noticed the first time and fail to understand why we so little expected to find them again. We remembered, we anticipated a peacock, and we find a peony.

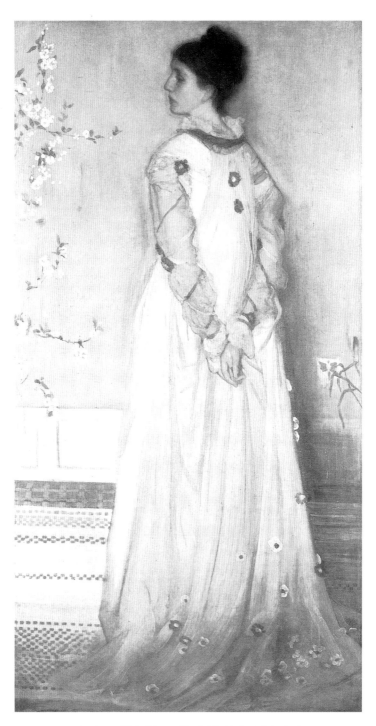

Symphony in Flesh Colour and Pink: Mrs Frederick R. Leyland,
James Abbott McNeill Whistler, 1871–73

The Narrator feels himself envying another boy for having touched Albertine's hands in the midst of playing a game. This envy triggers a decision: Albertine is to be the one for him. Although he prefers the beauty of Andrée's hands, he is willing from now on to devote himself to Albertine and her slightly plumper hands:

I was looking at Albertine, so pretty, so indifferent, so gay, who, though she little knew it, would be my neighbour when at last I should catch the ring in the right hands, thanks to a stratagem which she did not suspect, and would certainly have resented if she had. In the heat of the game her long hair had become loosened, and fell in curling locks over her cheeks on which it served to intensify, by its dry brownness, the carnation pink. 'You have the tresses of Laura Dianti, of Eleanor of Guyenne, and of her descendant so beloved of Chateaubriand. You ought always to wear your hair half-down like that,' I murmured in her ear as an excuse for drawing close to her.

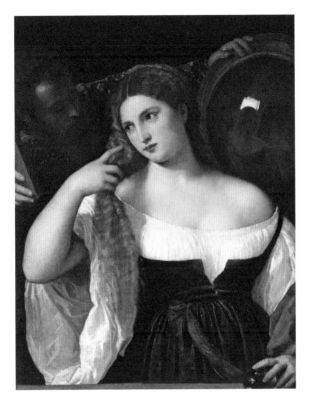

A Woman at her Toilet, Titian, 1515

The attachment between Albertine and the Narrator has intensified. As he makes his way up to her hotel room, he recalls her specific instructions to him – to come to her when she is in bed. He finds her there, and the sight of her bare throat and flushed cheeks excites him as he bends to kiss her:

'Stop it or I'll ring the bell!' cried Albertine, seeing that I was flinging myself upon her to kiss her. But I told myself that not for nothing does a girl invite a young man to her room in secret, arranging that her aunt should not know, and that boldness, moreover, rewards those who know how to seize their opportunities; in the state of exaltation in which I was, Albertine's round face, lit by an inner flame as by a night-light, stood out in such relief that, imitating the rotation of a glowing sphere, it seemed to me to be turning, like those Michelangelo figures which are being swept away in a stationary and vertiginous whirlwind. I was about to discover the fragrance, the flavour which this strange pink fruit concealed. I heard a sound, abrupt, prolonged and shrill. Albertine had pulled the bell with all her might.

Resurrection of Christ, with Nine Guards, Michelangelo, *c.* 1536–38

In a philosophical mood, the Narrator thinks that one way to solve the problem of existence is 'to get near enough to the things and people that have appeared to us beautiful and mysterious from a distance to be able to satisfy ourselves that they have neither mystery nor beauty'. Nevertheless he carries on idealizing the group of girls at Balbec, enraptured with Albertine, deaf to his own advice:

But, in relations such as I enjoyed with Albertine and her friends, the genuine pleasure which was there at the start leaves that fragrance which no artifice can impart to hothouse fruits, to grapes that have not ripened in the sun....My desire had sought so avidly to learn the meaning of eyes which now knew and smiled at me, but which, that first day, had crossed mine like rays from another universe, it had distributed colour and fragrance so generously, so carefully, so minutely, over the fleshly surfaces of these girls who now, stretched out on the cliff-top, simply offered me sandwiches or played guessing-games, that often, in the afternoon, while I lay there among them – like those painters who, seeking to match the grandeurs of antiquity in modern life, give to a woman cutting her toe-nail the nobility of the *Thorn Puller*, or, like Rubens, make goddesses out of women they know to people some mythological scene – I would gaze at those lovely forms, dark and fair, so dissimilar in type, scattered around me on the grass, without emptying them, perhaps, of all the mediocre content with which my everyday experience had filled them, and yet (without expressly recalling their celestial origin) as if, like young Hercules or Telemachus, I had been playing amid a band of nymphs.

The Three Graces, Peter Paul Rubens, 1639

VOLUME III

The Guermantes Way

To make conditions easier for his ailing grandmother, the Narrator's family has just moved into a flat that forms part of the Hôtel de Guermantes in Paris. The Narrator, steeped in visions of medieval heraldry, is disappointed to learn that the Guermantes family has occupied the place only since the seventeenth century. Some reassuring words regarding their social status return a lustre to the Guermantes family name:

But just as Elstir, when the bay of Balbec, losing its mystery, had become for me simply a portion, interchangeable with any other, of the total quantity of salt water distributed over the earth's surface, had suddenly restored to it a personality of its own by telling me that it was the gulf of opal painted by Whistler in his *Harmonies in Blue and Silver,* so the name Guermantes had seen the last of the dwellings that had issued from its syllables perish under Françoise's blows, when one day an old friend of my father said to us, speaking of the Duchesse; 'She has the highest position in the Faubourg Saint-Germain; hers is the leading house in the Faubourg Saint-Germain.'

Harmony in Blue and Silver: Trouville, James Abbott McNeill Whistler, 1865

The Narrator makes an extended visit to his friend Saint-Loup, who is billeted among the soldiers in the town of Doncières. While Saint-Loup is off on manoeuvres with his company, the Narrator meanders about the town, observing the officers and their men:

In a little curio shop a half-spent candle, projecting its warm glow over an engraving, reprinted it in sanguine, while, battling against the darkness, the light of a big lamp bronzed a scrap of leather, inlaid a dagger with glittering spangles, spread a film of precious gold like the patina of time or the varnish of an old master on pictures which were only bad copies, made in fact of the whole hovel, in which there was nothing but pinchbeck rubbish, a marvellous composition by Rembrandt.

The Money-Changer, Rembrandt (Harmensz.) van Rijn, 1627

Census at Bethlehem, Pieter Bruegel the Elder, *c.* 1566

The Narrator continues through Doncières on his way to meet Saint-Loup for dinner:

The wind grew stronger. It was grainy and bristling with coming snow. I returned to the main street and jumped on board the little tram, from the platform of which an officer was acknowledging, without seeming to see them, the salutes of the uncouth soldiers who trudged past along the pavement, their faces daubed crimson by the cold, reminding me, in this little town which the sudden leap from autumn into early winter seemed to have transported further north, of the rubicund faces which Brueghel gives to his merry, junketing, frostbound peasants.

Saint-Loup has become completely devoted to an actress, and his devotion gives way to wild jealousy and possessiveness. The Narrator can see little that is attractive about Rachel when she is offstage, but he dutifully attends her performances with Saint-Loup, as well as the parties afterwards:

I was delighted to observe, in the thick of a crowd of journalists or men of fashion, admirers of the actresses, who were greeting one another, talking, smoking, as though at a party in town, a young man in a black velvet cap and hortensia-coloured skirt, his cheeks chalked in red like a page from a Watteau album, who with smiling lips and eyes raised to the ceiling, describing graceful patterns with the palms of his hands and springing lightly into the air, seemed so entirely of another species from the sensible people in everyday clothes in the midst of whom he was pursuing like a madman the course of his ecstatic dream, so alien to the preoccupations of their life, so anterior to the habits of their civilisation, so enfranchised from the laws of nature, that it was as restful and refreshing a spectacle as watching a butterfly straying through a crowd to follow with one's eyes, between the flats, the natural arabesques traced by his winged, capricious, painted curvetings.

Standing Cavalier Wearing a Cape (L'Indifférent), Antoine Watteau, 1716

Turkish Merchant Smoking in his Shop, Alexandre-Gabriel Decamps, 1844

On the suggestion of M. de Norpois, the Narrator pays a call on Mme de Villeparisis. He is surprised to find there his old schoolfriend, Bloch. In the years since they have seen each other, the fallout from the Dreyfus Affair has left an insidious stain upon French life:

But in a French drawing-room the differences between those peoples are not so apparent, and a Jew making his entry as though he were emerging from the desert, his body crouching like a hyena's, his neck thrust forward, offering profound 'salaams,' completely satisfies a certain taste for the oriental. Only it is essential that the Jew in question should not be actually 'in' society, otherwise he will readily assume the aspect of a lord and his manners become so Gallicized that on his face a refractory nose, growing like a nasturtium in unexpected directions, will be more reminiscent of Molière's Mascarille than of Solomon. But Bloch, not having been limbered up by the gymnastics of the Faubourg, nor ennobled by a crossing with England or Spain, remained for a lover of the exotic as strange and savoury a spectacle, in spite of his European costume, as a Jew in a painting by Decamps.

Despite the complexities of political intrigue, society life continues, confident of its own immutable certainties. As a distinguished senior member of the Faubourg Saint-Germain, Mme de Villeparisis has flattery of the most polished kind lavished upon her:

Everyone had gathered round Mme de Villeparisis to watch her painting.

'Those flowers are a truly celestial pink,' said Legrandin, 'I should say sky-pink. For there is such a thing as sky-pink just as there is sky-blue. But,' he lowered his voice in the hope that he would not be heard by anyone but the Marquise, 'I think I still plump for the silky, the living rosiness of your rendering of them. Ah, you leave Pisanello and Van Huysum a long way behind, with their meticulous, dead herbals.'

An artist, however modest, is always willing to hear himself preferred to his rivals, and tries only to see that justice is done them.

Fruit and Flowers, Jan van Huysum, before 1726

The exuberance of the Narrator is wasted. Of all his fellow guests in Mme de Villeparisis's drawing room – diplomats, writers, critics – no one seems willing to entertain an admiration for Elstir equal to his own:

'A masterpiece?' cried M. de Norpois with a surprised and reproachful air. 'It makes no pretence of even being a picture, it's merely a sketch.' (He was right.) 'If you label a clever little thing of that sort "masterpiece," what will you say about Hébert's Virgin or Dagnan-Bouveret?'

Madonna of the Rose, Pascal Dagnan-Bouveret, 1885

Virgin and Child, Antoine-Auguste-Ernest Hébert, 1872

The commitment shared by the majority of upper-class socialites to embrace only conventional pictures convinces the Narrator of their shallow aesthetic sensibilities. He observes this 'negation of true taste' as M. de Norpois and the Prince von Faffenheim make a critique Mme de Villeparisis's painting:

And he asked her whether she had seen the flower paintings by Fantin-Latour which had recently been exhibited.

'They are first class, the work, as they say nowadays, of a fine painter, one of the masters of the palette,' declared M. de Norpois. 'Nevertheless, in my opinion, they cannot stand comparison with those of Mme de Villeparisis, which give a better idea of the colouring of the flower.'

Roses in a Bowl, Henri Fantin-Latour, 1882

During the prolonged illness of the Narrator's grandmother, the writer Bergotte comes each day to visit the family. Despite an awareness of the old man's increasing literary reputation, the Narrator now finds his idol's books to be less inspiring:

In Bergotte's books, which I constantly reread, his sentences stood out as clearly before my eyes as my own thoughts, the furniture in my room and the carriages in the street. All the details were easily visible, not perhaps precisely as one had always seen them, but at any rate as one was accustomed to see them now. But a new writer had recently begun to publish work in which the relations between things were so different from those that connected them for me that I could understand hardly anything of what he wrote. He would say, for instance, 'the hose-pipes admired the splendid upkeep of the roads' (and so far it was simple, I followed him smoothly along those roads) 'which set out every five minutes from Briand and Claudel.' At that point I ceased to understand, because I had expected the name of a place and was given that of a person instead. Only I felt that it was not the sentence that was badly constructed but I myself that lacked the strength and agility necessary to reach the end. I would start afresh, striving tooth and nail to reach the point from which I would see the new relationships between things. And each time, after I had got about half-way through the sentence, I would fall back again, as later on, in the Army,

in my attempts at the exercises on the horizontal-bar. I felt nevertheless for the new writer the admiration which an awkward boy who gets nought for gymnastics feels when he watches another more nimble. And from then onwards I felt less admiration for Bergotte, whose limpidity struck me as a deficiency. There was a time when people recognized things quite easily when it was Fromentin who had painted them, and could not recognize them at all when it was Renoir.

Egyptian Women on the Edge of the Nile (detail),
Eugène Fromentin, 1876

The Umbrellas (Les Parapluies) (detail),
Pierre-Auguste Renoir, 1888–86

As he continues to contemplate Bergotte's books, the Narrator formulates an understanding of the importance that new developments in art provide in refreshing and revitalizing our view of the world:

P eople of taste tell us nowadays that Renoir is a great eighteenth-century painter. But in so saying they forget the element of Time, and that it took a great deal of time, even at the height of the nineteenth century, for Renoir to be hailed as a great artist. To succeed thus in gaining recognition, the original painter or the original writer proceeds on the lines of the oculist. The course of treatment they give us by their painting or by their prose is not always pleasant. When it is at an end, the practitioner says to us: 'Now look!' And lo and behold the world around us (which was not created once and for all, but is created afresh as often as an original artist is born) appears to us entirely different from the old world, but perfectly clear. Women pass in the street, different from those we formerly saw, because they are Renoirs, those Renoirs we persistently refused to see as women. The carriages, too, are Renoirs, and the water, and the sky...Such is the new and perishable universe which has just been created. It will last until the next geological catastrophe is precipitated by a new painter or writer of original talent.

The Swing (La Balançoire), Pierre-Auguste Renoir, 1876

Consumed by his desire for Albertine, the Narrator conspires to see her alone in his room while his parents are out of the house. In loco parentis, Françoise takes up the role of moral chaperone, and with a certain flair for drama, ensures that the Narrator knows he is being watched:

She excelled in the preparation of these stage effects, intended to so enlighten the spectator, in her absence, that he already knew that she knew everything when in due course she made her entry....On this occasion, holding over Albertine and myself the lighted lamp whose searching beams missed none of the still visible depressions which the girl's body had made in the counterpane, Françoise conjured up a picture of 'Justice shedding light upon Crime'. Albertine's face did not suffer by this illumination.

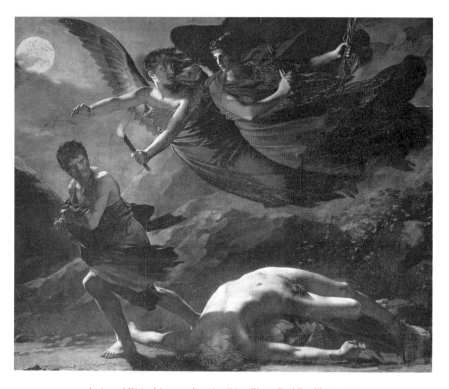

Justice and Divine Vengeance Pursuing Crime, Pierre-Paul Prud'hon, 1808

*Passionate attachments to women – Gilberte, Albertine, Mme de Guermantes
– have overwhelmed the Narrator at different moments of his sentimental education.
Now the idea of possessing the elusive Mme de Stermaria torments him:*

B etween the last festivity of summer and one's
winter exile, one anxiously ranges that romantic
world of chance encounters and lover's melan-
choly, and one would be no more surprised to learn that it
was situated outside the mapped universe than if, at
Versailles, looking down from the terrace, an observatory
round which the clouds gather against the blue sky in the
manner of Van der Meulen, after having thus risen above the
bounds of nature, one were informed that, there where
nature begins again at the end of the great canal, the villages
which one cannot make out, on a horizon as dazzling as the
sea, are called Fleurus and Nijmegen.

Arrival of Louis XIV at the Camp before Maastricht during the Dutch War, June 1673,
Adam Frans van der Meulen, 1673

Through his friendship with Saint-Loup, the Narrator has been accepted into a more select aristocratic social circle. He is invited to dinner at the Paris home of the Duc and Duchesse de Guermantes. Requesting to be left alone among their prize collection of paintings by Elstir, the Narrator reflects upon the painter's relationship to the masters who struggled before him:

T he people who detested these 'horrors' were astonished to find that Elstir admired Chardin, Perroneau, and many other painters whom they, the ordinary men and women of society, liked. They did not realise that Elstir for his own part, in striving to reproduce reality (with the particular trademark of his taste for certain experiments), had made the same effort as a Chardin or a Perroneau and that consequently, when he ceased to work for himself, he admired in them attempts of the same kind, anticipatory fragments, so to speak, of works of his own. Nor did these society people add to Elstir's work in their mind's eye that temporal perspective which enabled them to like, or at least to look without discomfort at, Chardin's paintings.

Portrait of a Man,
Jean-Baptiste Perronneau, 1766

The Skate, Jean-Baptiste-Siméon Chardin, 1728

As he admires the Guermantes' collection of paintings, the Narrator continues to muse about the effect of time upon work that was once considered to be shocking:

A nd yet the older among them might have reminded themselves that in the course of their lives they had gradually seen, as the years bore them away from it, the unbridgeable gulf between what they considered a masterpiece by Ingres and what they had supposed must forever remain a 'horror' (Manet's *Olympia*, for example) shrink until the two canvases seemed like twins. But we never learn, because we lack the wisdom to work backwards from the particular to the general, and imagine ourselves always to be faced with an experience which has no precedents in the past.

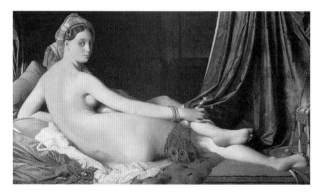

Grand Odalisque, Jean-Auguste-Dominique Ingres, 1814

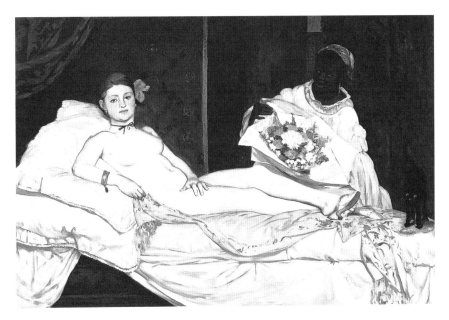

Olympia, Édouard Manet, 1863

The Narrator studies the Guermantes' Elstirs and recognizes the same person appearing in two canvases of different genres. This leads him to make an association that would have given Elstir pleasure:

I was moved by the discovery in two of the pictures (more realistic, these, and in an earlier manner) of the same person, in one of them in evening dress in his own drawing room, in the other wearing a frock-coat and tall hat at some popular seaside festival where he had evidently no business to be, which proved that for Elstir

he was not only a regular sitter but a friend, perhaps a patron, whom he liked to introduce into his paintings, as Carpaccio introduced – and in the most speaking likenesses – prominent Venetian noblemen into his...

Luncheon of the Boating Party (detail),
Pierre-Auguste Renoir, 1880–81

Arrival of the Ambassadors (detail), Vittore Carpaccio, 1495

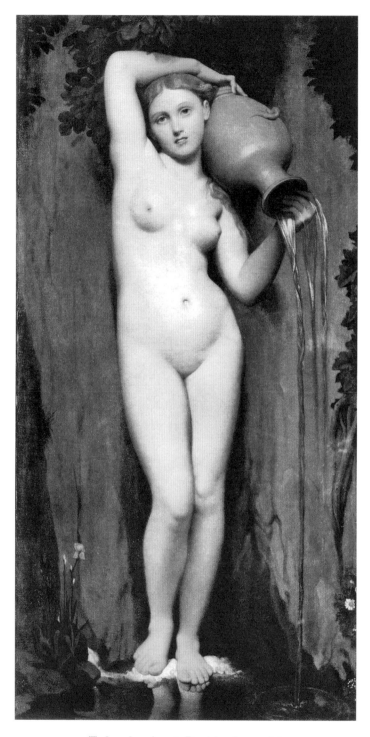

The Source, Jean-Auguste-Dominique Ingres, 1856

Some time later, at the same dinner party, the Narrator asks the Duc if he knows the identity of the man pictured twice in his Elstir pictures. M. de Guermantes cannot remember, but does not hesitate to announce his disdain for the painter:

'But tell me, you seem quite gone on his pictures. If I'd only known, I should have had it all at my fingertips. Not that there's much need to rack one's brains to get to the bottom of M. Elstir's work, as there would be for Ingres's *Source* or the *Princes in the Tower* by Paul Delaroche. What one appreciates in his work is that it's shrewdly observed, amusing, Parisian, and then one passes on to the next thing. One doesn't need to be an expert to look at that sort of thing. I know of course that they're merely sketches, but still, I don't feel myself that he puts enough work into them.'

The Children of Edward: Edward V, King of England, and Richard, Duke of York, in the Tower of London, Paul Delaroche, 1830

The Duc and Duchesse de Guermantes each take up a different position concerning the work of Elstir. But both expect the paintings by him in their collection to live up to the prestige afforded by the elevated surroundings:

'Swann had the nerve to try and make us buy a *Bundle of Asparagus*. In fact it was in the house for several days. There was nothing else in the picture, just a bundle of asparagus exactly like the ones you're eating now. But I must say I refused to swallow M. Elstir's asparagus. He wanted three hundred francs for them. Three hundred francs for a bundle of asparagus! A louis, that's as much as they're worth, even early in the season. I thought it a bit stiff. When he puts people in his pictures as well, there's something squalid and depressing about them that I dislike. I'm surprised to see a man of refinement, a superior mind like you, admiring that sort of thing.'

Bunch of Asparagus, Édouard Manet, 1880

'I don't know why you should say that, Basin,' interrupted the Duchesse, who did not like to hear people run down anything that her rooms contained. 'I'm by no means prepared to admit that there's no distinction in Elstir's painting. You have to take it or leave it. But it's not always lacking in talent. And you must admit that the ones I bought are remarkably beautiful.'

'Well, Oriane, in that style of thing I'd infinitely prefer to have the little study by M. Vibert we saw at the watercolour exhibition. There's nothing much in it, if you like, you could hold it in the palm of your hand, but you can see that the man's got wit to the tips of his fingers: that shabby scarecrow of a missionary standing in front of the sleek prelate who is making his little dog do tricks, it's a perfect little poem of subtlety, and even profundity.'

A Tasty Treat (L'Éducation d'Azor), Jehan-Georges Vibert, date unknown

Another evening at the Guermantes', the scintillating Duchesse holds forth about various family members, friends and acquaintances, placing each within a social niche somewhere above or below her. She graciously defers to her hierarchical superior, the Princesse de Parme, while in the same breath condescending intellectually to her:

'But Your Highness will find that it will all go quite smoothly. They are very kind people, and no fools. We took Mme de Chevreuse there,' added the Duchesse, knowing the force of this example, 'and she was enchanted. The son is really very pleasant…I'm going to tell you something that's not quite proper,' she went on, 'but he has a bedroom, and more especially a bed, in which I should love to sleep – without him! What is even less proper is that I went to see him once when he was ill and lying in it. By his side, on the frame of the bed, there was a sculpted Siren, stretched out at full length, absolutely ravishing, with a mother-of-pearl tail and some sort of lotus flowers in her hand. I assure you,' went on Mme de Guermantes…'that with the palm-leaves and the golden crown on one side, it was most moving, it was precisely the same composition as Gustave Moreau's *Death and the Young Man* (Your Highness must know that masterpiece, of course).'

The Princesse de Parme, who did not know so much as the painter's name, nodded her head vehemently and smiled ardently, in order to manifest her admiration for this picture. But the intensity of her mimicry could not fill the place of that light which is absent from our eyes so long as we do not understand what people are talking to us about.

The Young Man and Death, Gustave Moreau, 1856–65

Holding forth with wit and venom on whatever subject she finds amusing at the moment, Oriane de Guermantes returns repeatedly to people's taste in painting as a criterion on which to base her judgment of their characters. Listening to the Duchesse's regal declarations after dinner, the Narrator makes an assessment of his own:

'It seems that Emperor William is highly intelligent, but he doesn't care for Elstir's painting. Not that that's anything against him,' said the Duchesse, 'I quite share his point of view. Although Elstir has done a fine portrait of me. You don't know it? It's not in the least like me, but it's an intriguing piece of work. He's most interesting while one's sitting to him. He has made me like a little old woman. It's modelled on *The Women Regents of the Hospice*, by Hals. I expect you know those sublimities, to borrow one of my nephew's favourite expressions,' the Duchesse turned to me, gently flapping her black feather fan. More than erect on her chair, she flung her head nobly backwards, for, while always a great lady, she was a trifle inclined to act the part of the great lady too. I said that I had been once to Amsterdam and The Hague, but that to avoid getting everything muddled up, since my time was limited, I had left out Haarlem.

'Ah! The Hague! What a gallery!' cried M. de Guermantes. I said to him that he doubtless admired Vermeer's *View of Delft....* 'If it's to be seen, I saw it!'

'What! You've been to Holland and you never visited Haarlem!' cried the Duchesse. 'Why, even if you had only a quarter of an hour to spend in the place, they're an extraordinary thing to have seen, those Halses. I don't mind saying that a person who only caught a passing glimpse of them from the top of a tram without stopping, supposing they were hung out to view in the street, would open his eyes pretty wide.'

This remark shocked me as indicating a misconception in the way in which artistic impressions are formed in our minds, and because it seemed to imply that our eye is in that case simply a recording machine which takes snapshots.

The Women Regents of the Old Men's Almshouses, Frans Hals, 1664

Although he has little sympathy personally for the Duc de Guermantes, the Narrator nevertheless admires his host's remarkable capacity for upholding the family's history and keeping the flame of the Guermantes name burning bright:

The Prince d'Agrigente having asked why the Prince Von had said, in speaking of the Duc d'Aumale, 'my uncle,' M. de Guermantes replied, 'Because his mother's brother, the Duke of Württemberg, married a daughter of Louis-Philippe.' At once I was lost in contemplation of a reliquary such as Carpaccio or Memling used to paint, from its first panel in which the princess, at the wedding festivities of her brother the Duc d'Orléans, appeared wearing a plain garden dress to indicate her ill-humour at having seen her ambassadors, who had been sent to sue on her behalf for the hand of the Prince of Syracuse, return empty-handed, down to the last, in which she has just given birth to a son, the Duke of Württemberg (the uncle of the Prince with whom I had just dined), in that castle called Fantaisie, one of those places which are as aristocratic as certain families...

The Reliquary of St Ursula, Hans Memling, 1489

Having had a disturbing first encounter with the Baron de Charlus in Balbec, the Narrator slips out of a dinner party at the Guermantes' house to pay a call on the Baron at his. Kept waiting half an hour in a drawing-room, the Narrator is finally brought upstairs to meet Charlus, who lashes out at him:

I looked at M. de Charlus. Undoubtedly his magnificent head, though repellent, yet far surpassed that of any of his relatives; he was like an ageing Apollo; but an olive-hued, bilious juice seemed ready to start from the corners of his malevolent mouth; as for intellect, one could not deny that his, over a vast compass, had a grasp of many things which would always remain unknown to his brother Guermantes. But whatever the fine words with which he embellished all his hatreds, one felt that, whether he was moved by offended pride or disappointed love, whether his motivating force was rancour, sadism, teasing or obsession, this man was capable of committing murder, and of proving by dint of logic that he had been right in doing it and was still head and shoulders above his brother, his sister-in-law, or any of the rest.

'As, in Velazquez's *Surrender of Breda*,' he went on, 'the victor advances towards him who is the humbler in rank, and as is the duty of every noble nature, since I was everything and you were nothing, it was I who took the first steps towards you. You have made an imbecilic reply to what it is not for me to describe as an act of grandeur. But I did not allow myself to be discouraged. Our religion enjoins patience. The patience I have shown towards you will be counted, I hope, to my credit, and also my having only smiled at what might be denounced as impertinence, were it within your power to be impertinent to one who is so infinitely your superior. However, all this is now neither here nor there. I have subjected you to the test which the one eminent man of our world has ingeniously named the test of untoward kindness, and which he rightly declares to be the most terrible of all, the only one that can separate the wheat from the chaff. I can scarcely reproach you for having undergone it without success, for those who emerge from it triumphant are very few. But at least, and this is the conclusion which I am entitled to draw from the last words that we shall exchange on this earth, at least I intend to protect myself against your calumnious fabrications.'

The Surrender of Breda, Diego Velázquez, 1634–35

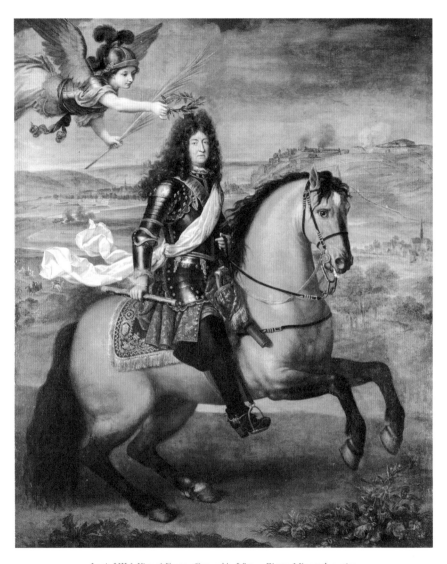

Louis XIV, King of France, Crowned by Victory, Pierre Mignard, *c.* 1692

Escorting the Narrator out after verbally abusing him, Charlus seems suddenly drained of rancour and treats his unsettled guest with an equally unexpected respect and sensitivity. They are walking through his rooms and the Narrator compliments him on their beauty. Charlus responds:

'On the whole it's quite good. It might perhaps be better, but after all it's not bad. Some pretty things, are there not? These are portraits of my uncles, the King of Poland and the King of England, by Mignard....Look, in this cabinet I have all the hats worn by Madame Elisabeth, by the Princesse de Lamballe, and by Marie-Antoinette. They don't interest you; it's as though you couldn't see. Perhaps you are suffering from an affection of the optic nerve.'

Before going out to call upon the Duc and Duchesse de Guermantes, the Narrator looks out from his window and across the courtyard to another building within his line of sight:

When its large rectangular windows, glittering in the sunlight like flakes of rock crystal, were thrown open to air the rooms, one felt, in following from one floor to the next the footmen whom it was impossible to see clearly but who were visibly shaking carpets, the same pleasure as when one sees in a landscape by Turner or Elstir a traveller in a stage-coach, or a guide, at different degrees of altitude on the Saint-Gothard.

The Devil's Bridge, Pass of St Gothard, Joseph Mallord William Turner, 1802

The Duc de Guermantes has coolly dismissed the Narrator's request for help in ascertaining the authenticity of an invitation to a party. Having made his rebuff, the Duc exudes charming manners and offers to show the Narrator and Swann some new pictures he has bought:

'Wait now, you're fond of painting, I must show you a superb picture I bought from my cousin, partly in exchange for the Elstirs, which frankly didn't appeal to us. It was sold to me as a Philippe de Champaigne, but I believe myself that it's by someone even greater. Would you like to know what I think? I think it's a Velazquez, and of the best period,' said the Duc, looking me boldly in the eyes, either to ascertain my impression or in the hope of enhancing it....

Portrait of a Man,
Phillippe de Champaigne, 1650

'Oh, well, if it comes from Gilbert's house it's probably one of your *ancestors*,' said Swann with a blend of irony and deference towards a grandeur which he would have felt it impolite and absurd to belittle, but to which for reasons of good taste he preferred to make only a playful reference.

'Of course it is,' said the Duc bluntly. 'It's Boson, the I forget how manyeth de Guermantes. Not that I care a damn about that. You know I'm not as feudal as my cousin. I've heard the names of Rigaud, Mignard, even Velazquez mentioned,' he went on, fastening on Swann the look of both an inquisitor and a torturer in an attempt at once to read into his mind and to influence his response. 'Well,' he concluded (for when he was led to provoke artificially an opinion which he desired to hear, he had the faculty, after a few moments, of believing that it had been spontaneously uttered), 'come now, none of your flattery. Do you think it's by one of those big guns I've mentioned?'

'Nnnnno,' said Swann.

Louis, Duke of Burgundy, Hyacinthe Rigaud, 1697

VOLUME IV

Sodom and Gomorrah

After having suffered considerable anxiety about the invitation, the Narrator finds himself handsomely welcomed by the Princesse de Guermantes at her home. He admires her skill in making introductions:

'Mme de Villemur, M. Detaille, wonderful painter that he is, has just been admiring your neck.' Mme de Villemur interpreted this as a direct invitation to join in the conversation; with the agility of a practised horsewoman, she would swivel round slowly in her chair through three quadrants of a circle, and, without in any way disturbing her neighbours, come to rest almost facing the Princess. 'You don't know M. Detaille?' exclaimed their hostess, for whom her guest's skilful and discreet about-face was not enough. 'I don't know him, but I know his work,' Mme de Villemur would reply with a respectful and winning air and an aptness which many of the onlookers envied her, addressing the while an imperceptible bow to the celebrated painter whom this invocation had not been sufficient to introduce to her in a formal manner. 'Come, Monsieur Detaille,' said the Princesse, 'Let me introduce you to Mme de Villemur.' That lady thereupon showed as much ingenuity in making room for the creator of *The Dream* as she had shown a moment earlier in wheeling round to face him.

The Dream (Le Rêve), Édouard Detaille, 1888

At the party given by the Prince and Princesse de Guermantes, the Narrator watches as Baron de Charlus individually greets 'le tout Paris':

True, there was an element of pride in this attitude. M. de Charlus was aware that he was a Guermantes, and that he occupied a predominant place at this festivity. But there was more in it than pride, and the very word festivity suggested, to the man with aesthetic gifts, the luxurious, rarefied sense that it might bear if it were being given not by people in contemporary society but in a painting by Carpaccio or Veronese. It is even more probable that the German prince M. de Charlus was must rather have been picturing to himself the reception that occurs in *Tännhauser*, and himself as the Margrave, standing at the entrance to the Warburg, with a kind word of condescension for each of the guests, while their procession into the castle or the park is greeted by a long phrase, a hundred times repeated, of the famous March.

Meeting of the Betrothed Couple and Departure of the Pilgrims (detail), from *The Life of St Ursula* cycle, Vittore Carpaccio, 1495

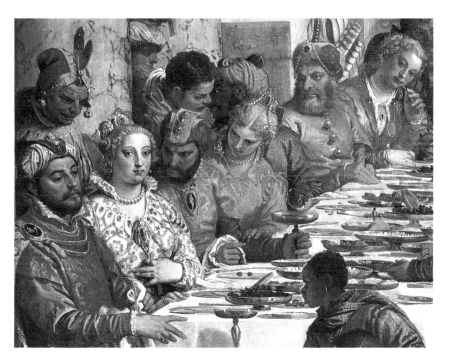

The Wedding at Cana (detail), Veronese, 1562–63

The Narrator wishes to be presented to the Prince de Guermantes. He requires the assistance of someone known to the Prince, who will make the introduction:

I had no one else to turn to but M. de Charlus, who had withdrawn to a room downstairs which opened on to the garden. I had plenty of time (as he was pretending to be absorbed in a fictitious game of whist which enabled him to appear not to notice people) to admire the deliberate, artful simplicity of his evening coat which, by the merest trifles which only a tailor's eye could have picked out, had the air of a 'Harmony in Black and White' by Whistler; black, white and red, rather, for M. de Charlus was wearing, suspended from a broad ribbon over his shirt-front, the cross, in white, black and red enamel, of a Knight of the religious Order of Malta.

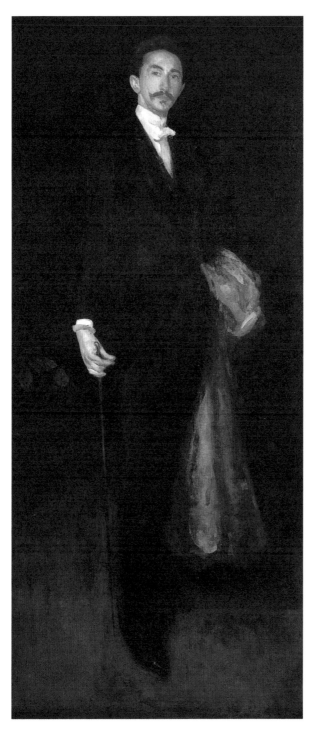

Arrangement in Black and Gold: Comte Robert Montesquiou-Fezensac,
James Abbott McNeill Whistler, 1891–92

Paying tribute to his wife at the party, the Duc de Guermantes speaks with an uncharacteristic sensitivity:

T he tone in which M. de Guermantes said this was, incidentally, quite inoffensive, without a trace of the vulgarity which he too often showed. He spoke with a slightly indignant melancholy, but his whole manner exuded that gentle gravity which constitutes the broad and unctuous charm of certain portraits by Rembrandt, that of the Burgomaster Six, for example.

Portrait of Jan Six, Rembrandt (Harmensz.) van Rijn, 1654

Baron Charlus, habitually haughty and suffering no fools, strives to ingratiate himself into the good graces of Mme de Surgis, much to her surprise. However, it is her good-looking sons who really interest him:

A t this moment, Mme de Surgis entered the room in search of her sons. As soon as he saw her M. de Charlus went up to her with friendliness by which the Marquise was all the more agreeably surprised in that an icy coldness was what she had expected from the Baron, who had always posed as Oriane's protector and alone of the family – the rest being too often inclined to indulgence towards the Duc's irregularities because of his wealth and from jealousy of the Duchesse – kept his brother's mistresses ruthlessly at a distance. And so Mme de Surgis would have fully understood the motives for the attitude that she dreaded to find in the Baron, but never for a moment suspected those for the wholly different welcome that she did receive from him. He spoke to her with admiration of the portrait that Jacquet had painted of her years before. This admiration waxed indeed to an enthusiasm which, if it was partly calculating, with the object of preventing the Marquise from going away, of 'engaging' her, as Robert used to say of enemy armies whose forces one wants to keep tied down at a particular point, was also perhaps sincere. For, if everyone was pleased to admire in her sons the regal bearing and the beautiful eyes of Mme de Surgis, the Baron could taste an inverse but no less keen pleasure in finding those charms combined in the mother, as in a portrait which does not in itself provoke desire, but feeds, with the aesthetic admiration that it does provoke, the desires that it awakens. These now gave in retrospect a voluptuous charm to Jacquet's portrait itself, and that moment the Baron would gladly have purchased it to study therein the physiological pedigree of the two Surgis boys.

Portrait of a Woman in a Hat, Gustave Jacquet, *c.* 1875

The Narrator and Saint-Loup are discussing women and affairs of the heart. Saint-Loup has been disabused of his illusions about his beloved Rachel:

'What were we talking about? Oh yes, that big, fair girl, Mme Putbus's maid. She goes with women too, but I don't suppose you mind that. I tell you frankly, I've never seen such a gorgeous creature.' 'I imagine her as being rather Giorgionesque?' 'Wildly Giorgionesque! Oh, if only I had a little time in Paris, what wonderful things there are to be done! And then one goes on to the next. Because love is all rot, you know, I've finished with all that.'

Sleeping Venus (The Dresden Venus), Giorgione, *c.* 1510

Portrait of Marie-Anne de Mailly-Nesle, Marquise de
La Tournelle, Duchesse de Châteauroux, as Eos,
Jean-Marc Nattier, *c.* 1740

Swann is momentarily intoxicated by Mme de Surgis, who is
embarrassed, but sighs deeply, 'so contagious can desire prove
at times'. Prompted by other desires, the Baron continues his
own assault on Mme de Surgis:

'Well!' M. de Charlus was saying to her in an effort to prolong the conversation, 'you must lay my tribute at the feet of the beautiful portrait. How is it? What has become of it?' 'Why,' replied Mme de Surgis, 'you know I haven't got it now; my husband wasn't pleased with it.' 'Not pleased! With one of the greatest works of art of our time, equal to Nattier's Duchesse de Châteauroux, and, moreover, perpetuating no less majestic and heart-shattering a goddess. Oh, that little blue collar! I swear, Vermeer himself never painted a fabric more consummately – but we must not say it too loud or Swann will fall upon us to avenge his favourite painter, the Master of Delft.'

An ongoing search for love leads the Narrator to pay calls on a variety of society women. He thinks of himself as going 'to visit other fairies and their dwellings':

I would have difficulty at first in recognising my hostess and her guests, even the Duchesse de Guermantes, who in her husky voice bade me come and sit down next to her, in a Beauvais armchair illustrating the Rape of Europa. Then I would begin to make out on the walls the huge eighteenth-century tapestries representing vessels whose masts were hollyhocks in blossom, beneath which I sat as though in the palace not of the Seine but of Neptune, by the brink of the river Oceanus, where the Duchesse de Guermantes became a sort of goddess of the waters. I should never get to the end of it if I began to describe all the different types of drawing-room. This example will suffice to show that I introduced into my social judgments poetical impressions which I never took into account when I came to add up the sum, so that, when I was calculating the merits of a drawing-room, my total was never correct.

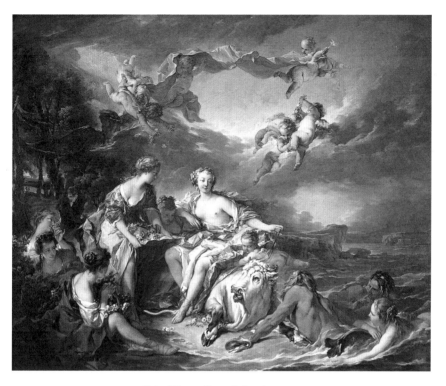

Rape of Europa, François Boucher, 1747

Supper, Léon Bakst, 1902

During his round of visits to society women, the Narrator notices how the fickle world of fashion hungers for the new. Men will flock to a new salon in hopes of finding a refreshing hostess; women must have whatever strikes them as necessarily 'of the moment':

When, with the prodigious flowering of the Russian Ballet, revealing one after another Bakst, Nijinsky, Benois and the genius of Stravinsky, Princess Yourbeletieff, the youthful sponsor of all these new great men, appeared wearing on her head an immense, quivering aigrette that was new to the women of Paris and that they all sought to copy, it was widely supposed that this marvellous creature had been imported in their copious luggage and as their most priceless treasure, by the Russian dancers...

Once again by the sea at Balbec, the Narrator finds himself drawn into in a world of making social calls and receiving visitors. The dowager Marquise de Cambremer makes an unexpected call on the Narrator, who at that moment has Albertine with him. The old woman has brought along her daughter-in-law, the sister of an old family friend from Combray:

'To return to more interesting topics,' went on Legrandin's sister, who addressed the old Marquise as 'Mother' but with the passing of the years had come to treat her with insolence, 'you mentioned water-lilies: I suppose you know Claude Monet's pictures of them. What a genius! They interest me particularly because near Combray, that place where I told you I had some land…' But she preferred not to talk too much about Combray. 'Why, that must be the series that Elstir told us about, the greatest living painter,' exclaimed Albertine, who had said nothing so far. 'Ah, I can see that this young lady loves the arts,' cried old Mme de Cambremer; and drawing a deep breath, she recaptured a trail of spittle.…

As the sun was beginning to set, the seagulls were now yellow, like the water-lilies on another canvas of that series by Monet. I said that I knew it, and (continuing to imitate the language of her brother, whom I had not yet ventured to name) added that it was a pity that she had not thought of coming a day earlier, for, at the same hour, there would have been a Poussin light for her to admire.

Landscape with Orpheus and Eurydice, Nicolas Poussin, 1650

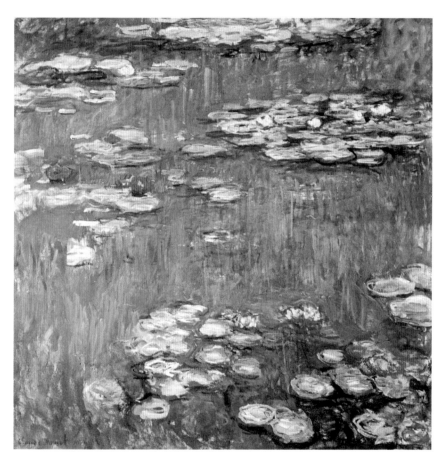

Water Lilies (Nymphéas), Claude Monet, 1916

Attempting to be polite to his distinguished elder visitor, the Narrator finds himself drawn into a conversation about painters with the younger lady, the supercilious Mme de Cambremer-Legrandin:

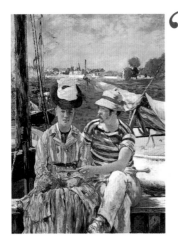

Argenteuil, The Boaters,
Édouard Manet, 1874

'In heaven's name, after a painter like Monet, who is quite simply a genius, don't go and mention an old hack without a vestige of talent, like Poussin. I don't mind telling you frankly that I find him the deadliest bore. I mean to say, you can't really call that sort of thing painting. Monet, Degas, Manet, yes, there are painters if you like…I used at one time to prefer Manet. Nowadays, I still admire Manet, of course, but I believe I like Monet even more. Ah, the cathedrals!' She was as scrupulous as she was condescending in informing me of the development of her taste. And one felt that the phases through which that taste had evolved were not, in her eyes, any less important than the different manners of Monet himself.

Rouen Cathedral (The Portal and Tour Saint-Romain, Impression of Morning: Harmony in White), Claude Monet, 1894

Place de la Concorde (Viscount Lepic and his Daughters Crossing the Place de la Concorde), Edgar Degas, 1875

The young Mme de Cambremer affects to like or dislike artists not as an indication of aesthetic sensibility, but rather in order to be perceived as someone 'au courante'. She, with her 'horror of sunsets', only needs to be told that someone is out of fashion to immediately dissolve an earlier devotion:

'But,' I remarked to her, feeling that the only way to rehabilitate Poussin in her eyes was to inform her that he was once more in fashion, 'M. Degas affirms that he knows nothing more beautiful than the Poussins at Chantilly.'

'Really? I don't know the ones at Chantilly,' said Mme de Cambremer, who had no wish to differ from Degas, 'but I can speak about the ones in the Louvre, which are hideous.'

'He admires them immensely too.'

'I must look at them again. My memory of them is a bit hazy,' she replied after a moment's silence, and as though the favourable opinion she was certain to form of Poussin before very long would depend, not upon the information that I had just communicated to her, but upon the supplementary and this time definitive examination that she intended to make of the Poussins in the Louvre in order to be in a position to change her mind.

Mars and Venus, Nicolas Poussin, *c.* 1630

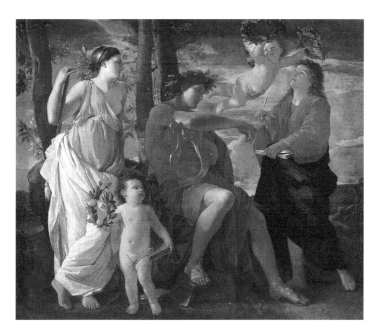

The Inspiration of the Poet, Nicolas Poussin, 1630

Part of the larger group gathered around Mme de Cambremer includes the family of a lawyer, who, assuming the air of a connoisseur, has been listening intently to the conversation about art and artists. His fondness for the recent work of Elstir is tepid at best. He champions another painter, whose work he collects.

He went so far as to invite me to come one day to his house in Paris to see his collection of Le Sidaners, and to bring with me the Cambremers, with whom he evidently supposed me to be on intimate terms. 'I shall invite you to meet Le Sidaner,' he said to me, confident that from that moment I would live only in expectation of that happy day. 'You shall see what a delightful man he is. And his pictures will enchant you. Of course, I can't compete with the great collectors, but I do believe that I own the largest number of his favorite canvases. They will interest you all the more, coming from Balbec, since they're marine subjects, for the most part at least.' The wife and son, blessed with a vegetable nature, listened composedly. One felt that their house in Paris was a sort of temple to Le Sidaner. Temples of this sort are not without their uses. When the god has doubts as to his own merits, he can easily stop the cracks in his opinion of himself with the irrefutable testimony of people who have dedicated their lives to his work.

Window at the Port of Honfleur, Henri Le Sidaner, 1922

At the Grand Hotel in Balbec, the Narrator begins to comprehend M. Nissim Bernard's ritual attendance in the dining room. Though not a guest of the hotel, Bloch's great-uncle has a place reserved for him every day at noon:

Since that day, M. Nissim Bernard had never failed to come and occupy his seat at the lunch-table (as a man might occupy his seat in the stalls who was keeping a dancer, a dancer in this case of a distinct and special type which still awaits its Degas)....

As a matter of fact, this misapprehension on the part of M. Nissim Bernard's relatives, who never suspected the true reason for his annual return to Balbec, and for what the pedantic Mme Bloch called his gastronomic absenteeism, was a deeper truth, at one remove. For M. Nissim Bernard himself was unaware of the extent to which a love for the beach at Balbec and for the view over the sea which one enjoyed from the restaurant, together with eccentricity of habit, contributed to the fancy that he had for keeping, like a little dancing girl of another kind which still lacks a Degas, one of his equally nubile servers.

Dancers Backstage, Edgar Degas, 1876–83

The elder Mme de Cambremer has rented her home, La Raspelière, to the Verdurins. Paying her tenants a visit as a courtesy, she and her daughter-in-law have arrived in time to hear a concert by the violinist Morel. The younger Mme de Cambremer adheres to her current passion for one school of aesthetic discourse:

In her passion for realism in art, no object seemed to her humble enough to serve as a model to painter or writer. A fashionable picture or novel would have made her sick; Tolstoy's moujiks, or Millet's peasants, were the extreme social boundary beyond which she did not allow the artist to pass. But to cross the boundary that limited her own social relations, to raise herself to an intimate acquaintance with duchesses, this was the goal of all her efforts, so inneffective had the spiritual treatment to which she subjected herself by the study of great masterpieces proved in overcoming the congenital and morbid snobbery that had developed in her.

The Angelus (L'Angélus), Jean-François Millet, 1857–59

The members of the little clan of the Verdurins continue to evolve. The Narrator has been welcomed to La Raspelière, and by commenting upon the painter Elstir draws from Mme Verdurin a critique of her former friend's current work:

'I don't know whether you call it painting, all those outlandish great compositions, those hideous contraptions he exhibits now that he has given up coming to me. I call it daubing, it's all so hackneyed, and besides, it lacks relief and personality. There are bits of everybody in it.'

'He has revived the grace of the eighteenth century, but in a modern form,' Saniette burst out, fortified and emboldened by my friendliness, 'but I prefer Helleu.'

'There's not the slightest connexion with Helleu,' said Mme Verdurin.

'Yes, yes, it's hotted-up eighteenth century. He's a steam Watteau,' and he began to laugh.

Autumn at Versailles, Paul Helleu, 1892

Lunching with the Verdurins and their assembled coterie of hangers-on, the Narrator is subjected to innumerable attempts at witticism and seemingly endless prattle:

'What is this prettily coloured thing that we're eating?' asked Ski.

'It's called strawberry mousse,' said Mme Verdurin.

'But it's ex-qui-site. You ought to open bottles of Château-Margaux, Château-Lafitte, port wine.'

'I can't tell you how he amuses me, he never drinks anything but water,' said Mme Verdurin, seeking to cloak with her delight at this flight of fancy her alarm at the thought of such extravagance.

'But not to drink,' Ski went on. 'You shall fill all our glasses, and they will bring in marvellous peaches, huge nectarines; there, against the sunset; it will be as luscious as a beautiful Veronese.'

'It would cost almost as much,' M. Verdurin murmured.

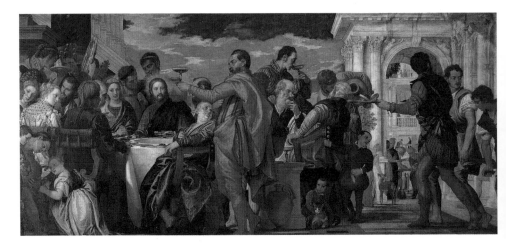

The Wedding at Cana (detail), Veronese, 1571

The Jewish Bride, Rembrandt (Harmensz.) van Rijn, 1665

In the strained context of the Dreyfus Affair, Baron de Charlus's outburst about one street becoming the 'Judengasse of Paris' appears mean-spirited, yet the Baron magnanimously disclaims any political interest and defers to the humanizing lessons he has learned from art:

'I take an interest in all that sort of thing only from the point of view of art. Politics are not in my line, and I cannot condemn wholesale, because Bloch belongs to it, a nation that numbers Spinoza among its illustrious sons. And I admire Rembrandt too much not to realize the beauty that can be derived from frequenting the synagogue.'

VOLUME V

The Captive

The Last Day of a Condemned Man (detail), Mihály Munkácsy, 1870

Many years have passed and the Narrator is now living with Albertine, who, thanks to his munificence, is gradually becoming a woman of fashion. He thinks back on their romantic history together and dissects the development of her complex character:

For other people, even those of whom we have dreamed so much that they have come to seem no more than pictures, figures by Benozzo Gozzoli against a greenish background, of whom we were inclined to believe that they varied only according to the point of vantage from which we looked at them, their distance from us, the effect of light and shade, such people, while they change in relation to ourselves, change also in themselves, and there had been an enrichment, a solidification and an increase of volume in the figure once simply outlined against the sea.

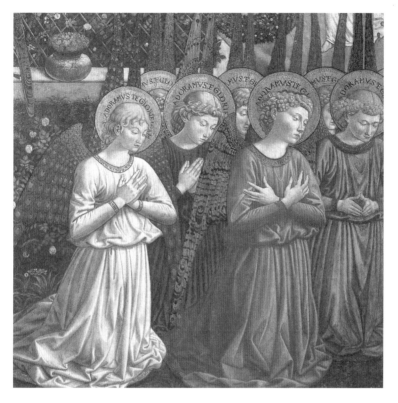

Procession of the Magi (detail), Benozzo Gozzoli, 1459

The Narrator studies Albertine, standing before him as she prepares to get into bed. Once she is lying beside him, he adoringly takes an inventory of her limbs and body:

Albertine would fold her arms behind her dark hair, her hip swelling, her leg drooping with the inflexion of a swan's neck that stretches upwards and then curves back on itself. When she was lying completely on her side, there was a certain aspect of her face (so sweet and so beautiful from in front) which I could not endure, hook-nosed as in one of Leonardo's caricatures, seeming to betray the malice, the greed for gain, the deceitfulness of a spy whose presence in my house would have filled me with horror and whom that profile seemed to unmask. At once I took Albertine's face in my hands and altered its position.

Two Grotesque Profiles, Leonardo da Vinci (copy after), 1485–90

Tormented by the question of Albertine's faithfulness, the Narrator wants to know at any cost what Albertine is thinking and whom she is seeing:

Albertine went to take off her things and, to lose no time in finding out what I wanted to know, I seized the telephone receiver and invoked the implacable deities, but succeeded only in arousing their fury which expressed itself in the single word 'Engaged.' Andrée was in fact engaged in talking to someone else. As I waited for her to finish her conversation, I wondered why it was – now that so many of our painters are seeking to revive the feminine portraits of the eighteenth century, in which the cleverly devised setting is a pretext for portraying expressions of expectation, sulkiness, interest, reverie – why it was that none of our modern Bouchers or Fragonards had yet painted, instead of *The Letter* or *The Harpsichord*, this scene which might be entitled *At the Telephone*, in which there would come spontaneously to the lips of the listener a smile all the more genuine because it is conscious of being unobserved.

The Music Lesson, Jean-Honoré Fragonard, 1769

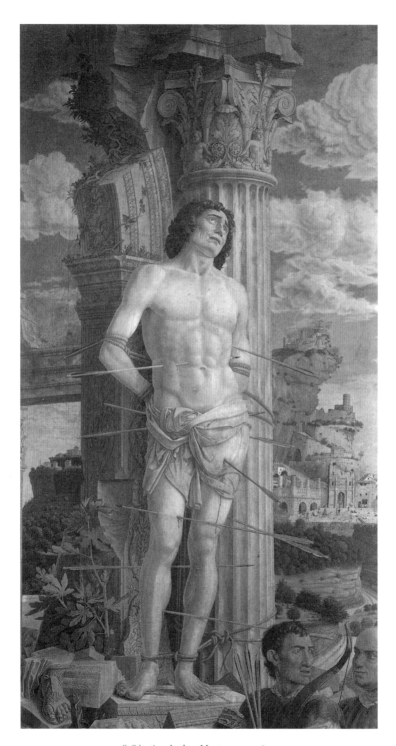

St Sebastian, Andrea Mantegna, *c.* 1480

Out driving in a motor car with the Narrator, Albertine easily manages her end of their conversation. Experiencing in her a complexity that reveals the extent of her developing intellectual capacities, he is dazzled and impressed. She graciously credits him with being an excellent teacher.

'How wonderful you are! If I ever do become clever, it will be entirely owing to you.'

'Why, on a fine day, tear your eyes away from the Trocadéro, whose giraffe-neck towers remind one of the Charterhouse of Pavia?'

'It reminded me also, standing up like that on its knoll, of a Mantegna that you have, I think it's of St Sebastian, where in the background there is a terraced city where you'd swear you'd find the Trocadéro.'

'There, you see! But how did you come across the Mantegna reproduction? You're absolutely staggering.'

News of the death of the novelist Bergotte reaches the Narrator. The writer had stopped paying calls and rarely left his own home, living quietly and simply. However, Bergotte was roused to have a last look at a much-loved painting, and rallied his strength to go to the exhibition:

The circumstances of his death were as follows. A fairly mild attack of uraemia had led to his being ordered to rest. But an art critic having written somewhere that in Vermeer's *View of Delft* (lent by the Gallery at The Hague for an exhibition of Dutch painting), a picture which he adored and imagined that he knew by heart, a little patch of yellow wall (which he could not remember) was so well painted that it was, if one looked at it by itself, like some priceless specimen of Chinese art, of a beauty that was sufficient in itself, Bergotte ate a few potatoes, left the house, and went to the exhibition. At the first few steps he had to climb, he was overcome by an attack of dizziness. He walked passed several pictures and was struck by the aridity and pointlessness of such an artificial kind of art, which was greatly inferior to the sunshine of a windswept Venetian palazzo, or of an ordinary house at the sea. At last he came to the Vermeer which he remembered as more striking, more different from anything else he knew, but in which, thanks to the critic's article, he noticed for the first time some small figures in blue, that the sand was pink, and, finally, the precious substance of the tiny patch of yellow wall. His dizziness increased; he fixed his gaze, like a child upon on a yellow butterfly that it wants to catch, on the precious little patch of wall. 'That's how I ought to have written,' he said. 'My last books are too dry, I ought to have gone over them with a few layers of colour, made my language precious in itself, like this little patch of yellow wall.' Meanwhile he was not unconscious of the gravity of his condition. In a celestial pair of scales there appeared to him, weighing down one of the pans, his own life, while the other contained the little patch of wall so beautifully painted in yellow. He felt that he had rashly sacrificed the former for the latter.…He repeated to himself: 'Little patch of yellow wall, with a sloping roof, little patch of yellow wall.'

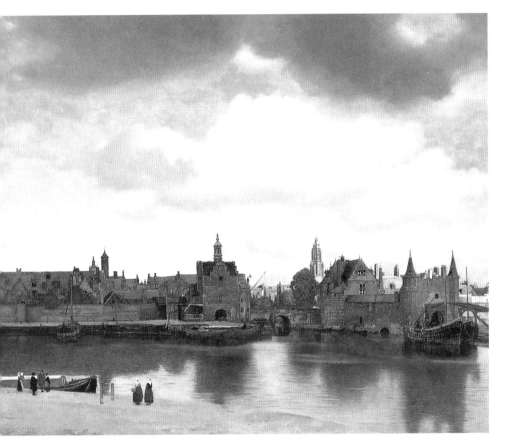

View of Delft, Jan Vermeer, 1659–60

Soon upon the death of one old friend comes news of the death of another. Charles Swann — sensitive aesthete, member of the Jockey Club, scholar of Vermeer — is no more, and the Narrator ponders how this cultured man, this devoted friend, will be remembered, and for how long, and what part he himself may play in ensuring Swann's immortality:

S wann on the contrary was a remarkable intellectual and artistic personality, and although he had 'produced' nothing, still he was lucky enough to survive a little longer. And yet, my dear Charles Swann, whom I used to know when I was still so young and you were nearing your grave, it is because he whom you must have regarded as a young idiot has made you the hero of one of his novels that people are beginning to speak of you again and that your name will perhaps live. If, in Tissot's picture representing the balcony of the Rue Royale club, where you figure with Galliffet, Edmond de Polignac and Saint-Maurice, people are always drawing attention to you, it is because they see that there are some traces of you in the character of Swann.

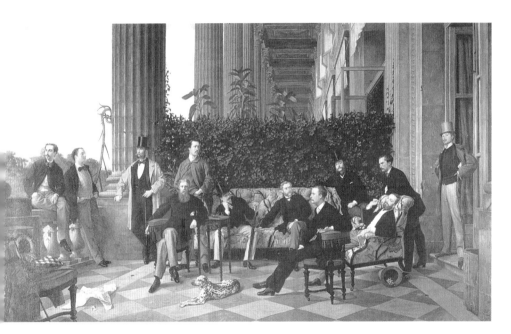

The Circle of the Rue Royale (Le Cercle de la rue Royale), James Tissot, 1868

On his way to Mme Verdurin's, the Narrator catches a glimpse of Baron de Charlus in the company of a ruffian. Sensing that he has been compromised, Charlus approaches the Narrator and attempts to make light of the incident, but in so doing amplifies, rather than mutes, his flamboyant character:

Pretending not to see the shady individual who was gliding in his wake (whenever the Baron ventured on to the boulevards or crossed the main hall of the Gare Saint-Lazare, these hangers-on who dogged his heels in the hope of touching him for a few francs could be counted by the dozen), and fearful lest the man might be bold enough to accost him, the Baron had devoutly lowered his mascara'ed eyelids which, contrasting with his powdered cheeks, gave him the appearance of a Grand Inquisitor painted by El Greco. But this priest was frightening and looked like an excommunicate, the various compromises to which he had been driven by the need to indulge his taste and to keep it secret having had the effect of bringing to the surface of his face precisely what the Baron sought to conceal, a debauched life betrayed by moral degeneration.

A Cardinal (probably Cardinal Niño de Guevara), El Greco, *c.* 1600

Regaining his composure, Charlus joins the Narrator and together they enter the Verdurins'. First he quizzes the Narrator about his old friend Bloch, and then he begins to praise at length the violinist Morel, extolling his talent as a musician, but also, especially, his beauty:

Since he admired everything about Morel, the latter's successes with women, causing him no offence, gave him the same joy as his successes on the concert platform or at cards. 'But do you know, my dear fellow, he has women,' he would say, with an air of revelation, of scandal, possibly of envy, above all of admiration. 'He's extraordinary,' he would continue, 'Wherever he goes, the most prominent whores have eyes for him alone. One notices it everywhere, whether it's on the underground or in the theatre. It's becoming such a bore! I can't go out with him to a restaurant without the waiter bringing him notes from at least three women. And always pretty women too. Not that it's anything to be wondered at. I was looking at him only yesterday, and I can quite understand them. He's become so beautiful, he looks like a sort of Bronzino; he's really marvellous.' But M. de Charlus liked to show that he loved Morel, and to persuade other people, possibly to persuade himself, that Morel loved him.

Portrait of a Young Man, Il Bronzino, 1530s

In an attempt to further the career of his young protégé Morel, Charlus had approached the writer Bergotte about helping the violinist publish some of his writings on music:

Bergotte for his part was well aware of the utilitarian motive for M. de Charlus's visits, but bore him no grudge; for though he was incapable of sustained kindness, he was anxious to give pleasure, tolerant, and impervious to the pleasure of administering a snub. As for M. de Charlus's vice, he had never to the smallest degree shared it, but found in it rather an element of colour in the person affected, *fas et nefas*, for an artist, consisting not in moral examples but in memories of Plato or of Il Sodoma.

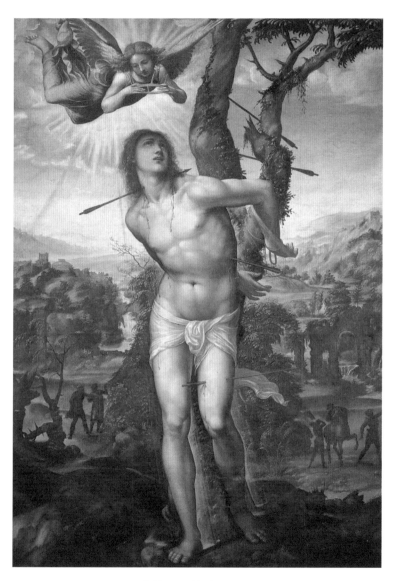

St Sebastian, Il Sodoma, 1525

At a musical soirée at the Verdurin home, the Narrator is ecstatic to hear more music by the composer Vinteuil, whose piano and violin sonata he knows so well and values so highly. He had been unaware of the existence of an unpublished septet and hears it now for the first time:

Presently these two motifs were wrestling together in a close embrace in which at times one of them would disappear entirely, and then only a fragment of the other could be glimpsed. A wrestling match of disembodied energies only, to tell the truth; for if these creatures confronted one another, they did so stripped of their physical bodies, of their appearance, of their names, finding in me an inward spectator – himself indifferent, too, to names and particulars – to appreciate their immaterial and dynamic combat and follow passionately its sonorous vicissitudes. In the end the joyous motif was left triumphant; it was no longer an almost anxious appeal addressed to an empty sky, it was an ineffable joy which seemed to come from paradise, a joy as different from that of the sonata as some scarlet-clad Mantegna archangel sounding a trumpet from a grave and gentle Bellini seraph strumming a theorbo. I knew that this new tone of joy, this summons to a supraterrestial joy, was a thing that I would never forget. But would it ever be attainable to me?

The Assumption (detail),
Andrea Mantegna, *c.* 1455

Enthroned Madonna (detail), San Giobbi altarpiece, Giovanni Bellini, 1487

After the performance, the hour being late, the Narrator begins to think of going home to Albertine. The Baron de Charlus chides the Narrator for his hasty departure from a party:

'Unfortunately you're in a hurry, in a hurry, no doubt, to go and do things which you would much better leave undone. People are always in a hurry, and leave at the moment when they ought to be arriving. We're like Couture's philosophers, this is the time to go over the events of the evening, to carry out what is called in military parlance a review of operations.'

Romans of the Decadence, Thomas Couture, 1847

Charlus continues to rhapsodize about the concert, about Morel's sublime playing and the depth of his concentration:

'Only young Charlie preserved a stony immobility, you couldn't even see him breathe, he looked like one of those objects of the inanimate world of which Théodore Rousseau speaks, which make us think but do not think themselves.'

Oak Trees in the Gorge of Apremont, Théodore Rousseau, c. 1855

The state of the affair between Albertine and the Narrator has seriously degenerated to one of mutual distrust and periodic loathing. Who is truly the captive in his house? the Narrator asks himself. He studies Albertine's impenetrable composure:

I t would have been impossible to say whether she blamed, whether she approved, whether she knew or did not know about these things. Her features no longer bore any relation to anything except one another. Her nose, her mouth, her eyes, formed a perfect harmony, isolated from everything else; she looked like a pastel, and seemed to have no more heard what had just been said than if it had been uttered in front of a portrait by La Tour.

Isabelle de Charrière, Maurice-Quentin de La Tour, 1766

In the wake of her discussions with Elstir, Albertine has become entirely devoted to his notion of style, and nothing less than his standards will do for her. As her provider, the Narrator goes to enormous expense to keep her happy, and, on several levels, he takes pleasure in her exacting tastes:

I n the matter of dress, what appealed to her most at this time was everything made by Fortuny. Those Fortuny gowns, one of which I had seen Mme de Guermantes wearing, were those of which Elstir, when he told us about the magnificent garments of the women of Carpaccio's and Titian's day, had prophesied the imminent return, rising from their ashes, as magnificent as of old, for everything must return in time, as it is written beneath the vaults of Saint Mark's, and proclaimed, as they drink from the urns of marble and jasper of the Byzantine capitals, by the birds which symbolize at once death and resurrection.

Portrait of a Lady, Titian, c. 1555

The Narrator is resting in bed. He asks Albertine to play the pianola in order to distract him from his burdensome preoccupations. Thoughtfully, she chooses to play something that is new to him, and his focus slowly shifts from himself to her:

And as she played, of all Albertine's multiple tresses I could see but a single heart-shaped loop of black hair clinging to the side of her ear like the bow of a Velasquez Infanta.

La Infanta María Teresa, Diego Velázquez, *c.* 1651–54

As he praises the great novels to Albertine, the Narrator discusses the affinity between painters and writers with a reference to Dostoevsky and his female characters:

Well, this novel beauty remains identical in all Dostoievsky's works. Isn't the Dostoievsky woman (as distinctive as a Rembrandt woman) with her mysterious face…isn't she always the same…figures as original, as mysterious, not merely as Carpaccio's courtesans, but as Rembrandt's Bathsheba.

Bathsheba at her Bath, Rembrandt (Harmensz.) van Rijn, 1654

Two Venetian Courtesans, Vittore Carpaccio, 1490

*Continuing his conversation with Albertine, the Narrator cites Dostoevsky as
an artist who brought a 'new kind of beauty into the world' but also one who was capable
of writing in overly broad strokes when trying to underscore a dramatic situation:*

B ut on the other hand when he wants 'ideas for paint-
ings' they're always stupid and would at best result
in the pictures where Munkácsy wanted to see
a condemned man represented at the moment when…etc.,
or the Virgin Mary at the moment when…, etc.

The Last Day of a Condemned Man, Mihály Munkácsy, 1870

Beautiful and intent upon her music, Albertine plays the piano. A vision of St Cecilia gradually suffuses the Narrator. The room becomes a sanctuary, a shrine to this 'angel musician'. However, the spell breaks as the Narrator becomes aware of trying to fabricate an aestheticized image:

But no, Albertine was for me not at all a work of art. I knew what it meant to admire a woman in an artistic fashion, having known Swann. For my own part, however, no matter who the woman might be, I was incapable of doing so, having no sort of power of detached observation, never knowing what it was that I saw, and I had been amazed when Swann added retrospectively an artistic dignity – by comparing her to me, as he liked to do gallantly to her face, to some portrait by Luini, by recalling in her attire the gown or the jewels of a picture by Giorgione – to a woman who had seemed to me to be devoid of interest. Nothing of that sort with me.

Portrait of a Lady, Bernardino Luini, *c.* 1520–25

One evening, overcome with boredom and jealousy, the Narrator loses his temper with Albertine. As he observes her for the first time wearing an extravagant boudoir gown he has given her, he is suddenly aware of how much he has sacrificed for her:

The Fortuny gown which Albertine was wearing that evening seemed to me the tempting phantom of that invisible Venice....And the sleeves were lined with a cherry pink which is so peculiarly Venetian that it is called Tiepolo pink.

The Triumph of Zephyr and Flora (Allegory of Spring),
Giovanni Battista Tiepolo, 1734

VOLUME VI

The Fugitive

Very early one morning before the Narrator has stirred, Albertine packs her bags and flees. Alternating waves of relief and despair wash over him. News of her sudden death arrives. His life is once more thrown into upheaval. He desperately attempts to discover just who Albertine was and what she meant to him:

I hummed a few phrases of Vinteuil's sonata. The thought that Albertine had so often played it to me no longer saddened me unduly, for almost all my memories of her had entered into that secondary chemical state in which they no longer cause an anxious oppression of the heart, but rather a certain sweetness. From time to time, in the passages which she used to play most often, when she was in the habit of making some observation which at the time I thought charming, of suggesting some reminiscence, I said to myself: 'Poor child,' but not sadly, merely investing the musical phrase with an additional value, as it were a historical, a curiosity value, like that which the portrait of Charles I by Van Dyck, already so beautiful in itself, acquires from the fact that it found its way into the national collection because of Mme du Barry's desire to impress the King.

Charles I, King of England, Hunting, Anthony van Dyck, *c.* 1635

Gilberte Swann, the young girl who so fascinated the Narrator as a boy, re-enters his life. Gilberte's father had been an admired fixture in society until he married her mother Odette; since his death, Gilberte has been shunned. Undaunted, she subscribes to her own social hierarchy:

S nobbery is with certain people analogous to those beverages in which the agreeable is mixed with the beneficial. Gilberte took an interest in some lady of fashion because she possessed priceless books and portraits by Nattier which my former friend would probably not have taken the trouble to inspect in the Bibliothèque Nationale or the Louvre, and I imagine that, in spite of their even greater proximity, the magnetic influence of Tansonville would have had less effect on drawing Gilberte towards Mme Sazerat or Mme Goupil than towards M. d'Agriente.

Portrait of Mathilde de Canisy, Marquise d'Antin,
Jean-Marc Nattier, 1738

The Narrator arrives for a visit in Venice with his mother, and finds that in her company he is open to impressions comparable to those he had made as a young boy at Combray. The complexity of his emotional response is now allied with the sensations aroused in him by select painters. Although Venice is certainly composed of more than monuments and dappled light, the Narrator chides most contemporary artists who choose to represent only its impoverished side:

A nd since, in Venice, it is works of art, things of priceless beauty, that are entrusted with the task of giving us our impressions of everyday life, it is to falsify the character of that city, on the grounds that the Venice of certain painters is coldly aesthetic in its most celebrated parts (let us make an exception of the superb studies of Maxime Dethomas), to represent only its poverty-stricken aspects, in the districts where nothing of its splendour is to be seen, and, in order to make Venice more intimate and more genuine, to give it a resemblance to Aubervilliers.

Venice Study, from Henri de Régnier's book *Esquisses Vénitiennes*, Maxime Dethomas, 1906

Between the extravagant expenditures he has made on Albertine's behalf and the mercurial nature of the stock market, the Narrator's fortune, inherited from his great aunt, has been severely reduced in size. His ability to seduce a young Venetian woman is tied in his mind to his newly reduced financial credibility, but this does not keep him from associating her with priceless pictures:

As for my comparative penury, it was all the more awkward at the moment, inasmuch as my Venetian interests had been concentrated for some little time past on a young vendor of glassware whose blooming complexion offered to the delighted eye a whole range of orange tones and filled me with such a longing to see her daily that, realizing that my mother and I would soon be leaving Venice, I had made up my mind to try to create some sort of position for her in Paris which would save me from being parted from her. The beauty of her seventeen years was so noble, so radiant, that it was like acquiring a genuine Titian before leaving the place. But would the scant remains of my fortune be enough to tempt her to leave her native land and come to live in Paris for my sole convenience?

Portrait of Isabella d'Este, Titian, 1536

Martyrdom of the Pilgrims and the Burial of St Ursula,
from *The Life of Saint Ursula* cycle (detail), Vittore Carpaccio, 1493

The treasures of Venice have prompted the Narrator to begin writing about the art critic John Ruskin. St Mark's basilica, with its Byzantine foundations and Gothic overlays, provides a Ruskinian ambience for him and his mother. Within the enclosure of those hallowed walls, art and life seem one and the same:

Seeing that I needed to spend some time in front of the mosaics representing the Baptism of Christ, and feeling the icy coolness that pervaded the baptistery, my mother threw a shawl over my shoulders. When I was with Albertine at Balbec, I felt that she was revealing one of those insubstantial illusions which clutter the minds of so many people who do not think clearly, when she used to speak of the pleasure – to my mind baseless – that she would derive from seeing works of art with me. Today I am sure that the pleasure does exist, if not of seeing, at least of having seen, a beautiful thing with a particular person. A time has now come when, remembering the baptistery of St Mark's – contemplating the waters of the Jordan in which St John immerses Christ, while the gondola awaited us at the landing-stage of the Piazzetta – it is no longer a matter of indifference to me that, beside me in that cool penumbra, there should have been a woman draped in her mourning with the respectful and enthusiastic fervour of the old woman in Carpaccio's *St Ursula* in the Accademia, and that that woman, with her red cheeks and sad eyes and in her black veils, whom nothing can ever remove from that softly lit sanctuary of St Mark's where I am always sure to find her because she has her place reserved there as immutably as a mosaic, should be my mother.

When not at St Mark's, the Narrator and his mother frequent the Accademia,
studying there an unparalleled collection of Carpaccio's paintings:

C arpaccio, as it happens, who was the painter we
visited most readily when I was not working in
St Mark's, almost succeeded one day in reviving my
love for Albertine. I was seeing for the first time *The Patriarch
of Grado exorcising a demoniac.* I looked at the marvellous
rose-pink and violet sky and the tall encrusted chimneys
silhouetted against it, their flared stacks, blossoming like
red tulips, reminiscent of so many Whistlers of Venice...

The Storm – Sunset, James Abbott McNeill Whistler, 1880

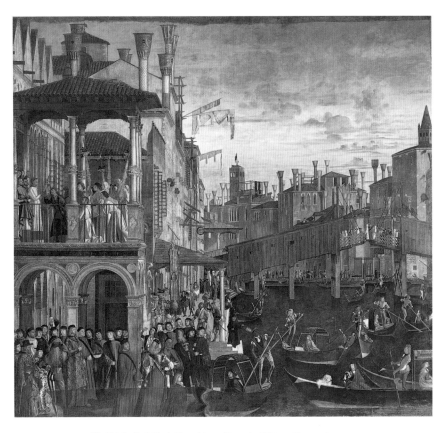

The Patriarch of Grado Exorcising a Demoniac, Vittore Carpaccio, 1494

…Finally, before leaving the picture, my eyes came back to the shore, swarming with the everyday Venetian life of the period. I looked at the barber wiping his razor, at the negro humping his barrel, at the Muslims conversing, at the noblemen in wide-sleeved brocade and damask robes and hats of cerise velvet, and suddenly I felt a slight gnawing at my heart. On the back of one of the *Compagni della Calza* identifiable from the emblem, embroidered in gold and pearls on their sleeves or their collars, of the merry confraternity to which they were affiliated, I had just recognized the cloak which Albertine had put on to come with me to Versailles in an open carriage on the evening when I so little suspected that scarcely fifteen hours separated me from the moment of her departure from my house. Always ready for anything, when I had asked her to come out with me on that melancholy occasion which she was to describe in her last letter as 'a double twilight since night was falling and we were about to part,' she had flung over her shoulders a Fortuny cloak which she had taken away with her next day and which I had never thought of since. It was from this Carpaccio picture that that inspired son of Venice had taken it, it was from the shoulders of this *Compagno della Calza* that he had removed it in order to drape it over the shoulders of so many Parisian women who were certainly unaware, as I had been until then, that the model for it existed in a group of noblemen in the foreground of the *Patriarch of Grado* in a room in the Accademia in Venice. I had recognized it down to the last detail, and, that forgotten cloak having restored to me as I looked at it the eyes and the heart of him who had set out that evening with Albertine for Versailles, I was overcome for a few moments by a vague and soon dissipated feeling of desire and melancholy.

Thinking of their old friend Charles Swann, the Narrator and his mother make a day's pilgrimage from Venice to Padua in order to see the paintings of the Arena Chapel in all their glory:

There were days when my mother and I were not content with visiting the museums and churches of Venice only, and once, when the weather was particularly fine, in order to see the 'Virtues' and 'Vices' of which M. Swann had given me reproductions that were probably still hanging on the wall of the schoolroom at Combray, we went as far afield as Padua. After walking across the garden of the Arena in the glare of the sun, I entered the Giotto chapel, the entire ceiling of which and the background of the frescoes are so blue that it seems as though the radiant daylight has crossed the threshold with the human visitor in order to give its pure sky a momentary breather in the coolness and shade, a sky merely of a slightly deeper blue now that it is rid of the glitter of the sunlight, as in those brief moments of respite when, though no cloud is to be seen, the sun has turned its gaze elsewhere and the azure, softer still, grows deeper.

Interior of the Arena Chapel facing *The Last Judgment*, west, Giotto, 1304–6

The sky of Padua outdoors and the sky of Giotto indoors act in concert as a stimulant to the Narrator's memory. Woven together under the chapel roof, their combined powers bring the past into contact with the realities of the present day:

This sky transplanted onto the blue-washed stone was peopled with flying angels which I was seeing for the first time, for M. Swann had given me reproductions only of the Vices and Virtues and not of the frescoes depicting the life of the Virgin and of Christ. Watching the flight of these angels, I had the same impression of actual movement, literally real activity, that the gestures of Charity and Envy had given me. For all the celestial fervour, or at least the childlike obedience and application, with which their miniscule hands are joined, they are represented in the Arena Chapel as winged creatures of a particular species that had really existed, that must have figured in the natural history of biblical and apostolic times. Constantly flitting about above the saints whenever the latter walk abroad, these little beings, since they are real creatures with a genuine power of flight, can be seen soaring upwards, describing curves, 'looping the loop,' diving earthwards head first, with the aid of wings which enable them to support themselves in positions that defy the laws of gravity, and are far more reminiscent of an extinct species of bird, or of young pupils of Garros practising gliding, than of the angels of the Renaissance and later periods whose wings have become no more than emblems and whose deportment is generally the same as that of heavenly beings who are not winged.

The Lamentation, Giotto, 1304–6

Acknowledging a defiant spirit within himself that he brutally imposes upon those he loves most, the Narrator refuses to comply with his mother's wish for him to go home with her. To be able to stay on in Venice, he sends her off to travel back to Paris by herself:

The sun continued to sink. My mother must be nearing the station. Soon she would be gone, and I should be alone in Venice, alone with the misery of knowing that I had distressed her, and without her presence to comfort me. The hour of the train's departure was approaching. My irrevocable solitude was so near at hand that it seemed to me to have begun already and to be complete. For I felt myself to be alone; things had become alien to me; I no longer had calm enough to break out of my throbbing heart and introduce into them a measure of stability. The town that I saw before me had ceased to be Venice. Its personality, its name, seemed to me to be mendacious fictions which I no longer had the will to impress upon its stones. I saw the palaces reduced to their basic elements, lifeless heaps of marble with nothing to choose between them, and the water as a combination of hydrogen and oxygen, eternal, blind, anterior and exterior to Venice, oblivious of the Doges or of Turner.

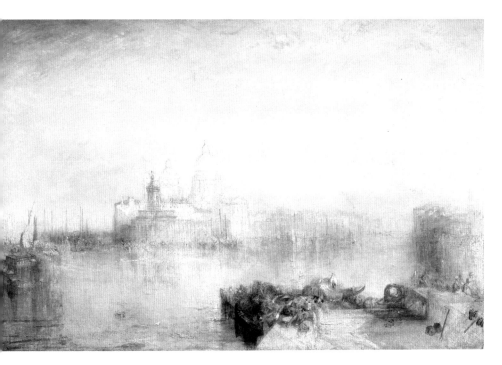

The Dogana and Santa Maria della Salute, Venice, Joseph Mallord William Turner, 1843

VOLUME VII

Time Regained

The Narrator is visiting Tansonville, near Combray, as a guest of Gilberte and Saint-Loup, who have married. Gilberte lends him a book to read in bed, an unpublished journal of the Goncourt brothers. In this passage, the writers find a likeness between one historical building in Paris and another on the Grand Canal:

'And upon my word, when we arrive, in the watery shimmer of a moonlight really just like that in which the paintings of the great age enwrap Venice, against which the silhouetted dome of the Institute makes one think of the Salute in Guardi's pictures, I have almost the illusion of looking out over the Grand Canal.'

Procession in front of Santa Maria della Salute, Francesco Guardi, *c.* 1775–80

*In the pages of the journal, the Narrator encounters people from his own life.
For example, the Goncourt brothers describe their friendship with Verdurin, whom
they know as an art critic and author of a volume on Whistler. Verdurin's house
is in a neighbourhood familiar to them from their youth:*

'A whole quarter which my childhood used idly to explore when my aunt de Courmont lived there, and which I am inspired to relove by rediscovering, almost next door to the Verdurin mansion, the sign of 'Little Dunkirk', one of the rare shops surviving elsewhere than in the crayon and wash vignettes of Gabriel de Saint-Aubin, to which the eighteenth-century connoisseur would come to pass a few leisure moments in cheapening trinkets French and foreign...'

LES. NOUVELLISTES.

The Gossips (Les Nouvellistes), Gabriel de Saint-Aubin, 1752

The Narrator continues to read the journal and comes across a description of Mme Verdurin, who refers to her husband as a 'crank'. The Goncourts are enchanted by her:

'And this charming woman, whose speech betrays her positive adoration of local colouring, talks with overflowing enthusiasm of the Normandy in which they once lived, a Normandy, so she says, like an immense English park, with the fragrance of tall woodlands that Lawrence might have painted...'

Elizabeth Farren, Later Countess of Derby,
Thomas Lawrence, 1790

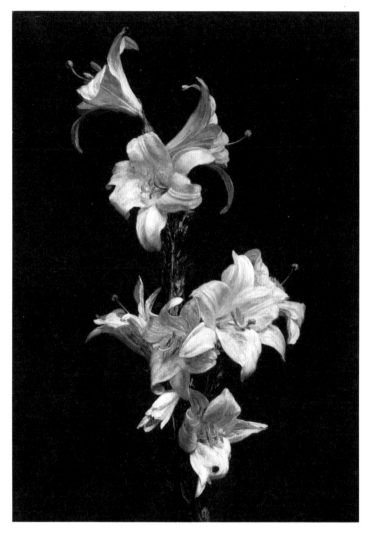

White Lilies, Henri Fantin-Latour, 1883

Mme Verdurin's character is dissected by the Goncourts in their journal. She strikes them as a modest, generous woman, full of intelligence and distinction, numbering many artists among her friends:

'And when I mention to Mme Verdurin Elstir's delicate pastel sketches of the landscapes and the flowers of that coast: "But it is through me that he discovered all those things," she bursts out with an angry toss of the head, "…as for flowers, he had never seen any, he couldn't tell a mallow from a hollyhock. It was I who taught him – you won't believe this – to recognise jasmine." And one must admit that it is a curious thought that the artist who is cited by connoisseurs today as our leading flower-painter, superior even to Fantin-Latour, would perhaps never, without the help of the woman sitting beside me, have known how to paint a jasmine.'

*Where does inspiration come from for an artist? Having digested the Goncourts'
journal, the Narrator decides that there is more truth to be found in a struggling
painter's modest descriptions of middle-class people than in a successful academician's
portraits of high society:*

W ill not posterity, when it looks at our time, find
the poetry of an elegant home and beautifully
dressed women in the drawing-room of the pub-
lisher Charpentier as painted by
Renoir, rather than in the portraits
of the Princesse de Sagan or the
Comtesse de la Rochefoucauld by
Cot or Chaplin?

Portrait of a Lady, Pierre-Auguste Cot, 1879

Madame Georges Charpentier and her Children, Pierre-Auguste Renoir, 1878

Head of a Young Woman with Profile to the Right, Pisanello, 1433

As a world war rages, the Narrator has been nursing back his health at a sanatorium. Demand for medical staff at the front forces the facility to close, so the frail patient finds himself back in Paris. Some evenings, as he watches elegant women promenade, he finds it difficult to believe that there is a war going on, but on closer inspection he discovers a connection:

I t was, so they said, because they did not forget that it was their duty to rejoice the eyes of these 'boys at the front,' that they still decked themselves of an evening not only in flowing dresses, but in jewelry which suggested the army by its choice of decorative themes, when indeed the actual material from which it was made did not come from, had not been wrought in the army; for instead of Egyptian ornaments recalling the campaign in Egypt, the fashion now was for rings or bracelets made out of fragments of exploded shells or copper bands from 75 millimetre ammunition, and for cigarette-lighters constructed out of two English pennies to which a soldier, in his dug-out, had succeeded in giving a patina so beautiful that the profile of Queen Victoria looked as if it had been drawn by the hand of Pisanello...

Saint-Loup, on leave from the front (with a battle scar on his handsome forehead) comes to see the Narrator. An emotional intensity hallows their reunion. It seems almost as if there were no war. Their mutual delight in the absurd comforts them:

And squadron after squadron, each pilot, as he soared thus above the town, itself now transported into the sky, resembled indeed a Valkyrie. Meanwhile on ground-level, at the height of the houses, there were also scraps of illumination, and I told Saint-Loup that, if he had been at home the previous evening, he might, while contemplating the apocalypse in the sky, at the same time have watched on the ground (as in El Greco's *Burial of Count Orgaz*, in which the two planes are distinct and parallel) a first-rate farce acted by characters in night attire, whose famous names merited a report to some successor of that Ferrari whose society paragraphs had so often provided amusement to the two of us, Saint-Loup and myself, that we used also to amuse ourselves by inventing imaginary ones. And that is what we did once more on the day I am describing, just as though we were not in the middle of a war, although our theme, the fear of the Zeppelins, was very much a 'war' one: 'Seen about town: the Duchesse de Guermantes magnificent in a nightdress, the Duc de Guermantes indescribable in pink pyjamas and a bathrobe, etc.'

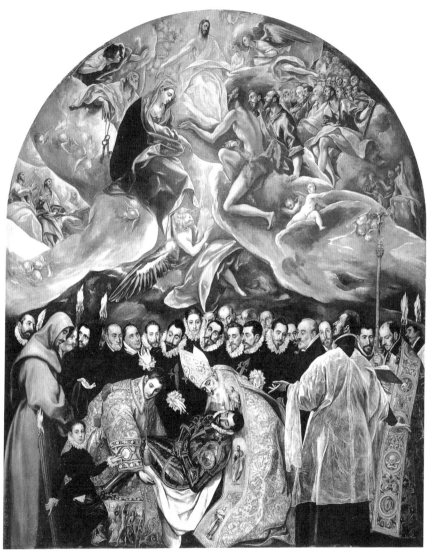

The Burial of the Count of Orgaz, El Greco, 1586–88

Out walking as the sun is going down, the Narrator moves from one neighbourhood to the next, remarking upon the variety of people and the numerous nationalities of the soldiers on parade:

There, the impression of an oriental vision which I had had earlier in the evening came to me again, and I thought too of the Paris of an earlier age, not now so much of the Paris of the Directory as of the Paris of 1815. As in 1815 there was a march past of allied troops in the most variegated uniforms; and among them, the Africans in their red divided skirts, the Indians in their white turbans were enough to transform for me this Paris through which I was walking into a whole imaginary exotic city, an oriental scene which was at once meticulously accurate with respect to the costumes and the colours of the faces and arbitrarily fanciful when it came to the background, just as out of the town in which he lived Carpaccio made a Jerusalem or a Constantinople by assembling in its streets a crowd whose marvellous motley was not more rich in colour than that of the crowd around me.

Sermon of St Stephen outside the Gates of Jerusalem, Vittore Carpaccio, 1514

Whether a friend has died in battle or in bed, in his uniform or in his pyjamas, death becomes a more familiar fact of life in a time of war. The Narrator has an elegiac response to the news of the demise of M. Verdurin, but his thoughts are really about Elstir:

He was soon followed by M. Verdurin, whose death caused grief to one person only and that, strangely enough, was Elstir. For whereas I had been able to study Elstir's work from a point of view which was to some extent objective, the painter himself, particularly as he grew older, linked it superstitiously to the society which had provided him with models and which had also, after thus transforming itself within him through the alchemy of impressions into a work of art, given him his public, his spectators. More and more he was inclined to believe materialistically that a not inconsiderable part of beauty is inherent in objects, and just as, at the beginning, he had adored in Mme Elstir the archetype of that rather heavy beauty which he had pursued and caressed in his paintings and in tapestries, so now in the death of M. Verdurin he saw the disappearance of one of the last relics of the social framework, the perishable framework – as quick to crumble away as the very fashions in clothes which form part of it – which supports an art and certifies its authenticity, and he was as saddened and distressed by this event as a painter of *fêtes galantes* might have been by the Revolution which destroyed the elegances of the eighteenth century, or Renoir by the disappearance of Montmartre and the Moulin de la Galette...

Ball at the Moulin de la Galette, Montmartre, Pierre-Auguste Renoir, 1876

The question of Elstir's importance as a painter will only be decided by posterity. Each generation sets its own aesthetic standards, sometimes circling back to embrace what it once condemned, sometimes not. Elstir mourns the loss of an advocate and a former friend:

But more than this, with M. Verdurin he saw disappear the eyes, the brain, which had had the truest vision of his painting, in which, in the form of a cherished memory, his painting was to some extent inherent. No doubt young men had come along who also loved painting, but painting of another kind; they had not, like Swann, like M. Verdurin, received lessons in taste from Whistler, lessons in truth from Monet, lessons which alone would have qualified them to judge Elstir with justice. So the death of M. Verdurin left Elstir feeling lonelier, although they had not been on speaking terms for a great many years: it was for him as though a little of the beauty of his own work had been eclipsed, since there had perished a little of the universe's sum total of awareness of its special beauty.

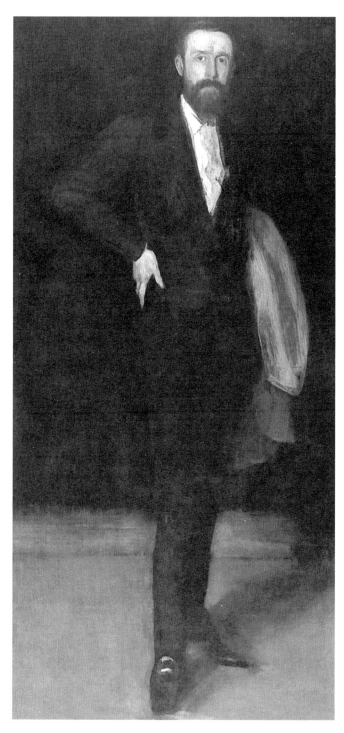

Arrangement in Black: Portrait of F. R. Leyland,
James Abbott McNeill Whistler, 1871–73

To question the use of patriotism as a standard by which to judge people in wartime requires considerable personal integrity, and Charlus, enraged by the blindness of his peers, finds himself standing alone:

Inevitably M. de Charlus was irritated by the triumphant optimism of people who did not know Germany and Germany's strength as he did, who believed every month in a crushing victory for the following month, and at the end of the year were as confident in making fresh predictions as though they had never, with equal confidence, made false ones – which they had, however, forgotten, saying, if they were reminded of them, that it 'was not the same thing.' Yet M. de Charlus, profound as his intelligence was in some directions, would perhaps have failed to see that in art 'This is not the same thing' is what the detractors of Manet return to those who tell them 'People said the same thing about Delacroix.'

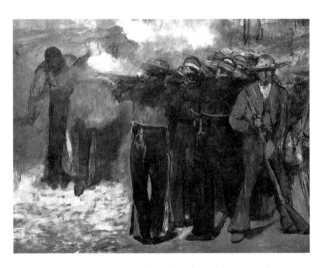

Execution of the Emperor Maximilian, Édouard Manet, 1867

Liberty Leading the People, Eugène Delacroix, 1830

Out strolling on a moonlit night in Paris, the Narrator weighs in his mind the beauty of the city and the very real threat of its destruction by bombardment. Seeing the crescent moon overhead, he thinks of looking out at the Bosphorus rather than the Seine, while Charlus, with whom he has been conversing, is making oriental associations of a different nature:

M de Charlus lingered a few moments more, while he said good-bye to me with a shake of my hand powerful enough to crush it to pieces – a Germanic peculiarity to be found in those who think like the Baron....Perhaps he thought that he was merely shaking my hand, as no doubt he thought that he was merely seeing a Senegalese soldier who passed in the darkness without deigning to notice that he was being admired. But in each case the Baron was mistaken, the intensity of contact and of gaze was greater than propriety permitted. 'Don't you see all the Orient of Decamps and Fromentin and Ingres and Delacroix in this scene?' he asked me, still immobilized by the passage of the Senegalese. 'As you know, I for my part am interested in things and in people only as a painter, a philosopher. Besides, I am too old. But how unfortunate that to complete the picture one of us two is not an odalisque!'

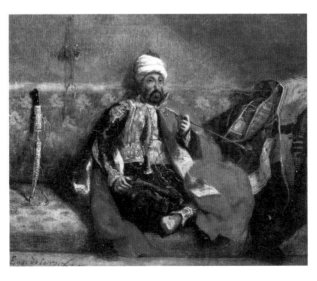

Turk, Smoking on a Divan, Eugène Delacroix, 1825

Falcon Hunting in Algeria: The Quarry, Eugène Fromentin, 1863

Attempts made at enforcing a marriage of politics and aesthetics have yielded disastrous consequences throughout history. The Narrator ponders this as he looks at pictures in the Guermantes' library and attempts to put the war in perspective:

The idea of a popular art, like that of a patriotic art, if not actually dangerous, seemed to me ridiculous. If the intention was to make art accessible to the people by sacrificing the refinements of form, on the ground that they are 'all right for the idle rich' but not for anyone else, I had seen enough of fashionable society to know that it is there that one finds real illiteracy and not, not, let us say, among electricians. In fact, an art that was 'popular' so far as form was concerned would have been better suited to the members of the Jockey Club than to those of the General Confederation of Labour – as for subject, the working classes are as bored by novels of popular life as children are by the books which are written specially for them. When one reads, one likes to be transported into a new world, and working men have as much curiousity about princes as princes about working men. At the beginning of the war M. Barrès had said that the artist (he happened to be talking about Titian) must first and foremost serve the glory of his country. But this he can do only by being an artist, which means only on the condition that, while in his own sphere he is studying laws, conducting experiments, making discoveries which are as delicate as those of science, he shall think of nothing – not even his country – but the truth which is before him. Let us not imitate the revolutionaries who out of 'civic sense' despised, if they did not destroy, the works of Watteau and de La Tour, painters who have brought more honour upon France than all those of the Revolution.

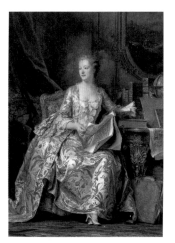

Madame de Pompadour,
Maurice-Quentin de La Tour, 1755

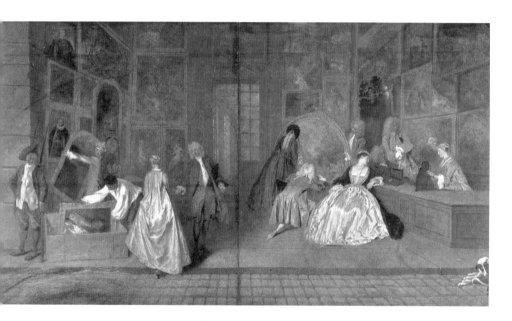

Gersaint's Shop Sign, Antoine Watteau, 1720

Having left Paris, and returned once more, the Narrator receives an invitation to a musical afternoon from the Princesse de Guermantes. Arriving at her house while a performance is in progress, he is asked to wait in the library until the piece is finished. As he studies the books surrounding him, he mentally fashions a room of his own design:

The library which I should thus assemble would contain volumes of an even greater value; for the books which I read in the past at Combray or in Venice, enriched now by my memory with vast illuminations representing the church of Saint-Hilaire or the gondola moored at the foot of San Giorgio Maggiore and the Grand Canal incrusted with sparkling sapphires, would have become the equals of those ancient 'picture books' – illustrated bibles or books of hours – which the collector nowadays opens not to read their text but to savour once more the enchantment of the colours which some rival of Foucquet has added to it and which make these volumes the treasures that they are.

St John at Patmos, from *The Book of Hours of Étienne Chevalier*, Jean Foucquet, 1455

The Narrator goes on to contemplate the relationship between an artist's motivation and the public's reception of works of art. He acknowledges the difficulty most people have in accepting what is inexpressible in art, and the lengths they go to in order to talk about something else. Just as they approach codifying an aesthetic experience, something new emerges:

T hen presently, whether it be in music or in literature or in painting, other works come along, works that may even be the very opposite of the ones which they supersede. For the ability to launch ideas and systems – and still more of course the ability to assimilate them – has always been much commoner than genuine taste, even among those who themselves produce works of art, and with the multiplication of reviews and literary journals (and with them of factitious vocations as writer or artist) has become very much more widespread. Not so long ago, for instance, the best part of the younger generation, the most intelligent and the most disinterested of them, through a change of fashion admired nothing but works with a lofty moral and

Resurrection of the Dead (detail),
Paul-Marc-Joseph Chenavard, 1845

sociological, and even religious, significance. This they imagined to be the criterion of a work's value, renewing the old error of David and Chenavard and Brunetière and all those who in the past thought like them.... The truth is that as soon as the reasoning intelligence takes upon itself to judge works of art, nothing is any longer fixed or certain: you can prove anything you wish to prove.

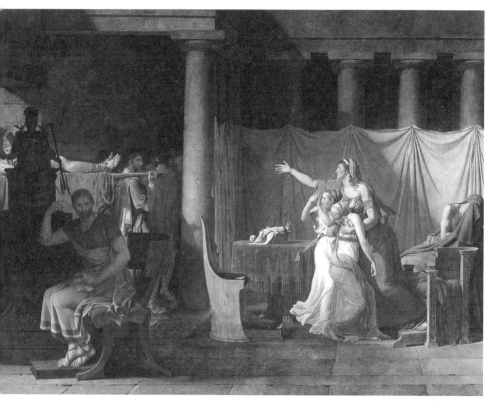

The Lictors Returning to Brutus the Bodies of His Dead Sons, Jacques-Louis David, 1789

Going to an afternoon tea party at the home of Mme de Guermantes strikes the Narrator as a frivolous pleasure, but one in which he indulges, believing himself beyond any serious capacity for work. Yet, sequestered in the library, he finally hears the first rumblings within himself of a writer's voice. He attempts to place himself in the spectrum of artistic endeavour:

T hrough art alone are we able to emerge from ourselves, to know what another person sees of a universe which is not the same as our own and of which, without art, the landscapes would remain as unknown to us as those that may exist on the moon. Thanks to art, instead of seeing one world only, our own, we see that world multiply itself and we have at our disposal as many worlds as there are original artists, worlds more different one from the other than those which revolve in infinite space, worlds which, centuries after the extinction of the fire from which their light first emanated, whether it is called Rembrandt or Vermeer, send us still each one its special radiance.

A Woman Bathing in a Stream (Hendrickje Stoffels?), Rembrandt (Harmensz.) van Rijn, 1654

Woman Holding a Balance, Jan Vermeer, 1662–63

Self-Portrait at the Age of Sixty-Three,
Rembrandt (Harmensz.) van Rijn, 1669

Memories of his love for Albertine flood the Narrator. He senses that there is a profound connection between suffering and the creative impulse:

For if unhappiness develops the forces of the mind, happiness alone is salutary to the body. But unhappiness, even if it did not on every occasion reveal to us some new law, would nevertheless be indispensable, since through its means alone we are brought back time after time to a perception of the truth and forced to take things seriously, tearing up each new crop of the weeds of habit and scepticism and levity and indifference. Yet it is true that truth, which is not compatible with happiness or with physical health, is not always compatible even with life. Unhappiness ends by killing. At every new torment which is too hard to bear we feel yet another vein protrude, to unroll its sinuous and deadly length along our temples or beneath our eyes. And thus gradually are formed those terrible ravaged faces, of the old Rembrandt, the old Beethoven, at whom the whole world mocked. And the pockets under the eyes and the wrinkled forehead would not matter much were there not also the suffering of the heart.

The time has come to join the party. Entering the sumptuous rooms, the Narrator is taken aback. Why is everyone wearing a disguise? Slowly he begins to recognize faces rather than masks, and realizes that this generation of elegant Parisians has aged considerably:

T he Marquis de Beausergent, whom I had seen, as a young lieutenant, in Mme de Cambremer's box on the day on which Mme de Guermantes had been with her cousin in hers, still had the same perfectly regular features, indeed they had become even more regular, since the pathological rigidity brought about by arteriosclerosis had even further exaggerated the impassive rectitude of his dandy's physiognomy and given to his features the intense hardness of outline, almost grimacing in its immobility, that they might have had in a study by Mantegna or Michelangelo. His complexion, once almost ribaldly red, was now solemnly pale; silvery hair, a slight portliness, the dignity of a Doge, an air of fatigue, even of somnolence, all combined to give him a new and premonitory impression of doomed majesty.

Cardinal Ludivico Trevisan,
Andrea Mantegna, 1459

Damned Soul, Michelangelo, 1525

As he makes his way through the assembled guests, the Narrator relies on the Duchesse de Guermantes to help him identify both people he knows and those he has not yet met. A young woman lying on a chaise-longue catches his attention. Mme de Sainte-Euverte is the wife of a great-nephew of a woman the Narrator knew long ago. She merely nods her head to the Duchesse and the Narrator:

As for the great-niece, I do not know whether it was owing to some malady of the stomach or the nerves or the veins, or because she was about to have or had just had a child or perhaps a miscarriage, that she lay flat on her back to listen to the music and did not budge for anyone. Very probably she was simply proud of her magnificent red silks and hoped on her *chaise longue* to look like Mme Récamier.

Madame Récamier, Jacques-Louis David, 1800

The afternoon has stimulated the Narrator to forge a new dedication to the writing life. The time has come for him to get to work. Only now he wonders, Is it too late? Mortality presents a new challenge to him:

Yet it was precisely when the thought of death had become a matter of indifference to me that I was beginning once more to fear death, under another form, it is true, as a threat not to myself but to my book, since for my book's incubation this life that so many dangers threatened was for a while at least indispensable. Victor Hugo says:

Grass must grow and children must die.

To me it seems more correct to say that the cruel law of art is that people die and we ourselves die after exhausting every form of suffering, so that over our heads may grow the grass not of oblivion but eternal life, the vigorous and luxuriant growth of a true work of art, and so that thither, gaily and without a thought for those who are sleeping beneath them, future generations may come to enjoy their *déjeuner sur l'herbe*.

Le Déjeuner sur l'herbe, Édouard Manet, 1863

Faced with the prospect of starting a new work, a new life, the Narrator pays homage to those artists and artworks that so inspired him. He recognizes at the same time the imperative of letting go of them in order to make his own mark:

B ut – as Elstir found with Chardin – you can make a new version of what you love only by first renouncing it.

Self-Portrait, Jean-Baptiste-Siméon Chardin, 1775

Marcel Proust on his Deathbed, Paul Helleu, 1922

NOTES

Unless otherwise indicated, works are oil on canvas. Dimensions are given wherever possible and are expressed in metric followed by imperial units (centimetres followed by inches, unless identified by different units), in the order of height by width. For the system of page references to *In Search of Lost Time*, see the explanatory note at the start of the index. All translations in quoted passages are the work of the author unless otherwise indicated.

p. 2 Marcel Proust (standing, centre) at an open-air luncheon party. Photo Mante-Proust Collection.

p. 3 Paolo Caliari, called Veronese (1528–1588), *The Wedding at Cana* (detail), 1562–63; 6.7 × 9.9 m (21 ft 10 in. × 32 ft 6 in.). Musée du Louvre, Paris.

p. 8 Jan Vermeer (1632–1675), *View of Delft* (detail), 1659–60; 96.5 × 115.7 (38 × 45⅝). Mauritshuis, The Hague.

INTRODUCTION

p. 11 Andrea Mantegna (1431–1506), *St James Led to Execution*, from *Martyrdom of St James*, 1450–54; fresco. Ovetari Chapel, Chiesa degli Eremitani, Padua (destroyed). See note to p. 67.

p. 12 Sandro Botticelli (1444–1510), *The Birth of Venus*, 1482–86; tempera on canvas, 172 × 278 (67¹¹⁄₁₆ × 109⁷⁄₁₆). Galleria degli Uffizi, Florence. See note to pp. 62–63.

p. 13 Édouard Manet, (1832–1883), *Asparagus (L'Asperge)*, 1880; 15.9 × 21 (6¼ × 8¼). Musée d'Orsay, Paris.

p. 14 Jean-Baptiste-Siméon Chardin (1699–1779), *Still Life with Jar of Olives*, 1760; 71 × 98 (27¹⁵⁄₁₆ × 38⁷⁄₁₆). Musée du Louvre, Paris.

p. 15 Jean-Baptiste-Camille Corot (1796–1875), *Chartres Cathedral*, 1830; 65.1 × 49.8 (25⅝ × 19⅝). Musée du Louvre, Paris.

 The town and cathedral of Chartres, dear to Proust, played a significant role in the formation of the sentimental landscape in and around Combray. Corot's painting of the cathedral appeared on the short list of works selected by Proust in 1920 in response to a request by the weekly journal *L'Opinion* to name the best French paintings. In *Jean Santeuil*, Proust's unfinished novel, Corot's work had a more vivid and substantial presence.

p. 17 John Everett Millais (1829–1896), *John Ruskin*, 1853–54; 78 × 68 (30¹¹⁄₁₆ × 26¾). Private Collection.

p. 18 Claude Monet (1840–1926), *Water Lilies (Nymphéas)*, 1907; diameter 81 (31⅞). Private Collection.

p. 20 Antoine Watteau (1684–1721), *The Embarkation for Cythera*, 1717; 129 × 194 (51 × 76½). Musée du Louvre, Paris. Little of substance is known about the short life of the Flemish-French artist Watteau. He died at the age of 37, yet within his own lifetime he was celebrated as a great draughtsman and painter. Watteau essentially created a new genre of painting that came to be known as the *fête galante*, erotically charged pictures of elegant women and men strolling through idyllic landscapes, cavorting and flirting, but also reflecting and brooding. The eighteenth-century Parisian world of theatre, opera and music in which Watteau flourished is highly reminiscent of the vibrant nineteenth-century period that made up Proust's formative milieu. Under the guise of apparent languor, both Proust and Watteau intently observed the intimate maladies of love in their myriad, complex manifestations. Proust credited Watteau with being the first to paint *l'amour moderne*.

 During and immediately after the French Revolution, mob sentiments against anything suggestive of aristocratic privilege destroyed all aesthetic considerations. In the École des Beaux-Arts during the Revolutionary era, Watteau's *Embarkation* served as a target for pellets of bread from the drawing students, and pellets of clay from the sculptors. Proust has Elstir's thoughts about the destruction of eighteenth-century elegance plant a seed, which later blossoms in the Narrator's mind as his defence against the idea of 'popular art'. See note to p. 311.

p. 22 Jean-Auguste-Dominique Ingres (1780–1867), *Odalisque and Slave*, 1842; 76 × 105.4 (29¹⁵⁄₁₆ × 41½). Walters Art Gallery, Baltimore.

p. 23 Sandro Botticelli (1444–1510), *The Trials of Moses*, from *Episodes from the Life of Moses* (detail), 1481–82; fresco. Sistine Chapel, Vatican. See note to pp. 62–63.

p. 25 Vittore Carpaccio (1460–1525), *Apotheosis of St Ursula*, 1491; 4.81 × 3.36 m (15 ft 8½ in. × 11 ft). Gallerie dell'Accademia, Venice.

p. 27 James Abbott McNeill Whistler (1834–1903), *Arrangement in Grey and Black No. 2: Portrait of Thomas Carlyle*, 1872–73; 171 × 143.5 (67⅛ × 56½). Glasgow Art Gallery and Museum.

The following works are quoted in the Introduction:
 p. 10 Marcel Proust, *Correspondence*, ed. Philip Kolb (Paris: Plon, 1993), vol. XII, p. 222; **p. 14** Lawrence Gowing, *Vermeer* (New York: Harper and Row, 1952, repr. 1970), pp. 27–28, 38; **p. 17** John Berger, 'The Eyes of Claude Monet', in his *Selected Essays* (New York: Pantheon Books, 2001), p. 424; **p. 18** Marcel Proust, quoted in Kazuyoshi Yoshikawa, 'Proust et les nymphéas de Monet', *Bulletin Marcel Proust* 48 (1998), 77–93, at 89; Jean-Yves Tadié, *Marcel Proust*, tr. Euan Cameron (New York: Viking, 2000), p. 210; **p. 19** Paul Valéry, 'Autour de Corot (About Corot)', *Vingt Estampes de Corot* (Paris:

Éditions des Bibliothèques Nationales, 1932);
p. 20 Marcel Proust, *On Art and Literature*, tr.
Sylvia Townsend Warner (London: Chatto
& Windus, 1957), p. 319; John Hollander,
The Gazer's Spirit (Chicago: University Chicago
Press, 1995), p. 6; **p. 21** Marcel Proust, *Contre
Sainte-Beuve précédé de Pastiches et mélanges et suivi
de Essais et articles*, ed. Pierre Clarac and Yves
Sandre (Paris: Pléiade, 1971), p. 617; Jacques
Rivière, quoted in *Marcel Proust: l'écriture et les arts*,
ed. Jean-Yves Tadié, (Paris: Bibliothèque
Nationale de France, 1999), p. 273; Maurice
Barrès, quoted in Walter Benjamin, *Illuminations*,
tr. Harry Zohn (New York: Schocken Books,
1968), p. 209; Anatole Broyard, 'Yesterday's
Gardenia', *New York Times*, 5 August, 1974, p. 21;
p. 22 Colette, quoted in Edmund White,
Marcel Proust (New York: Viking, 1999), p. 6;
p. 26 George Painter, *Marcel Proust* (New York:
Random House, 1959), vol. 2, p. 29.

VOLUME I: **Swann's Way**
p. 28 Pieter de Hooch (1629–1684), *The Mother* (detail),
c. 1670; 92 × 100 (36 ¹/₄ × 39 ⁶/₁₀).
Gemäldegalerie, Staatliche Museen, Berlin.
p. 31 Carlo Lasinio (1796–1855), after Benozzo
Gozzoli, *The Sacrifice of Abraham*, *c.* 1806;
engraving. Galleria degli Uffizi, Florence.

In the fifteenth century, Benozzo Gozzoli was
commissioned to paint a series of frescoes on
the life of the patriarch Abraham at the Campo
Santo in Pisa. Gozzoli's *Sacrifice of Abraham*
illustrated the Old Testament story in which
God tested Abraham's faith by demanding the
sacrifice of his son Isaac. Standing in the hallway
in his white nightshirt and turbaned scarf, the
Narrator's father resembles Abraham as he
appears in Gozzoli's fresco and in the engraving
of the fresco that has been given to the Narrator
by Charles Swann. But unlike Abraham, the
Narrator's father has suddenly and unexpectedly
dismissed any idea of sacrifice. He decrees,
to the contrary, that mother and son shall be
allowed to remain together. A figure in a painting
inexplicably comes to life before the eyes of the
Narrator and, at the same moment, his internal
state shifts from one of misery to one of joy.
The mystery of the unpredictable, transformative
power of pictures is thus revealed to the
impressionable boy.
The young Narrator watches the light
of his father's candle dwindle and fade as his
father walks off to bed. The adult Narrator tells
us that the wall of this very hallway was long
ago demolished, 'and in myself, too, many things
have perished which I imagined would last
forever'. Like Roman copies of Greek bronzes,
nineteenth-century engravings after Renaissance
paintings are often all that remain to inform
us of lost original works of art. The Gozzoli

frescoes of the life of Abraham were largely
destroyed after Proust's death, as the result
of an Allied bombing raid during the Second
World War.
p. 32 Hubert Robert (1733–1808), *View of a Park with
a Water Fountain*, 1783; 168 × 59.5 (66 ¹/₈ × 23 ⁷/₁₆).
Musée du Louvre, Paris.

Robert was a painter, curator and architect
who organized the vast collections of the
Louvre into a cohesive body during France's
tumultuous eighteenth century. He made
paintings of the museum's interiors that show
how the Louvre looked during this period as
it navigated the official change of status from
royal collection to public museum. Proust read
Robert's paintings of fountains as images of
creative and sexual energies, interpretations
certainly outside the expectations and
comprehension of the Narrator's grandmother.
p. 33 Joseph Mallord William Turner (1775–1851),
Vesuvius Erupting, 1817; watercolour on paper,
28.6 × 39.7 (11 ¹/₄ × 15 ⁵/₈). Yale Center for
British Art, New Haven, Connecticut.

Turner was highly esteemed by the English
critic John Ruskin, through whose writings
Proust began to develop a mature aesthetic
in the late 1890s. The symbolism of the English
painter's oils, watercolours and drawings of
Vesuvius spewing fire had a decided impact
upon the young Ruskin, who wrote about a print
of the volcano that was his first exposure to
Turner: 'I used to feast on that engraving every
evening for months, and return to it again and
again for years, before I knew anything either
about drawing, or Turner, or myself…it proves
irrefutably that Turner was reserving his power,
while he made all these tender and beautiful
drawings; that he had already within himself
the volcano of fiercer fire' (*À la recherche du
temps perdu*, ed. Jean-Yves Tadié, 4 vols. (Paris:
Gallimard, 1987), 1.1117). Proust experienced
the impact of these pictures vicariously, and
he understood the image of a volcano belching
molten lava to be, in one sense, a portrait of
the artist as a young man.
p. 34 Raphael Morghen (1758–1833), after Leonardo
da Vinci, *The Last Supper*, 1800; etching and
engraving, 65.6 × 103.3 (40 ¹¹/₁₈ × 66 ¹/₈). The Leo
Steinberg Collection, Blanton Museum of Art,
The University of Texas at Austin.

Based in Florence, Morghen made a career
of copying masterworks, and this engraving
of *The Last Supper*, commissioned by the Duke
of Tuscany, was one of his most commercially
successful. By the time he made it, however,
the fifteenth-century fresco had already been
considerably restored. Nevertheless, Morghen's
work was instrumental in disseminating
Leonardo's powerful image into the culture
at large and establishing its iconic status. The art

historian Leo Steinberg, in whose personal collection this engraving was once found, made the claim that 'no good home' in the nineteenth century was without an impression of this print. Proust certainly came to know *The Last Supper* through such an engraving.

p. 35 Giovanni Battista Piranesi (1720–1778), *View of the Piazza del Popolo* from *Views of Rome (Vedute di Roma)*, 1750; etching. Metropolitan Museum of Art, New York.

p. 36 Giotto di Bondone (1266–1336), *Charity*, 1304–6; fresco. Scrovegni Chapel (also called Madonna dell'Arena Chapel), Padua.

p. 39 Giotto di Bondone (1266–1336), *Envy* and *Justice*, 1304–6; fresco. Scrovegni Chapel (also called Madonna dell'Arena Chapel), Padua.

Painted very early in the fourteenth century, Giotto's series of frescoes for the Scrovegni Chapel in Padua is the most singular example of artistic innovation during the dawn of European painting. Built on the site of a former Roman amphitheatre, the single-nave church is also known as the Arena Chapel.

In 1900, as a pilgrim following in Ruskin's footsteps, Proust visited the chapel with the Venezuelan-born composer Reynaldo Hahn. Years later, as he worked on his novel, Proust often had his Library Edition of John Ruskin near to hand, open to the photographs of these images from Padua. *Charity*, according to Ruskin, was the most remarkable of the series.

Giotto painted seven Virtues (Justice, Prudence, Courage, Temperance, Hope, Faith and Charity) and seven Vices (Folly, Inconstancy, Anger, Injustice, Infidelity, Envy and Despair) in muted monochromes, and they read as isolated bas-relief sculptures underneath the more complex narrative scenes overhead. Knowing the plates primarily from Ruskin's book, Proust was far more familiar with the Vices and Virtues than with the rest of the chapel's deeply hued wall paintings, but it is also characteristic of him to have fashioned literary gold from the lesser metals of so colourful a mine. The hold of these images upon Proust was so strong that at one point in time he considered using 'The Vices and Virtues of Padua and Combray' as a subtitle for a section of his burgeoning novel.

p. 41 Gentile Bellini (1429–1507), *The Sultan Mehmet II*, 1480; 69.9 × 52.1 (27 ½ × 20 ½). National Gallery, London.

Gentile Bellini returned to Venice from a stay in Istanbul and brought back with him his portrait of the Ottoman Sultan Mehmet II. The picture became widely known and it exerted a strong orientalizing influence on Venetian painting at the time. Proust's allusion to it here similarly introduces into the novel the exotic personage of the Jew in French society, as revealed not only in Bloch but in Swann himself as well. And while others, aware of Proust's mother's cultural heritage, certainly considered the writer to be Jewish, he himself had no such self-identification. An occasional churchgoer, Proust never denied his ancestry and took an early, public stand in support of Alfred Dreyfus, the Jewish artillery officer wrongly convicted of treason in 1896. Proust was determined to see justice enacted, even at the risk of banishment from certain anti-Semitic social circles.

p. 43 Hubert Robert (1733–1808), *The Cenotaph of Jean-Jacques Rousseau in the Tuileries, Paris*, 1794. Musées de la Ville de Paris, Musée Carnavalet, Paris.

p. 45 Charles Gleyre (1806–1874), *Lost Illusions (Le Soir)*, 1843; 156.5 × 238 (61 ⅝ × 93 ¹¹/₁₆). Musée du Louvre, Paris.

p. 46 Gentile Bellini (1429–1507), *Procession in Piazza San Marco*, 1496; 3.67 × 7.45 m (12 ft ½ in. × 24 ft 10 in.). Gallerie dell'Accademia, Venice.

p. 47 Vittore Carpaccio (1460–1525), *St George Baptizing the Selenites*, 1507; 139 × 285 (54 ¾ × 112 ¹/₁₆). Scuola di San Giorgio degli Schiavone, Venice.

The bustling, densely composed canvases of this Venetian painter exerted a particularly strong charm on Proust, who claimed to prefer his pictures to those of almost any other painter. Proust's initial exposure to Carpaccio most likely came from reading Ruskin. In this, the novel's first reference to Carpaccio, Wagner, Baudelaire and Carpaccio form an intimate pantheon of artists, held aloft as an example of refinement and complexity, exuding, like Mme de Guermantes herself, *un épiderme de lumière*.

p. 49 Pieter de Hooch (1629–1684), *The Mother*, 1670; 92 × 100 (36 ¼ × 39 ⅜). Gemäldegalerie, Staatliche Museen, Berlin.

pp. 50 and 53 Sandro Botticelli (1444–1510), *The Trials of Moses* (detail), from *Episodes from The Life of Moses*, 1481–82; fresco. Sistine Chapel, Vatican.

In Swann's erudite mind, Vermeer may hold sway, but in his heart the Florentine Botticelli prevails, creator of the image he was to carry with him forever after the occasion of this second visit to Odette's house. As if from nowhere, he has been struck by her distinct resemblance to Zipporah, Moses's wife, the daughter of Jethro, rendered by Botticelli on the walls of the Sistine Chapel.

In *Mornings in Florence*, Ruskin wrote, 'Well, yes, Botticelli is affected, in the way that all men in that century necessarily were. Much euphemism, much studied grace of manner, much formal assertion of scholarship, mingling with his force of imagination' (*The Works of John Ruskin*, ed. E. T. Cook and Alexander Wedderburn (London: George Allen 1903–12), vol. XXIII). Ruskin could be describing Swann. Proust owned a copy of *Mornings in Florence* with

a frontispiece of Ruskin's own watercolour study of Zipporah.

p. 54 Jacopo Tintoretto (1518–1594), *Self-Portrait*, 1588; 65 × 52 (25 ¹/₂ × 20 ¹/₂). Musée du Louvre, Paris.

p. 55 Domenico Ghirlandaio (1449–1494), *Portrait of an Old Man and a Young Boy*, 1490; oil on wood, 157.5 × 116.8 (62 × 46). Musée du Louvre, Paris.

Writing in his memoir, Lucien Daudet recalled how, as a young man, he had stood with Proust in front of Ghirlandaio's double portrait at the Louvre, and how Proust had commented that the old man with the polyps on his nose resembled the Marquis de Lau, a consummate aristocrat known to them both. (*Autour de soixante lettres de Marcel Proust* (Paris: Gallimard, 1929) pp. 18–19.) This seemingly frivolous game, where people in pictures are identified with living acquaintances and people seen in the world echo figures in pictures, reveals Proust's intensely creative powers of observation. The fluidity of access to overlapping realities of life and art, and the willingness to swim between them, were integral aspects of Proust's consciousness.

p. 57 Antoine Watteau (1684–1721), *Five Studies of the Face and Bust of a Woman*, c. 1713; drawing. Musée du Louvre, Paris.

p. 59 Rembrandt (Harmensz.) van Rijn (1606–1669), *The Night Watch*, 1642; 363 × 437 (142 ¹⁵/₁₆ × 172 ¹/₁₆). Rijksmuseum, Amsterdam.

Proust might well have seen Rembrandt's *The Night Watch* in Paris, where it was on temporary exhibit in 1898, but he certainly would have seen it on one, if not both, of his two inspirational visits to Holland. The first of these trips was also in 1898, when he travelled there to take in an exhibition of 120 Rembrandts in Amsterdam. He returned again in 1902, travelling with his friend Bertrand de Fénelon. On this latter trip, Proust also visited Haarlem in order not to miss the Halsmuseum (a fate to which he condemns his Narrator). These two voyages considerably swelled the novelist's already teeming library of visual images, and bits and pieces of Dutch paintings ultimately came to suffuse his entire novel. In the pages of *In Search of Lost Time*, scenes from these trips to Holland re-emerge, transformed and superimposed on France.

When Biche, the painter of Mme Verdurin's clan, exclaims vehemently against the work of another artist, Proust puts into his mouth a vivid criticism he had heard levelled at the contemporary Spanish painter José Maria Sert: 'Sert peint avec de l'or et de la merde.' ('Sert paints with gold and with shit.') Sert is referred to by name later in the novel, in connection with the Ballets Russes.

p. 61 Gustave Moreau (1826–1898), *The Apparition* (detail), 1876; watercolour on paper, 142 × 103 (55 ⁷/₈ × 40 ⁹/₁₆). Musée Gustave Moreau, Paris.

Many times a painter will be hailed by Proust as one of his personal favourites, and such a claim is made by him about Moreau. The symbolist painter was the subject of an early essay by Proust, written in 1898. Moreau's *œuvre* serves as one source of inspiration for what were to become the early paintings of Elstir.

p. 62a Sandro Botticelli (1444–1510), *Venus Presenting Flowers to a Youth Accompanied by the Graces* (detail), 1486; fresco. Musée du Louvre, Paris.

p. 62b Sandro Botticelli (1444–1510), *Madonna of the Pomegranate*, c. 1487; tempera on wood, diameter 143.5 (56). Galleria degli Uffizi, Florence.

p. 63 Sandro Botticelli (1444–1510), *Primavera*, 1482; tempera on wood, 203 × 314 (79 ⁷/₈ × 123 ⁵/₈). Galleria degli Uffizi, Florence.

Proust's familiarity with these paintings comes from his immersion in monographs and periodicals as well as the descriptions of art historians, critics and friends. He never travelled to the Vatican or to Tuscany. Florence, home of the great Sandro Botticelli and a tempting destination for a Ruskinian pilgrim, was always associated with flowers and fragrance in Proust's mind, and therefore to be avoided at all costs due to his vulnerable asthmatic condition. 'When I thought of Florence', Proust wrote in *Swann's Way*, 'it was of a town miraculously scented and flower-like, since it was called the City of the Lilies, and its cathedral, Our Lady of the Flower.' (§I.467, *I.552, †I.381)

p. 65 Sebastiano del Piombo (1485–1527), *The Martyrdom of St Agatha*, 1520; oil on wood, 127 × 178 (50 × 70 ¹/₁₆). Pitti Palace, Florence.

p. 66 Albrecht Dürer (1471–1528), *St George*, Paumgartner altar, 1503; oil on wood, 157 × 61 (61 ¹³/₁₆ × 24). Pinakoteca, Munich. Andrea Mantegna (1431–1506), San Zeno altarpiece, right-hand panel (detail), 1457–60; oil on wood. Basilica di San Zeno, Verona.

p. 67 Andrea Mantegna (1431–1506), *St James Led to Execution* (detail), from *Martyrdom of St James*, 1450–54; fresco. Ovetari Chapel, Chiesa degli Eremitani, Padua (destroyed).

Mantegna was born and raised in Padua, known as *Patavium* during the Roman period. His life-long study of the remains of antiquity surfaced in his own painted figures, which have been criticized for their statue-like severity and bloodlessness. Proust perfectly captures this quality in describing the fleet of Mantegna-like manservants attending to Swann during the extended description of his entrance up the majestic stairs into the Saint-Euvertes' party. Just as the 'tall, magnificent, idle footmen' pull Swann into the festivities, so does Proust's narrative force evoke Mantegna's manipulation

of perspective, pulling the viewer in to participate in what art historian Lawrence Gowing calls 'the fatal system of the picture' ('Mantegna' in *Andre Mantegna*, exhibition catalogue ed. Jane Martineau, (London: Olivetti/Electa, 1992) pp. 1–6, at p. 2).

It was on a visit to Padua with Reynaldo Hahn in May 1900 that Proust saw the monumental series of Mantegna frescoes, just a few hundred yards from Giotto's Scrovegni Chapel. *The Martyrdom of St James* is 'one of the paintings I love best in the world', he wrote to his erstwhile mentor Robert de Montesquiou (quoted in Painter, *Marcel Proust*, vol. 1, p. 272). Sadly, Swann's vivid memory of this fresco cycle from the Eremitani, 'where he had come in contact with it and where it still dreams', is not the modern experience of the paintings. Another terrible casualty of the Second World War, most of these majestic frescoes were destroyed by Allied bombs in 1944. Only fragments remain today.

p. 69 Giotto di Bondone (1266–1336), *Injustice*, 1304–6; fresco. Scrovegni Chapel (also called Madonna dell'Arena Chapel), Padua.

p. 70 Jan Vermeer (1632–1675), *Diana and her Companions*, 1653–54; 97.8 × 104.6 (38 ¹/₂ × 41 ³/₁₆). Mauritshuis, The Hague.

This painting was put up for auction in 1876 as part of the sale of Neville Goldschmidt's collection in Paris, and it was sold to the distinguished museum at The Hague, the Mauristhuis. That same year, the picture was attributed to the painter Nicolaes Maes. By 1891, however, there was considerable speculation about the painting actually being a very early Vermeer. There were questions about a false signature by Maes on the canvas, and the possibility of an obscured signature reading 'Ver Meer' or 'Van der Meer'.

Proust would have read about the controversy and he made spectacular use of it in his novel, as fuel not only for Swann's scholarly curiosity but also for his anxieties about leaving Paris. To travel to The Hague in order to make an assessment of the painting would mean leaving Odette behind unattended, which would inflame Swann's chronic fears of her being unfaithful to him with other women. To make matters worse, careful study of this particular painting would only intensify his emotional insecurity; the viewer of the picture is put in the position of Actaeon unexpectedly coming upon Diana in the relaxed company of several attractive, attentive females.

p. 72 Jean-Baptiste Auguste Leloir (1809–1892), *A Portrait of Two Boys With a Sketchbook*, 1896. 157.5 × 113.7 (62 × 44 ¼). Private Collection.

p. 73 Jules Machard (1839–1900), *Young Woman in an Evening Dress with Hydrangeas*, 1896. Private Collection.

p. 75 Fra Giovanni da Fiesole, called Fra Angelico (1387–1455), *Coronation of the Virgin*, 1434; tempera on wood, 112 × 114 (44 ¹/₈ × 44 ⁷/₈). Galleria degli Uffizi, Florence.

p. 77 Giotto di Bondone (1266–1336), *The Sacrifice of Joachim* and *The Dream of Joachim*, 1304–6; fresco. Scrovegni Chapel (also called Madonna dell'Arena Chapel), Padua.

p. 79 Nicolas Poussin (1594–1665), *Spring, or The Earthly Paradise*, 1660; 118 × 160 (46 ¹/₂ × 63). Musée du Louvre, Paris.

p. 81 Constantin Guys (1805–1892), *Promenade in the Woods*, after 1860; pen, ink and watercolour on paper. Musée des Arts Décoratifs, Paris.

p. 83 Michelangelo (1475–1564), *Creation of the Planets* (detail), Sistine Chapel ceiling, 1511; fresco. Sistine Chapel, Vatican.

VOLUME II: **Within a Budding Grove**

p. 84 Giotto di Bondone (1266–1336), *Wedding Procession of the Virgin* (detail), 1304–6; fresco. Scrovegni Chapel (also called Madonna dell'Arena Chapel), Padua.

p. 87 Tiziano Vecelli, called Titian (1485–1576), *The Assumption of the Virgin*, 1516–18; oil on panel, 6.9 × 3.6 m (22 ft 7 ⁹/₁₆ in. × 1 ft 9 ¼ in.). Basilica dei Frari, Venice.

The greatest praise the Narrator can think of to bestow upon the actress known as 'La Berma' involves the invocation of two formidable Venetian painters. They act as a gold standard, upholding 'la valeur exacte de Beau', 'the precise value of Beauty'. However, Titian and Carpaccio exert separate and distinct claims on Proust. Although there are a nearly equal number of references to each artist distributed throughout the book – Carpaccio is mentioned eleven times, Titian, fourteen – Proust uses the painterly styles of each to different literary ends. With a notable exception (see p. 139), Titian comes to represent the consummate accomplishment of pictorial excellence, while the paintings of Carpaccio seem to flow into the very bloodstream of the novel. In almost all cases, Titian's refined and masterful images are inserted as supreme representations of art and beauty. His pictures provide pedigree; they are the aristocrats of art history. A Titian portrait of an ancestor gives Mme Villeparisis comfort – she and her necklace authenticate the Titian in which the necklace appears, and in return, the Titian authenticates her family's elevated status. By contrast, Proust uses Carpaccio's pictures to suggest warmth and sensuality, and as a conduit to the feminine. They bring to life the elegance and bustle of the heyday of the Venetian Republic, 'the Queen of the Adriatic'. In Proust's heated imagination, Carpaccio's pageantry reveals a complexity that allows both erotic associations with Albertine and

spiritual evocations of the goodness of the Narrator's mother.

p. 89 Leonardo da Vinci (1452–1519), *A 'Star of Bethlehem' and Other Plants*, 1505; pen and ink over red chalk, 19.8 × 16 (7 ¹³/₁₆ × 6 ⁵/₁₆). Royal Library, Windsor.

p. 90 Juan Gris (1887–1927), *Homage to Pablo Picasso*, 1912; 93 × 74.1 (36 ¹⁰/₁₆ × 29 ³/₁₆). The Art Institute of Chicago, gift of Leigh B. Block, 1958.525.

Proust began his novel in earnest around the same time that Picasso, barely a few miles away in Montmartre, was undermining the conventions of picture-making. As this textual reference to cubism and futurism makes clear, Proust managed from his bedroom to monitor contemporary painting as it continued to evolve in Paris, while he was beginning a gradual remove from his previously animated social and artistic life. He was aware of the young Spaniard who, having devoured the lessons of Cézanne, was striving to assume the mantle of the leader of the avant-garde. A reference made to the cubists in *The Captive* exemplifies Proust's ability to remain *au courant* – the Narrator mocks the conservative ways of Baron de Charlus, comparing him to a disciple of Monet confronting a cubist. Even Monet had become *passé*, the cutting edge had moved on, and Proust, insisting on the inevitability of this cycle, was no fool.

Picasso clocked Proust as well. He had the opportunity to observe the fur-wrapped writer savouring the close company of dukes at a party on New Year's Eve in 1921. Picasso commented to his friend Jean Hugo, 'Look at Proust; he is *sur le motif*, a knowing compliment slyly paid, equating the mastery of Proust and Cézanne over their respective subject matter. (Jean Hugo, *Le Regard de la mémoire* (Paris: Actes Sud, 1983), p. 201.) Jean Cocteau was a friend of both Picasso and Proust; he had his portrait drawn by the painter in a delicate neoclassical style. When Proust saw the drawing, he wrote of 'the great and admirable Picasso, who has concentrated all Cocteau's features into a portrait of such noble rigidity that, when I contemplate it, even the most enchanting Carpaccios in Venice tend to take a second place in my memory' (Painter, *Marcel Proust*, vol. 2, p. 341). Sydney Schiff, a wealthy English patron of the arts, attempted to have Picasso make a similar portrait drawing of Proust, but between the painter's resistance to commissioned work and Proust's probable ambivalence toward the project, coupled with his eccentric day-for-night schedule, the opportunity never presented itself.

p. 93 Fra Bartolommeo (1469–1517), *Portrait of Savonarola*, 1498; oil on wood, 47 × 31 (18 ¹/₂ × 12 ³/₁₆). San Marco, Florence.

p. 95 Benozzo Gozzoli (1420–1497), *Journey of the Magi* (detail), 1459; fresco. Palazzo Medici Riccardi, Florence.

Among the throng of worshippers in Gozzoli's Renaissance fresco, art historians have identified the Florentine noblemen Pietro and Lorenzo de Medici. In addition to identifying members of the nobility of his own day, Swann had a penchant for seeing people from all walks of life, mixing high-born and low.

p. 97 Franz Xavier Winterhalter (1805–1873), *Empress Maria Aleksandrovna*, 1857; 120 × 95 (47 × 37 ¹/₂). Hermitage, St Petersburg.

p. 99 Bernardino Luini (1480–1532), *Adoration of the Magi*, 1520–25; fresco, 222 × 165 (87 ¹/₂ × 65). Musée du Louvre, Paris.

p. 100 Leonardo da Vinci (1452–1519), *Mona Lisa (La Gioconda)*, 1503–6; oil on wood, 77 × 53 (30 ⁵/₁₆ × 20 ⁷/₈). Musée du Louvre, Paris.

p. 101 Antoine Watteau (1684–1721), *The Italian Serenade*, 1715; oil on panel, 33.5 × 27 (13 ³/₁₆ × 10 ⁵/₈). Nationalmuseum, Stockholm.

p. 103 Sandro Botticelli (1444–1510), *Madonna of the Magnificat*, 1480–81; tempera on wood, diameter 118 (46). Galleria degli Uffizi, Florence.

p. 105 Paolo Caliari, called Veronese (1528–1588), *The Crucifixion*, 1580–88; 102 × 102 (40 ³/₁₆ × 40 ³/₁₆). Musée du Louvre, Paris.

p. 106 Jean-Baptiste-Siméon Chardin (1699–1779), *Self-Portrait Wearing Spectacles*, 1771; pastel on paper, 46 × 37.5 (18 ¹/₈ × 14 ³/₄). Musée du Louvre, Paris.

p. 107 James Abbott McNeill Whistler (1834–1903), *Harmony in Pink and Grey: Valerie, Lady Meux* (detail), 1881; 193.7 × 93.5 (76 ¹/₄ × 36 ⁵/₈). Frick Collection, New York.

The Narrator, anxious about his imminent departure for Balbec, attempts to calm himself by turning his attentions to the family's devoted servant. In this affectionate observation of Françoise's skill in transforming a hand-me-down, Proust takes up two separate threads woven in his novel, those of character and style. He reveals his respect for the integrity and modesty of working-class women, and this admiration is crowned with a laurel-like reference to one of the artists he most reveres, Chardin. At the same time, Françoise's 'simple but unerring taste' is celebrated, and who better than Whistler to convey so refined a condition? Describing the ribbons on a hat, Proust fashions an aesthetic juxtaposition of the supremely humble alongside the extravagantly fashionable and, in Françoise, discovers unexpected compatibility between the two. The spirits of Chardin and Whistler are otherwise not especially harmonious, though

each held a significant position in Proust's inclusive world view. Around 1895 he wrote a study of Chardin in which he explained 'how great painters initiate us into the knowledge of, and love for, the external world, how they are those "by whom our eyes are unsealed" and in effect, opened onto the world'. There was beauty, 'where I had never imagined before that it could exist' (Jean-Yves Tadié, *Marcel Proust*, tr. Euan Cameron (New York: Viking, 2000), p. 228). When asked in 1920 by the art critic Vaudoyer to list his favourite French paintings in the Louvre, Proust included three works by Chardin among the eight pictures he selected.

The appeal of Whistler's work was sufficiently compelling for Proust to allow himself to overturn in his mind Ruskin's severe judgment against the American-born painter. Rousing himself from his sickbed on 15 June 1905, Proust got himself to the École des Beaux-Arts to view an exhibition of Whistler paintings. He described seeing the landscapes 'of Venice in turquoise, of Amsterdam in topaz, of Brittany in opal' (Ibid., p. 405). George Painter wrote in his biography of Proust that it was as if the novelist was seeing 'paintings by Elstir of the places he would never see again' (Painter, *Marcel Proust*, vol. 2, p. 38). The following week Proust wrote about Whistler to his fellow Ruskin translator, Marie Nordlinger, 'if he is not a great painter, then one has to wonder if there ever has been one' (Tadié, *Marcel Proust*, p. 405). At the time, Nordlinger was working for Charles Freer, the leading American collector of Whistler's work. Proust admired Whistler for his 'unerring taste', but he revered Chardin for his integrity.

p. 109 Jean Bourdichon (1457–1521), *Anne with Patron Saints,* from the *Great Hours of Anne of Brittany, Queen of France,* 1500–08; illuminated manuscript. Bibliothèque Nationale, Paris, ms. lat. 9474.

p. 111 Gustave Moreau (1826–1898), *Jupiter and Semele*, 1895; 212 × 118 (83 × 46). Musée Gustave Moreau, Paris.

p. 112 Tiziano Vecelli, called Titian (1485–1576), *Portrait of a Lady in White*, 1555; 103 × 88 (40 9/16 × 34 5/8). Gemäldegalerie Alte Meister, Staatliche Kunstsammlungen, Dresden.

p. 113 Eugène Carrière (1849–1906), *Lady Leaning her Elbows on a Table*, 1893; 66 × 54 (29 × 23 1/2). Hermitage, St Petersburg.

p. 114 Armand Guillaumin (1841–1927), *Environs of Paris*, c. 1890; 74 × 93 (29 1/8 × 36 5/8). Private Collection.

p. 115 Albrecht Dürer (1471–1528), *The Adoration of the Magi*, 1504; oil on wood, 99 × 113.5 (38 1/2 × 44 1/4). Galleria degli Uffizi, Florence.

p. 117 Rembrandt (Harmensz.) van Rijn (1606–1669), *Philosopher in Meditation*, 1632; oil on wood, 28 × 34 (11 × 13 1/2). Musée du Louvre, Paris.

p. 119 Antonio Pisano, called Pisanello (1395–1455), *Female Winter Duck Swimming*, 1434–45; coloured drawing, 14 × 21.4 (5 1/2 × 8 7/16). Musée du Louvre, Paris.

p. 121 James Abbott McNeill Whistler (1834–1903), *Crepuscule in Opal, Trouville*, 1865; 35 × 46 (13 1/4 × 18 1/8). Toledo Museum of Art, Ohio, gift of Florence Scott Libbey, 1923.20.

There is an actual Whistler canvas entitled *Harmony in Pink and Grey* (see p. 107), but it is a portrait, whereas the 'Harmony in Grey and Pink' described here is a seascape. This is the first of several Whistlerian titles that are sprinkled throughout the novel, evoking the seascapes and portraits of the Chelsea master. In *The Guermantes Way*, there is a reference to a 'gulf of opal painted by Whistler in his "Harmonies in Blue and Silver"' and in *Sodom and Gommorah* there is a '"Harmony in Black and White" by Whistler'. Just as he fashioned his characters as pastiches of real people, Proust created paintings evocative of real canvases, many derived in form and title from Whistler.

p. 123 Giotto di Bondone (1266–1336), *Wedding Procession of the Virgin*, 1304–6; fresco. Scrovegni Chapel (also called Madonna dell'Arena Chapel), Padua.

p. 125 William Hogarth (1697–1764), *John and Elizabeth Jeffreys and their Children* (detail), 1730; 72 × 91 (28 3/8 × 35 13/16). Paul Mellon Collection, Yale Center for British Art, New Haven, Connecticut.

p. 127 Tiziano Vecelli, called Titian (1485–1576), *Landscape with a Dragon and a Nude Woman Sleeping*, date unknown; pen, ink and wash on paper, 25.6 × 40.5 (10 1/16 × 15 15/16). Musée Bonnat, Bayonne.

p. 128 Paolo Caliari, called Veronese (1528–1588), *Portrait of a Venetian Lady (La Belle Nani)*, 1560; 119 × 103 (47 × 40 1/2). Musée du Louvre, Paris.

p. 129 Édouard Manet (1832–1883), *Woman with Fans (Nina de Callias)*, 1873; 113.5 × 166.5 (44 5/8 × 65 1/2). Musée d'Orsay, Paris.

p. 131 Giotto di Bondone (1266–1336), *Idolatry (Infidelitas)*, 1304–6; fresco. Scrovegni Chapel (also called Madonna dell'Arena Chapel), Padua.

p. 133 Vittore Carpaccio (1460–1525), *Meeting of the Betrothed Couple and Departure of the Pilgrims* (detail), from *The Life of St Ursula* cycle, Scuola di S. Orsola, 1495; 2.8 × 6.11 m (9 ft 2 1/4 in. × 20 ft 9/16 in.). Gallerie dell'Accademia, Venice.

Proust's reading of these complex Venetian pictures as historical documents was informed by Gabrielle and Léon Rosenthal's 1906 book on Carpaccio. Elstir holds forth at length on the subject of women

and the sea, exemplifying Proust's own narrative technique of blending the past with the present, transfiguring art into life and then transforming it back into art.

Responding to Albertine's rapture, Elstir speaks about the couturier Fortuny, whose designs were inspired by Carpaccio. The Venetian fabrics and dresses come to figure significantly in the developing complex relationship between Albertine and the Narrator. However, this Balbec episode in *Within a Budding Grove* occurs prior to the historical emergence of Fortuny, whose luxurious garments did not appear until the first decade of the twentieth century. This is one of the rare oversights in Proust's novel; one can feel the writer entirely given over to the word-painting he is creating, oblivious or indifferent to details of historical verisimilitude.

p. 135 Gentile Bellini (1429–1507), *Mary with Angels Making Music*, central panel of *Madonna* triptych (detail), 1488; oil on wood, central panel 184 × 79 (72 $^7/_{16}$ × 31 $^1/_8$); side panels 115 × 56 (45 $^1/_4$ × 22 $^1/_{16}$) each. Church of Santa Maria Gloriosa dei Frari, Venice.

p. 137 James Abbott McNeill Whistler (1834–1903), *Symphony in Flesh Colour and Pink: Mrs Frederick R. Leyland*, 1871–73; 195.9 × 102.2 (77 $^1/_8$ × 40 $^1/_4$). Frick Collection, New York.

p. 139 Tiziano Vecelli, called Titian (1485–1576), *A Woman at her Toilet*, 1515; 93 × 76 (36 $^1/_2$ × 30). Musée du Louvre, Paris.

The coupling of the names Albertine and Laura Dianti notches up the decidedly erotic mood in the passage where, 'in the heat of the game', the soon-to-be lovers first touch. Laura Dianti was Titian's model, and Proust glories in the painter's exquisitely sensual vision of her. This use of a Titian reference to raise the sexual tension in a scene marks an exception to Proust's otherwise reverential handling of the Venetian painter as an exalted master in the rest of the book.

p. 141 Michelangelo (1475–1564), *Resurrection of Christ, with Nine Guards*, c. 1536–38; red chalk on paper, 15.2 × 16.9 (6 × 6 $^5/_8$). Musée du Louvre, Paris.

p. 143 Peter Paul Rubens (1577–1640), *The Three Graces*, 1639; 221 × 181 (87 × 71 $^1/_4$). Prado, Madrid.

VOLUME III: **The Guermantes Way**

p. 144 Diego Rodríguez de Silva y Velázquez (1599–1660), *The Surrender of Breda* (detail), 1634–35; 3.1 × 3.7 m (10 ft 1 in. × 12 ft 1 in.). Prado, Madrid.

p. 147 James Abbott McNeill Whistler (1834–1903), *Harmony in Blue and Silver: Trouville*, 1865; 49.5 × 75.5 (19 $^1/_2$ × 29 $^3/_4$). Isabella Stewart Gardner Museum, Boston.

In the late summer of 1865, Whistler joined Gustave Courbet at Trouville, where he painted this spare, Japanese-influenced picture that included the corpulent body of the French painter by the sea's edge. This modest canvas was part of the Whistler exhibition that Proust dragged himself from bed to see at the École des Beaux-Arts in June 1905.

p. 148 Rembrandt (Harmensz.) van Rijn (1606–1669), *The Money-Changer*, 1627; oil on panel, 32 × 42 (12 $^5/_8$ × 16 $^9/_{16}$). Gemäldegalerie, Staatliche Museen, Berlin.

p. 149 Pieter Bruegel the Elder (1525–1569), *Census at Bethlehem*, c. 1566; oil on wood, 115.5 × 163.5 (45 $^1/_2$ × 64 $^3/_8$). Musées Royaux des Beaux-Arts de Belgique, Brussels.

p. 151 Antoine Watteau (1684–1721), *Standing Cavalier Wearing a Cape (L'Indifférent)*, 1716; red, black and white chalk on paper, 27.2 × 18.9 (10 $^{11}/_{16}$ × 7 $^7/_{16}$). Museum Boijmans Van Beuningen, Rotterdam.

This Watteau drawing is one of a number of studies for his painting *L'Indifférent*, one of two Watteau paintings Proust could not bring himself to choose between for Vaudoyer's requested shortlist of favourite paintings in the Louvre. The other painting is his *Embarkation for Cythera*. Another study for *L'Indifférent* belonged to the Goncourt brothers and may have been known to Proust.

p. 152 Alexandre-Gabriel Decamps (1803–1860), *Turkish Merchant Smoking in his Shop*, 1844; 36 × 28 (14 $^3/_{16}$ × 11). Musée d'Orsay, Paris.

p. 155 Jan van Huysum (1682–1749), *Fruit and Flowers*, before 1726; oil on mahogany panel, 79.9 × 59.5 (31 $^7/_{16}$ × 23 $^7/_{16}$). Wallace Collection, London.

p. 156 Pascal Dagnan-Bouveret (1852–1929), *Madonna of the Rose*, 1885; 85.7 × 68.6 (33 $^3/_4$ × 27). Metropolitan Museum of Art, New York.

p. 157 Antoine-Auguste-Ernest Hébert (1817–1908), *Virgin and Child*, 1872. Église de La Tronche, Grenoble.

p. 159 Henri Fantin-Latour (1836–1904), *Roses in a Bowl*, 1882; 36.5 × 46 (14 $^3/_8$ × 18 $^1/_8$). Musée d'Orsay, Paris.

p. 160 Eugène Fromentin (1820–1876), *Egyptian Women on the Edge of the Nile* (detail), 1876; 120 × 105 (47 $^1/_4$ × 41 $^5/_{16}$). Musée d'Orsay, Paris.

p. 161 Pierre-Auguste Renoir (1841–1919), *The Umbrellas (Les Parapluies)* (detail), 1881–86; 180.3 × 114.9 (71 × 45 $^1/_4$). National Gallery, London.

p. 163 Pierre-Auguste Renoir (1841–1919), *The Swing (La Balançoire)*, 1876; 92 × 73 (36 $^1/_4$ × 28 $^1/_4$). Musée d'Orsay, Paris.

p. 165 Pierre-Paul Prud'hon (1758–1823), *Justice and Divine Vengeance Pursuing Crime*, 1808; 244 × 294 (96 × 115 $^1/_2$). Musée du Louvre, Paris.

Throughout the various editorial phases of publication, Proust consistently misnamed this painting. Its title is not *Justice Shedding Light on Crime*, which is perhaps more suggestive of Françoise and her lighted lamp, but the more militant *Justice and Divine Vengeance Pursuing Crime*.

p. 167 Adam Frans van der Meulen (1632–1690), *Arrival of Louis XIV at the Camp before Maastricht during the Dutch War, June 1673*, 1673; 230 × 332 (90 ⁹/₁₆ × 130 ¹³/₁₆). Musée du Louvre, Paris.

p. 168 Jean-Baptiste Perronneau (1715–1783), *Portrait of a Man*, 1766; 72.5 × 58.5 (25 ⁵/₈ × 23). National Gallery of Ireland, Dublin.

p. 169 Jean-Baptiste-Siméon Chardin (1699–1779), *The Skate*, 1728; 115 × 146 (45 ¹/₄ × 57 ¹/₂). Musée du Louvre, Paris.

p. 170 Jean-Auguste-Dominique Ingres (1780–1867), *Grand Odalisque*, 1814; 91 × 162 (36 × 64). Musée du Louvre, Paris.

p. 171 Édouard Manet (1832–1883), *Olympia*, 1863; 130.5 × 190 (51 ⅜ × 74 ¹³/₁₆). Musée d'Orsay, Paris.

The Narrator juxtaposes these two nineteenth-century masterworks to present to the reader an example of how time can bridge aesthetic chasms, even one as deep as that between the reactionary Ingres and the revolutionary Manet. One hundred pages later, Proust has the Duchesse de Guermantes proclaim to the Princesse de Parme, 'The other day I was with the Grand Duchesse in the Louvre and we happened to pass Manet's *Olympia*. Nowadays nobody is in the least surprised by it. It looks just like an Ingres!' (§III.604, *III.716, †II.812).

p. 172 Pierre-Auguste Renoir (1841–1919), *Luncheon of the Boating Party* (detail), 1880–81; 129.5 × 172.5 (51 × 67 ⁵/₁₆). The Phillips Collection, Washington, DC.

p. 173 Vittore Carpaccio (1460–1525), *Arrival of the Ambassadors* (detail), 1495; 2.75 × 5.89 m (9 ft ¹/₄ in × 19 ft 3 ⅞ in.). Gallerie dell'Accademia, Venice.

Proust's example of having Elstir configure one man in two separate paintings set in very different milieus was most likely inspired by Renoir's two paintings featuring Charles Ephrussi. One is a conventional formal portrait and in another, shown here, Ephrussi figures at the rear of a crowded, informal luncheon party, easy to identify in his inappropriate attire of frock coat and top hat. In addition to being a distinguished collector and art publisher, Ephrussi was an important patron and friend of many impressionist painters.

Carpaccio included these two full-figure portraits of Venetian nobleman he knew in his cycle of St Ursula paintings; the two

individuals shown here have been identified as Pietro and Andrea Loredan.

p. 174 Jean-Auguste-Dominique Ingres (1780–1867), *The Source*, 1856; 164 × 82 (64 ⁹/₁₆ × 32 ⁵/₁₆). Musée d'Orsay, Paris

p. 175 Paul Delaroche (1797–1856), *The Children of Edward: Edward V, King of England, and Richard, Duke of York, in the Tower of London*, 1830; 181 × 215 (71 ¹/₄ × 84 ⅝). Musée du Louvre, Paris.

p. 176 Édouard Manet (1832–1883), *Bunch of Asparagus*, 1880; 46 × 54.9 (18 ¹/₈ × 21 ⅝). Wallraf-Richartz Museum, Cologne.

p. 177 Jehan-Georges Vibert (1840–1902), *A Tasty Treat (L'Éducation d'Azor)*, date unknown; oil on cradled panel, 37.5 × 45.7 (14 ¹/₄ × 18). Private Collection.

p. 179 Gustave Moreau (1826–1898), *The Young Man and Death*, 1856–65; 215.9 × 123.2 (85 × 48 ¹/₂). Fogg Art Museum, Harvard University Art Museums, Cambridge, Massachusetts. Gift of Grenville L. Winthrop, Class of 1886.

p. 181 Frans Hals (1580–1666), *The Women Regents of the Old Men's Almshouses*, 1664; 170.5 × 249.5 (67 ¹/₄ × 94 ¹/₄). Frans Hals Museum, Haarlem.

This arresting group portrait imprinted itself powerfully in Proust's mind when he first came across it in Haarlem, and he later referred to it in his writings on several occasions. *The Women Regents*, a haunting late masterwork, manifests Hals's scrupulous methodology, of which Proust made much use in his monumental novel. Without tangible models before him, Proust confronted an imaginary group of sitters in his mind, and with similar gifts of technique, composition and divination, he painted their portraits.

p. 183 Hans Memling (1433–1494), *The Reliquary of St Ursula*, 1489; gilded and painted wood, 87 × 33 × 91 (34 ¹/₄ × 13 × 35 ¹³/₁₆). Memling Museum, Bruges.

p. 185 Diego Rodríguez de Silva y Velázquez (1599–1660), *The Surrender of Breda*, 1634–35; 3.1 × 3.7 m (10 ft 1 in. × 12 ft 1 in.). Prado, Madrid.

The Baron de Charlus calls forth Velázquez's presentation of a humbling gesture in order to squelch what he perceives as the effrontery of the Narrator. Charlus is at once condescending and proud, triumphant in his own presumption and grandiosity, channelling the exultant Spanish commander as he receives the keys of Breda from the leader of the vanquished Flemish troops.

For Proust, art and life were inextricably interwoven and it was not always obvious which imitated the other. In *The Guermantes Way*, Proust described the outrageous behaviour of an ignoble nobleman, based in part on the novelist's friend Robert, Comte de Montesquiou. Reading the book upon its publication, Montesquiou was highly

suspicious of having been mocked. He recognized various aspects of himself in the character of the Baron, and haughtily withdrew the privilege of his company from his young acolyte, a reaction more in character with the fictional Charlus than with Robert himself. Proust did his best to parry the thrust of the Comte's disbelieving fury, promising that if another edition of the book were to appear, after the line 'the one eminent man of our world' ('le seul homme éminent de notre monde') he would have de Montesquiou's name inscribed. The breach was not irreparable, but the friendship was permanently strained. Proust had come once again to outgrow a mentor. In this most complex *roman-à-clef*, there is decidedly Proustian cheek in the writer's choice of Velázquez's painting depicting the handing over of a set of keys.

p. 186 Pierre Mignard (1612–1695), *Louis XIV, King of France, Crowned by Victory, c.* 1692; 3.6 × 2.6 m (11 ft 9 ⁵/₁₆ in. × 8 ft 6 in.). Musée National du Château du Versailles.

p. 189 Joseph Mallord William Turner (1775–1851), *The Devil's Bridge, Pass of St Gothard*, 1802; pencil, watercolour, bodycolour and scraping-out on white paper, 47.1 × 31.8 (18 ⁹/₁₆ × 12 ¹/₂). British Museum, London.

p. 190 Phillippe de Champaigne (1602–1674), *Portrait of a Man*, 1650; 91 × 72 (35 ¹³/₁₆ × 28 ³/₈). Musée du Louvre, Paris.

p. 191 Hyacinthe Rigaud (1659–1743), *Louis, Duke of Burgundy*, 1697; 131 × 98 (51 ⁹/₁₆ × 38 ⁹/₁₆). Galleria Sabauda, Turin.

VOLUME IV: **Sodom and Gomorrah**

p. 192 François Boucher (1703–1770), *Rape of Europa* (detail), 1747; 161 × 194 (63 ¹/₂ × 76 ¹/₂). Musée du Louvre, Paris.

p. 195 Édouard Detaille (1848–1912), *The Dream (Le Rêve)*, 1888; 3 × 4 m (9 ft 10 in. × 13 ft 1 in.). Musée d'Orsay, Paris.

p. 196 Vittore Carpaccio (1460–1525), *Meeting of the Betrothed Couple and Departure of the Pilgrims from The Life of Saint Ursula* cycle, Scuola di S. Orsola, 1495; 2.8 × 6.1 m (9 ft 2 in. × 20 ft 1 in.). Gallerie dell'Accademia, Venice.

p. 197 Paolo Caliari, called Veronese (1528–1588), *The Wedding at Cana* (detail), 1562–63; 6.66 × 9.9 m (21 ft 10 in. × 32 ft 6 in.). Musée du Louvre, Paris.

p. 199 James Abbott McNeill Whistler (1834–1903), *Arrangement in Black and Gold: Comte Robert Montesquiou-Fezensac*, 1891–92; 208.6 × 91.8 (82 ¹/₈ × 36 ¹/₈). Frick Collection, New York.

Arrangement in Black and Gold is a portrait of Comte Robert de Montesquiou by Whistler, just as the Baron de Charlus is Proust's portrait of the Comte. Despite the refusal of his *amour propre* to believe that he could be the

inspiration for as grotesque a figure as Charlus, Montesquiou was nevertheless suspicious. How enraged would he have been were he to have read this earlier incarnation of the passage quoted, in which Charlus is made to appear even more *louche* and absurd? The Narrator comments, 'Besides, it seemed to me, hearing from a distance his ceaseless patter, that the word Balzac used, but which one no longer dares today to use, of "Auntie", would magnificently amplify and render ridiculous his ample skirts, his subdued pallor, white and black like *Whistler's Mother*' (*À la recherche du temps perdu*, ed. Tadié, III.1308n). Having one's own portrait by Whistler used to describe a buffoon was distasteful enough; having oneself compared to *Whistler's Mother* might have been too much to bear.

p. 201 Rembrandt (Harmensz.) van Rijn (1606–1669), *Portrait of Jan Six*, 1654; 112 × 102 (44 ¹/₈ × 40 ¹/₂). Six Family Collection, Amsterdam.

p. 203 Gustave Jacquet (1846–1909), *Portrait of a Woman in a Hat, c.* 1875. Galerie Nataf, Paris.

p. 204 Giorgione (1477–1510), *Sleeping Venus (The Dresden Venus), c.* 1510; 108.5 × 165 (42 ¹⁵/₁₆ × 64 ⁹/₁₆). Gemäldegalerie Alte Meister, Staatliche Kunstsammlungen, Dresden.

p. 205 Jean-Marc Nattier (1685–1766), *Portrait of Marie-Anne de Mailly-Nesle, Marquise de La Tournelle, Duchesse de Châteauroux, as Eos, c.* 1740; 130 × 97 (51 ³/₁₆ × 38 ³/₁₆). Musée des Beaux-Arts, Marseilles.

p. 207 François Boucher (1703–1770), *Rape of Europa*, 1747; 161 × 194 (63 ¹/₂ × 76 ¹/₂). Musée du Louvre, Paris.

While at Cabourg in the summer of 1907, Proust asked his friend Emmanuel Bibesco to recommend churches and landscapes for him to wander through in the surrounding Norman countryside. Making extravagant use of the newly established Unic taxi service, Proust motored south of Bayeux, upon Bibesco's directive, to visit the Château of Balleroy. There Proust saw the tapestries by Boucher that he later transposed in the pages of his novel from those massive rooms decorated by Mignard to the Château de Guermantes.

The French painter and society portraitist Paul Helleu, a new friend, was Proust's travelling companion on this outing, and it is in part Helleu's work that informs the paintings by Elstir that the Narrator lingers over on his first visit to the Guermantes' home. See note to p. 221.

p. 208 Léon Bakst (1866–1924), *Supper*, 1902; 150 × 100 (59 ¹/₁₆ × 39 ³/₈). State Russian Museum, St Petersburg.

On June 4, 1910, Proust went with the composer Reynaldo Hahn and the critic Jean-Louis Vaudoyer to the opening-night

performance of the Ballets Russes, when *Scheherazade* was danced by the electrifying, eighteen-year-old Nijinsky. Drinking in the green tent, blue doors and orange carpet of the stage set, Proust exclaimed to Hahn that he had never seen anything so beautiful. Léon Bakst designed costumes and sets for Diaghilev's legendary troupe, and his explosive, saturated use of colour penetrated into the novelist's psyche. Perhaps, inspired by the Russian designer, Proust avoided the fate of Bergotte, whose dying regret was not to have layered as much colour in his writing as Vermeer had done in his painting.

Proust regularly attended the performances of the Ballets Russes at the Paris Opéra, and entered into the intense, creative social circle of its dancers, intellectuals, painters and musicians. Misia Edwards, née Godebska, was often seen at these performances next to the company's impresario, Diaghilev. She wore a Persian aigrette in her hair in the manner of the woman portrayed in Bakst's painting, and soon Parisian women were seen everywhere adorned with such feathers. Edwards was the model for Proust's Princess Yourbeletieff.

p. 210 Nicolas Poussin (1594–1665), *Landscape with Orpheus and Eurydice*, 1650; 124 × 200 (49 × 78 ¹/₂). Musée du Louvre, Paris.

p. 211 Claude Monet (1840–1926), *Water Lilies (Nymphéas)*, 1916; 200 × 200 (78 ³/₄ × 78 ³/₄). Museum of Western Art, Tokyo.

p. 212 Édouard Manet (1832–1883), *Argenteuil, The Boaters*, 1874; 149 × 115 (59 ¹/₄ × 45 ¹/₄). Musée des Beaux-Arts, Tournai.

p. 213a Claude Monet (1840–1926), *Rouen Cathedral (The Portal and Tour Saint-Romain, Impression of Morning; Harmony in White)*, 1894; 106 × 73 (41 ³/₄ × 28 ³/₄). Musée d'Orsay, Paris.

p. 213b Edgar Degas (1834–1917), *Place de la Concorde (Viscount Lepic and his Daughters Crossing the Place de la Concorde)*, 1875; 78.4 × 117.5 (30 ⁷/₈ × 46 ¹/₄). Hermitage, St Petersburg.

p. 215a Nicolas Poussin (1594–1665), *Mars and Venus*, c. 1630; 155 × 213.5 (61 × 84¹/₁₆). Museum of Fine Arts, Boston.

p. 215b Nicolas Poussin (1594–1665), *The Inspiration of the Poet*, 1630; 182.5 × 213 (71 ⁷/₈ × 83 ⁷/₈). Musée du Louvre, Paris.

The Narrator introduces Edgar Degas as an artist, collector and paradigm of exquisite taste. Degas had a singularly effective impact upon the resurrection of the reputation of Poussin; he made several copies of the seventeenth-century master's classical scenes, and Degas's own early historical paintings, such as *The Young Spartans Exercising*, were deeply influenced by Poussin.

The years between 1894 and 1906, in which the Dreyfus Affair took hold of France, saw the idea of 'purity' begin to infect even aesthetic considerations. As has often occurred historically during such retrograde periods, attempts to transpose 'classical values' onto a contemporary world engendered outbreaks of xenophobia. Degas and Cézanne, both fierce nationalists and anti-Dreyfusards, championed the 'golden light' of Poussin. In all walks of French life, the Dreyfus Affair shattered unities, even those of modernism.

p. 217 Henri Le Sidaner (1862–1939), *Window at the Port of Honfleur*, 1922; 92.8 × 112 (36 ¹/₂ × 44). Private Collection.

p. 219 Edgar Degas (1834–1917), *Dancers Backstage*, 1876–83; 24.2 × 18.8 (9 ¹/₂ × 7 ³/₈). Ailsa Mellon Bruce Collection, National Gallery of Art, Washington, DC.

p. 221 Jean-François Millet (1815–1875), *The Angelus (L'Angélus)*, 1857–59; 55.5 × 66 (21 ⁷/₈ × 26). Musée d'Orsay, Paris.

p. 223 Paul Helleu (1859–1927), *Autumn at Versailles*, 1892; 126 × 126 (49 ⁵/₈ × 49 ⁵/₈). Musée d'Orsay, Paris.

Proust and Helleu first met in 1895, and later became friends during their overlapping stays in Cabourg in 1907 and 1912. Undoubtedly attracted to the handsome, benign society portraitist –'Even physically he is charming' he wrote to his old friend Mme Strauss (quoted in Tadié, *Marcel Proust*, p. 889) – Proust managed to maintain a safe emotional distance, which enabled him to extract from the painter a certain refined essence unclouded by infatuation. Proust's visits to Helleu's studio and their conversations about painting figure considerably in the emergence of the character of Elstir. Helleu was a passionate admirer and collector of Watteau, one of Proust's favourite painters. He was a great believer in the superiority of eighteenth-century painting in general, and tried, unsuccessfully, to disabuse Proust of his love for the Italian masters of the early and late Renaissance.

Although Proust mocked the bourgeois taste and attitudes of the Cambremers, he left himself open to similar censure when, in the preface to his translation of Ruskin's *Bible of Amiens*, he made the claim that '...for interiors of cathedrals I know of none to equal in beauty those of the great painter Helleu' (Painter, *Marcel Proust*, vol. 2, p. 92). Putting aside the question of Helleu's cathedral interiors, Proust's hyperbolic praise of him as a great painter seriously compromised his own integrity as a critic. Affection only occasionally blinded his judgment.

During one of the many visits to the painter's studio, probably in 1907, Proust admired a canvas entitled *Autumn at Versailles*. He wrote to Reynaldo Hahn shortly afterwards that 'it's the

most beautiful thing of his I know' (Marcel Proust, *Correspondence*, ed. Philip Kolb (Paris: Plon, 1993), vol. VIII, p. 50). Upon hearing of this, Helleu presented the picture to Proust. As portrayed in Jean-Yves Tadié's biography, Proust 'was embarrassed, was torn between wanting to refuse the present, wanting to buy it, and gratitude' (Tadié, *Marcel Proust*, p. 884).

When Proust died in his bedroom at 44 rue Hamelin, Helleu came to pay his respects, and was asked to sketch the writer on his deathbed (see p. 328).

p. 224 Paolo Caliari, called Veronese (1528–1588), *The Wedding at Cana* (detail), 1571; 207 × 457 (81 1/2 × 179 15/16). Gemäldegalerie Alte Meister, Staatliche Kunstsammlungen, Dresden.

p. 225 Rembrandt (Harmensz.) van Rijn (1606–1669), *The Jewish Bride*, 1665; 121.5 × 166.5 (47 7/8 × 65 1/2). Rijksmuseum, Amsterdam.

VOLUME V: **The Captive**

p. 226 Mihály Munkácsy (1844–1900), *The Last Day of a Condemned Man* (detail), 1870; oil on wood, 139 × 194 (54 1/4 × 76 1/8). Hungarian National Gallery, Budapest.

p. 229 Benozzo Gozzoli (1420–1497), *Procession of the Magi* (detail), 1459; fresco. Palazzo Medici Riccardi, Florence.

p. 231 Leonardo da Vinci (1452–1519) (copy after), *Two Grotesque Profiles*, 1485–90; pen and ink with wash, 16.3 × 14.3 (6 7/16 × 5 5/8). Queen's Gallery, Royal Collection, London.

p. 233 Jean-Honoré Fragonard (1732–1806), *The Music Lesson*, 1769; 80 × 65 (31 1/2 × 25 9/16). Musée du Louvre, Paris.

p. 234 Andrea Mantegna (1431–1506), *St Sebastian*, c. 1480; 255 × 140 (100 1/2 × 55). Musée du Louvre, Paris.

p. 237 Jan Vermeer (1632–1675), *View of Delft*, 1659–60; 96.5 × 115.7 (38 × 45 9/16). Mauritshuis, The Hague.

On his second voyage to the Netherlands in 1902, Proust first visited the town of Delft and then went on to The Hague. There, at the Mauritshuis, he saw Vermeer's *View of Delft*. Years later, writing to another friend, the scholar and critic Jean-Louis Vaudoyer, he claimed that it was at that moment he knew 'I had seen the most beautiful painting in the world' (Tadié, *Marcel Proust*, p. 744). Standing before Vermeer's absorbing masterwork in The Hague, the future author of *In Search of Lost Time* experienced the triumph of art over time.

Following the devastation of the Great War, the region of Flanders sponsored an exhibition in Paris of works from its treasury of Dutch paintings in order to raise much-needed funds for rebuilding. The diplomat Paul Morand had made a special case to the Dutch authorities to include *View of Delft*, since he knew it would

please his friend Marcel Proust. The exhibition opened at the Jeu de Paume in April 1921. To coincide with the run of the show, the magazine *L'Opinion* published a three-part appreciation entitled 'The Mysterious Vermeer' by Proust's friend Vaudoyer. In this essay, Vaudoyer claimed that in the middle of the eighteenth century Vermeer 'was not somewhat unknown, he was unknown' (*À la recherche du temps perdu*, ed. Tadié, III.1740n). It had been only in 1866, more than two hundred years after *View of Delft* had been painted, that the appearance of another article ('Van der Meer of Delft' by the critic Théophile Thoré-Bürger) marked the Dutch painter's re-emergence from obscurity and the beginning of his international acclaim.

Declining in health, haggard and breathless, but nevertheless working heroically on his novel, Proust wrote to Vaudoyer to compliment him on this essay. (Even more flatteringly, he modified phrases from his friend's article and inserted them directly into his own text, including the ineffably evocative 'little patch of yellow wall'.) Proust proposed a visit to the exhibition: would Vaudoyer 'be so kind as to take me there and allow me to lean on your arm?' (Tadié, *Marcel Proust*, p. 745.) Proust, who was usually just getting to bed at eleven in the morning, stayed up long enough to stand before a work of art whose power he once again found completely *bouleversant*. Feeling well enough to peek in at an Ingres exhibition nearby and then go on to have lunch at the Ritz with Vaudoyer, Proust finally went home, exhausted. It was his last time out to look at pictures.

Proust worked and reworked this passage on the death of Bergotte (which he had first conceived several years earlier) until the very end of his own life. Although they did not ultimately appear in the definitive text, passages he dictated on the last day he was alive reveal his ongoing investment in this scene, as he journeyed between Bergotte's death and his own.

p. 239 James Tissot (1836–1902), *The Circle of the Rue Royale (Le Cercle de la rue Royale)*, 1868; 215.9 × 330.2 (85 × 130). Collection Baron Hottinger.

Hearing the news of Swann's death, the Narrator speaks directly to the memory of his departed old friend, as well as to his image in this group portrait by Tissot. The picture includes not only Charles Swann but also other high-born aristocrats known to Proust – the Marquis de Lau, General Galliffet and Prince Edmond de Polignac. (The Baron Hottinger is also pictured; it was he who won the Tissot group portrait when club members drew lots for it, and the picture still remains in the

possession of his descendants.) Naturally, the Tissot painting does not include a likeness of the fictional Charles Swann. Leaving a discreet blank space for the name of the 'real' Charles, Proust (in a voice quite distinct from the Narrator's) tips his hat to his old friend Charles Haas. If Haas is at all remembered today it is for having been Sarah Bernhardt's lover, for having been the only Jewish member of the effete Jockey Club, but most especially for having been Proust's formative role model in the creation of the character Charles Swann. Haas/Swann is the standing figure on the far right.

Tissot's painting of a circle of men at the highest pinnacle of society was inadvertently a group portrait of an endangered species. In 1974 the critic Anatole Broyard wrote: 'You might almost say that the French aristocracy expired in Proust's arms. He ghost-wrote its last words and thereby conferred on it an immortality it might never have achieved and probably did not deserve.' ('Yesterday's Gardenia', p. 21.)

p. 241 Doménicos Theotokópoulos, called El Greco (1541–1614), *A Cardinal* (probably Cardinal Niño de Guevara), c. 1600; 71 × 108 (42 1/2 × 67 7/8). Metropolitan Museum of Art, New York.

p. 243 Agnolo di Cosimo, called Il Bronzino (1503–1572), *Portrait of a Young Man*, 1530s; oil on wood, 95.6 × 74.9 (37 5/8 × 29 1/2). Metropolitan Museum of Art, New York.

p. 245 Giovanni Antonio Bazzi, called Il Sodoma (1477–1549), *St Sebastian*, 1525; 206 × 154 (81 1/8 × 60 5/8). Pitti Palace, Florence.

p. 246 Andrea Mantegna (1431–1506), *The Assumption* (detail), c. 1455; fresco. Church of The Eremitani, Padua.

p. 247 Gentile Bellini (1429–1507), *Enthroned Madonna* (detail), San Giobbi altarpiece, 1487; oil on wood, 4.7 × 2.6 m (15 ft 5 in. × 8 ft 5 in.). Gallerie dell'Accademia, Venice.

p. 249 Thomas Couture (1815–1879), *Romans of the Decadence*, 1847; 4.7 × 7.9 m (15 ft 6 in. × 25 ft 11 in.). Musée du Louvre, Paris.

p. 251 Théodore Rousseau (1812–1867), *Oak Trees in the Gorge of Apremont*, c. 1855; 63.5 × 99.5 (25 × 39 1/8). Musée du Louvre, Paris.

p. 252 Maurice-Quentin de La Tour (1704–1788), *Isabelle de Charrière*, 1766; pastel on paper, 32 × 24 (12 5/8 × 9 7/16). Musée Antoine Lecuyer, Saint-Quentin.

p. 253 Tiziano Vecelli, called Titian (1485–1576), *Portrait of a Lady*, c. 1555; 98 × 74 (38 1/2 × 29 1/8). National Gallery of Art, Washington, DC.

p. 255 Diego Rodríguez de Silva y Velázquez (1599–1660), *La Infanta Maria Teresa*, 1651–54; 128.6 × 100.6 (50 5/8 × 39 5/8). Metropolitan Museum of Art, New York.

p. 256 Rembrandt (Harmensz.) van Rijn (1606–1669), *Bathsheba at her Bath*, 1654; 142 × 142 (56 × 56). Musée du Louvre, Paris.

p. 257 Vittore Carpaccio (1460–1525), *Two Venetian Courtesans*, 1490; 94 × 64 (37 × 25 3/16). Museo Correr, Venice.

p. 259 Mihály Munkácsy (1844–1900), *The Last Day of a Condemned Man*, 1870; oil on wood, 139 × 194 (54 3/4 × 76 3/8). Hungarian National Gallery, Budapest.

Munkácsy was born in Munkács, Hungary. Named Mihály Lieb at birth, he, like artists of earlier generations, later came to be known by the name of his hometown. He lived in Paris during the years of Proust's childhood and young adulthood, and as a budding socialite Proust met the painter at the literary salon of M. and Mme Arman de Caillavet. Munkácsy's painting, *The Last Day of a Man Condemned to Death* had been exhibited at the Salon of 1872.

Throughout the long and complex publishing history of *In Search of Lost Time*, with all its various phases of textual clarification, this particular reference to Munkácsy serves as an example of how the definitive text of Proust only slowly emerged after decades of labour-intensive research. Possibly the result of a misreading of Proust's often illegible scrawl, or the fact of the early editors having no knowledge at all of Munkácsy, Munkácsy's name was never used in the earliest editions of the novel. Prince Myshkin has just been mentioned in the discussion between the Narrator and Albertine about Dostoevsky, and in early editions of the text the prince's name was repeated in the next sentence in place of Proust's intended reference to Munkácsy, creating a confusing allusion to 'the paintings where Myshkin wants to see the representation of a condemned man'. The intense editorial scrutiny of Jean-Yves Tadié restored Munkácsy to his rightful place in the now-definitive Pléiade text, and his correction resulted in the change also finally being made by D. J. Enright in his revision of the Moncrieff/Kilmartin English translation, some seventy years after the first publication of Proust's book.

p. 261 Bernardino Luini (1480–1532), *Portrait of a Lady*, c. 1520–25; oil on wood, 77 × 57.5 (30 1/8 × 22 1/2). Andrew W. Mellon Collection, National Gallery of Art, Washington, DC.

p. 263 Giovanni Battista Tiepolo (1696–1770), *The Triumph of Zephyr and Flora (Allegory of Spring)*, 1734; 4 × 2.3 m (12 ft 11 in. × 7 ft 5 in.). Ca'Rezzonico, Venice.

In contrast to his extractions from the other Venetian masters, Proust does not scavenge

Tiepolo's paintings for imagery or historical documentation, but solely to draw brilliant hues for his sumptuous descriptions of women's clothing. His other three references to the artist in the novel include the 'Tiepolo pink' of Odette's tea gown in *Within a Budding Grove*, a splash of 'Tiepolo red' in one of the Duchesse de Guermantes's evening wraps in *Sodom and Gomorrah*, as well as her 'Tiepolo cloak' with its band of rubies.

VOLUME VI: **The Fugitive**

p. 264 James Abbott McNeill Whistler (1834–1903), *The Storm – Sunset* (detail), 1880; pastel on paper, 8.6 × 29 (7 ⁵/₁₆ × 11 ⁷/₁₆). Fogg Art Museum, Harvard University Art Museums, Cambridge, Massachusetts. Bequest of Grenville L. Winthrop.

p. 267 Anthony van Dyck (1599–1641), *Charles I, King of England, Hunting, c.* 1635; 266 × 207 (104 ¹/₂ × 81 ¹/₂). Musée du Louvre, Paris.

p. 269 Jean-Marc Nattier (1685–1766), *Portrait of Mathilde de Canisy, Marquise d'Antin*, 1738. Musée Jacquemart-André/Institut de France, Paris.

p. 271 Maxime Dethomas (1867–1929), *Venice Study*, from Henri de Régnier's book *Esquisses Vénitiennes*, 1906; copperplate engraving.

p. 273 Tiziano Vecelli, called Titian (1485–1576), *Portrait of Isabella d'Este*, 1536; 102 × 64 (40 ³/₁₆ × 25 ³/₁₆). Kunsthistorisches Museum, Vienna.

p. 274 Vittore Carpaccio (1460–1525), *Martyrdom of the Pilgrims and the Burial of St Ursula* (detail), from *The Life of St Ursula* cycle, Scuola di S. Orsola 1493; 2.7 × 5.6 m (8 ft 11 in. × 18 ft 5 in.). Gallerie dell'Accademia, Venice.

p. 277 James Abbott McNeill Whistler (1834–1903), *The Storm – Sunset*, 1880; pastel on paper, 18.6 × 29 (7 ⁵/₁₆ × 11 ⁷/₁₆). Bequest of Grenville L. Winthrop, Fogg Art Museum, Harvard University Art Museums, Cambridge, Massachusetts.

p. 278 Vittore Carpaccio (1460–1525), *The Patriarch of Grado Exorcising a Demoniac*, 1494; 3.7 × 3.9m (11 ft 11 in. × 12 ft 9 in.). Gallerie dell'Accademia, Venice.

'Carpaccio happens to be a painter I know very well, I have spent entire days…in front of *St Ursula*', Proust wrote to Reynaldo Hahn's sister, Maria de Madrazo. (*Correspondence*, ed. Philip Kolb, vol. xv, p. 58.) She was, by marriage, an aunt to the Venetian couturier Fortuny. Madrazo became a critical source of information for the novelist in his search for knowledge about the relationship between Fortuny dresses and Carpaccio paintings. Proust also read extensively about Carpaccio, consulting books on the painter lent to him by Mme de Madrazo, borrowing generously for his own text from their intricate explications of *The Patriarch of Grado*.

p. 281 Giotto di Bondone (1266–1336), Interior of the Arena Chapel facing *The Last Judgment*, west, 1304–6; fresco. Scrovegni Chapel (also called Madonna dell'Arena Chapel), Padua.

Unlike the Vices and Virtues he knew so well from the pages of his Library Edition of John Ruskin, the majority of Giotto's frescoes in the Scrovegni Chapel were less familiar to Proust. When he finally saw them, the luminous intensity of these paintings of New Testament stories made an impression upon him that was to last the rest of his life. Under the brilliant blue barrel-vaulted dome, Proust finally found himself in a place he had long dreamed of visiting. It was one of those rare occasions in his life when longing and being co-existed.

p. 283 Giotto di Bondone (1266–1336), *The Lamentation*, 1304–6; fresco. Scrovegni Chapel (also called Madonna dell'Arena Chapel), Padua.

The names of famous aviators appear at different stages in the development of this passage, with its poignant association of angels and pilots. In one variant, the Wright brothers are cited; in another the aviator is René Fonck. Cocteau's friend Roland Garros died in aerial combat in 1918. His name is retained in the Enright revision of the Moncrieff/Kilmartin English translation. In the definitive French edition, the Pléiade text retains Fonck.

p. 285 Joseph Mallord William Turner (1775–1851), *The Dogana and Santa Maria della Salute, Venice*, 1843; 62 × 93 (24 ¹/₈ × 36 ⁵/₈). National Gallery of Art, Washington, DC.

Proust knew this Turner painting from its reproduction in Ruskin's landmark study, *Modern Painters*. Along with Monet's Venice pictures, Turner's multiple renditions of this dramatic entrance to the Grand Canal served as inspirations for Elstir's painting of La Salute.

VOLUME VII: **Time Regained**

p. 286 Paul-Marc-Joseph Chenavard (1807–1895), *Resurrection of the Dead* (detail), 1845; 2.9 × 3.1 m (9 ft 6 in. × 10 ft). Bohal Parish Church, France.

p. 289 Francesco Guardi (1712–1793), *Procession in front of Santa Maria della Salute, c.* 1775–80; 67 × 101 (26 ¹/₂ × 40). Musée du Louvre, Paris.

p. 291 Gabriel de Saint-Aubin (1724–1780), *The Gossips (Les Nouvellistes)*, 1752; etching, 10.1 × 14.5 (4 × 5 ¹¹/₁₆). Katherine E. Bullard Fund in memory of Francis Bullard, 62.608, Museum of Fine Arts, Boston.

p. 293 Thomas Lawrence (1769–1830), *Elizabeth Farren, Later Countess of Derby*, 1790; 238.8 × 146.1 (94 × 57 ¹/₂). Metropolitan Museum of Art, New York.

p. 294 Henri Fantin-Latour (1836–1904), *White Lilies*, 1883; 43 × 33 (16 ¹⁵/₁₆ × 13). Victoria & Albert Museum, London.

p. 296 Pierre-Auguste Cot (1837–1883), *Portrait of a Lady*, 1879; 139.7 × 90.2 (55 × 35 ¹/₂). Chrysler Museum of Art, Norfolk, Virginia, gift of Walter P. Chrysler, Jr. 71.2068.

p. 297 Pierre-Auguste Renoir (1841–1919), *Madame Georges Charpentier and her Children*, 1878; 153.7 × 190.2 (60 ¹/₂ × 74 ⁷/₈). Metropolitan Museum of Art, New York.

p. 298 Antonio Pisano, called Pisanello (1395–1455), *Head of a Young Woman with Profile to the Right*, 1433; drawing, 24.5 × 18.2 (9 ⁵/₈ × 7 ³/₁₆). Musée du Louvre, Paris.

p. 301 Doménicos Theotokópoulos, called El Greco (1541–1614), *The Burial of the Count of Orgaz*, 1586–88; 4.8 × 3.6 m (15 ft 9 in. × 11 ft 10 in.). Parish Church of Santo Tome, Toledo.

This is the third and most expansive of three references to El Greco in the novel. In *Within a Budding Grove*, an account is given of the Narrator's father stopping in Toledo in order to admire the work of a 'student of Titian'. In *The Captive*, Charlus is said to resemble a Grand Inquisitor painted by El Greco (see p. 239). In this passage from *Time Regained*, El Greco's *Burial of the Count of Orgaz* is superimposed on a night-time bombing raid over Paris, accompanied by full-throttle Wagnerian scoring. Bombs are falling and yet the Narrator recognizes that a farce is under way. Words, painting and music coalesce, all orchestrated by Proust as an onslaught of sensory stimuli that serves to heighten the few final hours of affection left to the Narrator and Saint-Loup.

Like Vermeer, El Greco was a painter who had had precious little exposure or reputation in Paris at the end of the nineteenth century. Robert de Montesquiou had written an article on the Spanish painter for *Le Figaro* in which he called El Greco's *The Burial of the Count of Orgaz* 'the world's most extraordinary painting' (quoted in Kazuyoshi Yoshikawa, 'Proust et le Greco', *Bulletin Marcel Proust* 44 (1994), 29–41, at 33). Maria de Madrazo expanded Proust's knowledge of the painter from Toledo; she had married into a family of Spanish painters. As documented by Yoshikawa, Proust came to know the Madrazo family's painting collection in their home near the Arc de Triomphe, where for many years El Greco's *Sainte Famille* had a pride of place (Ibid., p. 32).

p. 303 Vittore Carpaccio (1460–1525), *Sermon of St Stephen outside the Gates of Jerusalem*, 1514; 148 × 194 (58 ¹/₄ × 76 ¹/₂). Musée du Louvre, Paris.

p. 305 Pierre-Auguste Renoir (1841–1919), *Ball at the Moulin de la Galette, Montmartre*, 1876; 131 × 175 (51 ⁵/₈ × 68 ⁷/₈). Musée d'Orsay, Paris.

p. 307 James Abbott McNeill Whistler (1834–1903), *Arrangement in Black: Portrait of F. R. Leyland*, 1871–73; 218.5 × 119.4 (86 × 47). Freer Gallery, Washington, DC.

p. 308 Édouard Manet (1832–1883), *Execution of the Emperor Maximilian*, 1867; 195.9 × 259.7 (77 ¹/₈ × 102 ¹/₄). Museum of Fine Arts, Boston.

p. 309 Eugène Delacroix (1798–1863), *Liberty Leading the People*, 1830; 260 × 325 (102 ¹/₄ × 128). Musée du Louvre, Paris.

p. 310 Eugène Delacroix (1798–1863), *Turk, Smoking on a Divan*, 1825; 25 × 30 (9 ¹¹/₁₆ × 11 ¹¹/₁₆). Musée du Louvre, Paris.

p. 311 Eugène Fromentin (1820–1876), *Falcon Hunting in Algeria: The Quarry*, 1863; 162.5 × 118 (64 × 46 ¹/₂). Musée d'Orsay, Paris.

p. 312 Maurice-Quentin de La Tour (1704–1788), *Madame de Pompadour*, 1755; pastel on grey-blue paper mounted on canvas, 177.5 × 131 (69 ⁷/₈ × 51 ⁷/₁₆). Musée du Louvre, Paris.

p. 313 Antoine Watteau (1684–1721), *Gersaint's Shop Sign*, 1720; 163 × 308 (64 ¹/₁₀ × 121 ¹/₄). Schloss Charlottenburg, Berlin.

The Narrator's remarks on the subject of popular art form a thinly veiled commentary by Proust. On one hand, the appallingly low degree of culture he has encountered among the ostensibly higher classes has never ceased to amaze him. On the other, he recoils from the barbaric narrow-mindedness of patriotic fervour being used as a basis for determining aesthetic judgments. Poised between opposing factions, sympathetic but removed, Proust exemplifies the role of the artist as perennial observer and outsider.

p. 315 Jean Foucquet (1420–1480), *St John at Patmos*, from *The Book of Hours of Étienne Chevalier*, 1455; illumination on parchment, c. 16.5 × 12 (6 ¹/₂ × 4 ³/₄). Musée Condé, Chantilly.

p. 316 Paul-Marc-Joseph Chenavard (1807–1895), *Resurrection of the Dead*, 1845; 2.9 × 3.1 m (9 ft 6 in. × 10 ft). Bohal Parish Church, France.

p. 317 Jacques-Louis David (1748–1825), *The Lictors Returning to Brutus the Bodies of His Dead Sons*, 1789; 3.2 × 4.2 (10 ft 7 in. × 13 ft 10 in.). Musée du Louvre, Paris.

According to Baudelaire and, by extension, Proust, the 'old error of David and Chenavard' involved making painting subservient to philosophy and religion, and believing that painting should serve to illustrate moral rectitude.

p. 318 Rembrandt (Harmensz.) van Rijn (1606–1669), *A Woman Bathing in a Stream* (Hendrickje Stoffels?), 1654; oil on oak, 61.8 × 47 (24 ³/₁₀ × 18 ¹/₂). National Gallery, London.

p. 319 Jan Vermeer (1632–1675), *Woman Holding a Balance*, 1662–63; 39.7 × 35.5 (15 ⁷/₈ × 14). National Gallery of Art, Washington, DC.

p. 320 Rembrandt (Harmensz.) van Rijn (1606–1669), *Self-Portrait at the Age of Sixty-Three*, 1669; 86 × 70.5 (33 ⁷/₈ × 27 ³/₄). National Gallery, London.

p. 322 Andrea Mantegna (1431–1506), *Cardinal Ludovico Trevisan*, 1459; tempera on wood,

44.8 × 33.9 (17 $^5/_8$ × 13 $^3/_8$). Gemäldegalerie, Staatliche Museen, Berlin.

p. 323 Michelangelo (1475–1564), *Damned Soul*, 1525; black chalk on white paper, 29.8 × 20.5 (11 $^3/_4$ × 8 $^1/_{16}$). Galleria degli Uffizi, Florence.

p. 325 Jacques-Louis David (1748–1825), *Madame Récamier*, 1800; 174 × 244 (68 $^1/_2$ × 96). Musée du Louvre, Paris.

p. 327 Édouard Manet (1832–1883), *Le Déjeuner sur l'herbe*, 1863; 2.1 × 2.6 m (6 ft 10 in. × 8 ft 8 in.). Musée d'Orsay, Paris.

In his editorial discussion of Manet's *Déjeuner sur l'herbe* (first shown at the 1863 Salon des Refusés under the title *Plein Air*) Jean-Yves Tadié refers to the painting as a work 'that symbolizes the carefree insouciance with which each aesthetic generation raises itself on the negation of the one that went before it' (*À la recherche du temps perdu*, IV.1313n). Proust's indirect reference to the Manet picture uses *déjeuner sur l'herbe* not as the title of a painting but rather as a euphemism for mortality and the laws of nature, echoing Hugo. That this title would be implicitly understood in the 1920s as referring to Manet's painting is an indication of its already iconic status, celebrated here by Proust.

p. 329 Jean-Baptiste-Siméon Chardin (1699–1779), *Self-Portrait*, 1775; pastel on paper, 46 × 38 (18 × 15). Musée du Louvre, Paris.

Elstir knelt in homage before Chardin, and in recognition of this act of obeisance the Narrator positions himself similarly. He bows to the inspiring, creative force of renunciation.

The strength that Proust himself derived from Chardin's example was considerable.

In matters of style, the novelist's writing may appear far too florid to be compared to the controlled restraint of the painter, but in matters of substance, their affinities emerge more clearly. Proust seemed always to trust the solidity, the reality of Chardin's pictures, and throughout his writing life this trust repeatedly paid off. 'The artist through his unique vision can transform concrete objects from daily life into symbolic images of great power.' This possibility for transformation, this mysterious alchemy, kept Proust in its clutches as the long years of writing and dictating wore on. From beginning to end, Chardin was a fellow traveller, a mentor with whom Proust never severed ties.

p. 330 Paul Helleu, *Marcel Proust on his Deathbed*, 1922; etching.

Paul Helleu's etching of Marcel Proust was worked in copper on 19 November 1922 directly from the body of the dead writer laid out in his bedroom at 44 rue Hamelin in Paris. Helleu had long wanted to make a portrait study of his friend, whose luminous skin, black beard and strong features were accentuated by Proust's having eaten no solid food in the last five months of his life. According to Helleu, 'Everything superfluous was dissolved away,' (William C. Carter, *Marcel Proust* (New Haven: Yale University Press, 2000), p. 809). Two proofs were pulled from the plate. One was kept by Robert Proust, who had requested that Helleu make the image of his brother; the other was given to Proust's devoted housekeeper, Céleste Albaret.

INDEX OF PAINTERS AND PAINTINGS

This index lists every reference to a specific painter or painting in *In Search of Lost Time*. General references to a painter are cited in the order in which they appear in the novel; where a painting has been reproduced in *Paintings in Proust* to illustrate a general reference, its title is given in parentheses. References to paintings named by Proust are cited in alphabetical order thereafter under the heading of the artist. The titles used for paintings are those best known in English. Page references in this book are given in parentheses, prefaced by 'p.'; page references to Proust's text are given by volume followed by page number for three different editions:

§ *In Search of Lost Time*, tr. C. K. Scott Moncrieff and Terence Kilmartin (vol. 6 tr. Andreas Mayor and Terence Kilmartin), rev. D. J. Enright, 6 vols. (London: Chatto & Windus, 1992)

* *In Search of Lost Time*, tr. C. K. Scott Moncrieff and Terence Kilmartin (vol. 6 tr. Andreas Mayor and Terence Kilmartin), rev. D. J. Enright, 6 vols. (New York: Modern Library, 1992–93)

† *À la recherche du temps perdu*, ed. Jean-Yves Tadié, 4 vols. (Paris: Pléiade, 1987–89)

Bakst, Léon, §II.608, *II.718, †II.298; §IV.165, *IV.193, †III.140 (*Supper*, p. 208); §VI.50, *VI.59, †IV.310

Bellini, Gentile, §I.198–99, *I.234, †I.164 (*Procession in Piazza San Marco*, p. 46) *The Sultan Mehmet II* (p. 41): §I.114–15, *I.134, †I.96; §I.428–29, *I.505, †I.349

Bellini, Giovanni, §II.564, *II.666, †II.262 (*Madonna triptych*, p. 135); §V.294, *V.347, †III.765 (*Enthroned Madonna*, p. 247)

Bellini (family), §III.544, *III.645, †II.762; §III.603, *III.715, †II.811

Botticelli, Sandro, §I.280, *I.330, †I.229 *Birth of Venus* (p. 12): §I.377, *I.445, †I.308 *Madonna of the Magnificat* (p. 103): §II.256, *II.264, †I.607 *Madonna of the Pomegranate* (p. 63): §I.337, *I.398, †I.276 *Primavera* (p. 63): §I.337, *I.398, †I.276; §I.377, *I.445, †I.308 *The Trials of Moses* (pp. 23, 50): §I.267–70, *I.314–18, †I.219; §I.286, *I.337, †I.234

Venus Presenting Flowers to a Youth Accompanied by the Graces (p. 62): §I.377, *I.445, †I.308

Boucher, François, §II.389, *II.459, †II.116; §III.7, *III.9, †II.315; §V.105, *V.124, †III.607; §V.224, *V.264, †III.706 *Rape of Europa* (p. 207): §IV.163, *IV.191, †III.139

Bourdichon, Jean, *Great Hours of Anne of Brittany* (p. 109): §II.262, *II.309, †I.10

Il Bronzino [Agnolo di Cosimo], §V.241, *V.284, †III.723 (*Portrait of a Young Man*, p. 243)

Bruegel, Pieter the Elder, §III.105, *III.124–25, †II.397 (*Census at Bethlehem*, p. 149)

Carpaccio, Vittore, §I.213, *I.251, †I.176 (*St George Baptizing the Selenites*, p. 47); §II.13, *II.14, †I.432; §III.485, *III.575, †II.713; §III.620–1, *III.735, †II.825; §IV.57, *IV.66, †III.49 (*Meeting of the Betrothed Couple and Departure of the Pilgrims*, p. 196); § VI.90, * VI.106, †IV.342 (*Sermon of St Stephen Outside the*

Gates of Jerusalem, p. 303); § v.421, *v.497, †iii.871

Apotheosis of St Ursula (p. 25)

Martyrdom of the Pilgrims and the Burial of St Ursula (p. 274): § v.742, *v.876, †iv.225

Meeting of the Betrothed Couple and Departure of the Pilgrims (p. 133): §ii.552–3, *ii.652–4, †ii.252–3

The Patriarch of Grado Exorcising a Demoniac (p. 278): §v.742–43, *v.876–87, †iv.225–26

Two Venetian Courtesans (p. 257): §v.431, *v.508, †iii.879

Carrière, Eugène, §ii.386, *ii.457, †ii.114 (*Lady Leaning her Elbows on a Table,* p. 113); §iii.637, *iii.755, †ii.839

Champaigne, Phillippe de, §iii.668, *iii.792, †ii.865 (*Portrait of a Man*, p. 190)

Chaplin, Charles, §vi.38, *vi.45, †iv.300

Chardin, Jean-Baptiste-Siméon, §ii.261, *ii.309, †ii.10 (*Self-Portrait Wearing Spectacles,* p. 106); §iii.484–85, *iii.574–5, †ii.713 (*The Skate,* p. 169); §v.718, *v.848, †iv.205; §vi.445–46, *vi.525, †iv.620 (*Self-Portrait,* p. 329)

Still Life with Jar of Olives (p. 14)

Chenavard, Paul-Marc-Joseph, §vi.250, *vi.295, †iv.472 (*Resurrection of the Dead,* p. 316)

Corot, Jean-Baptiste-Camille, §i.24, *i.28, †i.22; §i.28, *i.33, †i.25

Chartres Cathedral (p. 15): §i.46, *i.54, †i.40

Cot, Pierre-Auguste, §vi.38, *vi.45, †iv.300 (*Portrait of a Lady,* p. 296)

Couture, Thomas, §v.324, *v.382, †iii.791 (*Romans of the Decadence,* p. 249)

Dagnan-Bouveret, Pascal-Adolphe-Jean, §iii.253, *iii.299, †ii.520 (*Madonna of the Rose,* p. 156)

David, Jacques-Louis, §vi.438, *vi.295, †iv.472 (*The Lictors Returning to Brutus the Bodies of his Dead Sons,* p. 317)

Madame Récamier (p. 325): §vi.420, *vi.495, †iv.602

Decamps, Alexandre Gabriel, §iii.215, *iii.253, †ii.488 (*Turkish Merchant Smoking in his Shop,* p. 152); §vi.147, *vi.173, †iv.388

Degas, Edgar, §iv.243–44, *iv.285, †iii.206 (*Place de la Concorde,* p. 213); §iv.280–81, *iv.329–30, †iii.238–39 (*Dancers Backstage,* p. 217)

Delacroix, Eugène, §vi.105, *vi.124, †iv.354 (*Liberty Leading the People,* p. 309); §vi.147, *vi.173, †iv.388 (*Turk, Smoking on a Divan,* p. 310); §vi.421, *vi.495, †iv.602

Delaroche, Paul, *The Children of Edward: Edward v, King of England, and Richard, Duke of York, in the Tower of London* (p. 175): §iii.578, *iii.686, †ii.790

Detaille, Édouard, *The Dream (Le Rêve)* (p. 195): §iv.41, *iv.47–48, †iii.36

Dethomas, Maxime, *Venice Study* (p. 271): §v.718, *v.848, †iv.205

Dürer, Albrecht, §i.390, *i.460, †i.318 (*St George,* p. 66); §ii.427, *ii.505, †ii.148 (*The Adoration of the Magi,* p. 115 ['like the Arabian king in a Renaissance portrait of the Epiphany'])

Fantin-Latour, Henri, §iii.314, *iii.371, †ii.571 (*Roses in a Bowl,* p. 159); §vi.29, *vi.34, †iv.292 (*White Lilies,* p. 294)

Foucquet, Jean, §vi.245, *vi.288, †iv.466 (*St John at Patmos,* from *The Book of Hours of Étienne Chevalier,* p. 315)

Fra Angelico [Fra Giovanni da Fiesole], §i.465, *i.549, †i.379 (*Coronation of the Virgin,* p. 75); §iv.412, *iv.485, †iii.348

Fra Bartolommeo, *Portrait of Savonarola* (p. 93): §ii.124, *ii.147, †i.525

Fragonard, Jean-Honoré, §v.105, *v.124, †iii.607 (*The Music Lesson,* p. 233)

Fromentin, Eugène, §III.375, *III.445,
 †II.623 (*Egyptian Women on the Edge
 of the Nile*, p. 160); §VI.147, *VI.173,
 †IV.388 (*Falcon Hunting in Algeria*,
 p. 311)

Gérôme, Jean-Léon, §II.92, *II.109, †I.498

Ghirlandaio, Domenico, §I.267, *I.315,
 †I.219 (*Portrait of an Old Man and
 a Young Boy*, p. 55)

Giorgione, §I.471, *I.556, †I.384; §I.472,
 *I.558, †I.385; §III.492, *III.584,
 †II.719; §IV.111, *IV.129, †III.94
 (*Sleeping Venus*, p. 204); §IV.176,
 *IV.206, †III.150; §V.438, *V.517,
 †III.885

Giotto di Bondone, §I.469, *I.554, †I.382
 (*The Sacrifice of Joachim* and *The Dream
 of Joachim*, p. 77); §II.447, *II.528,
 †II.165 (*Wedding Procession of the Virgin*,
 p. 123); §V.450, *V.531, †III.895;
 §V.744, *V.878–9, †IV.226–27 (*The
 Lamentation*, p. 283)
 Arena Chapel interior (p. 281), §V.744,
 *V.878, †IV.226–27
 Charity (p. 36): §I.94–95, *I.110–12, †I.80;
 §I.144, *I.169, †I.119–21
 Envy (p. 39): §I.95–96, *I.111–12, †I.81;
 §III.163, *III.192, †II.444
 Justice (p. 39): §I.96, *I.112, †I.81
 Idolatry (Infidelitas) (p. 131): §II.539, *II.637,
 †II.241
 Injustice (p. 69): §I.394, *I.465, †I.322

Gleyre, Charles-Gabriel, §I.175, *I.206,
 †I.144 (*Lost Illusions*, p. 45)

Goya, Francisco de, §I.392, *I.462, †I.320

Gozzoli, Benozzo,
 The Sacrifice of Abraham (p. 31): §I.41, *I.49,
 †I.36
 Journey of the Magi (p. 95): §II.125, *II.148,
 †I.525
 Procession of the Magi (p. 229): §V.71, *V.83,
 †III.577

El Greco [Doménicos Theotokópoulos],
 §II.323, *II.382, †II.61; §V.231,
 *V.272, †III.712 (*Cardinal Niño de
 Guevara*, p. 241)
 Burial of the Count of Orgaz (p. 301): §VI.85,
 *VI.100, †IV.338

Gris, Juan, §II.121, *II.143, †I.523
 (*Homage to Pablo Picasso*, p. 90
 ['cubism, futurism or what you will'])

Guardi, Francesco, §VI.24, *VI.28, †IV.288
 (*Procession in front of Santa Maria
 della Salute*, p. 289)

Guillaumin, Armand, §II.389, *II.460,
 †II.116 (*Environs of Paris*, p. 114)

Guys, Constantin, §I.503, *I.595, †I.411
 (*Promenade in the Woods*, p. 81)

Hals, Frans, §III.607–8, *III.718, †II.814;
 §III.628, *III.752, †II.837
 *The Women Regents of the Old Men's
 Almshouses* (p. 181): §I.306, *I.361,
 †I.250; §III.605, †III.717, *II.813

Hébert, Antoine-Auguste-Ernest,
 Virgin and Child (p. 157): §III.253,
 *III.299, †II.520

Helleu, Paul, §IV.390, *IV.459, †III.329
 (*Autumn in Versailles*, p. 223)
 Marcel Proust on His Deathbed (p. 330)

Hogarth, William, *John and Elizabeth Jeffreys
 and their Children* (p. 125): §II.472,
 *II.557, †II.185

Hooch, Pieter de, §I.262, *I.308, †I.215,
 (*The Mother*, p. 49)

Ingres, Jean-Auguste-Dominique,
 §III.485, *III.575, †II.713
 (*Grand Odalisque*, p. 170); §III.604,
 *III.716, †II.812; §VI.147,
 *VI.173, †IV.388; §VI.421, *VI.495–96,
 †IV.602
 Odalisque and Slave (p. 22)
 The Source (p. 174): §III.578, *III.686,
 †II.790

Jacquet, Gustave, §IV.109–10; *IV.127–28, †III.93 (*Portrait of a Woman in a Hat*, p. 203)

Lasinio, Carlo (see Gozzoli), §I.41, *I.49, †I.36 (*The Sacrifice of Abraham*, p. 31, ['in the engraving after Benozzo Gozzoli which M. Swann had given me'])

La Tour, Maurice-Quentin de, §V.398, *V.470, †III.851 (*Isabelle de Charrière*, p. 252); §VI.238, *VI.280, †IV.467 (*Madame de Pompadour*, p. 312)

Lawrence, Thomas, §VI.27, *VI.32, †IV.291 (*Elizabeth Farren, Later Countess of Derby*, p. 293)

Lebourg, Albert-Charles, §II.389, *II.460, †II.116

Leloir, Jean-Baptiste Auguste, §I.452, *I.534, †I.369 (*A Portrait of Two Boys With a Sketchbook*, p. 72)

Leonardo da Vinci, §II.84, *II.99, †I.491; §II.87, *II.103, †II.494 (*A 'Star of Bethlehem' and Other Plants*, p. 89); II.262, I.605; §II.583, *II.689, †II.277; §V.83, *V.97, †III.587 (*Two Grotesque Profiles*, p. 231); §VI.30, *VI.35, †IV.293 *La Gioconda (Mona Lisa)* (p. 100): §II.25, *II.29, †I.442; §II.222, *II.262, †I.605 *The Last Supper*, (p. 34): §I.46, *I.54, †I.40; §I.199, *I.234, †I.164

Le Sidaner, Henri, §IV.237, *IV.278, †III.201; §IV.24244, *IV.284–86, †III.205–7; §IV.25455, *IV.299, †III.216 (*Window at the Port of Honfleur*, p. 217).

Luini, Bernardino, §V.438, *V.516, †III.885 (*Portrait of a Lady*, p. 261) *Adoration of the Magi* (p. 99): §II.170, *II.201, †I.563

Machard, Jules, §I.452, *I.533–34, †I.368–69 (*Young Woman in an Evening Dress with Hydrangeas*, p. 73)

Maes, Nicolaes (see Vermeer), *Diana and her Companions* (p. 70): §I.425, *I.502, †I.347

Manet, Édouard, §II.511, *II.604, †II.218 (*Woman with Fans (Nina de Callias)*, p. 129); §IV.243, *IV.285, †III.206 (*Argenteuil, The Boaters*, p. 212); §VI.105, *VI.124, †IV.354 (*Execution of Emperor Maximilian*, p. 308) *Asparagus* (p. 13) *Bunch of Asparagus* (p. 176): §III.577–78, *III.686, †III.790–91 *Le Déjeuner sur l'herbe* (p. 327): §VI.438, *VI.516, †IV.615 *Olympia* (p. 171): §III.485, *III.575, †II.713; §III.604, *III.716, †II.812

Mantegna, Andrea, §I.174, *II.206, †I.566; §II.257, *II.303, †II.6; §III.607, *III.720, †II.814; §VI.310, *VI.364, †IV.518 (*Cardinal Ludovico Trevisan*, p. 322) *The Assumption* (p. 246): §V.294, *V.347, †III.765 *St James Led to Execution* (pp. 11, 67): §I.390, *I.460–61, †I.318 *St Sebastian* (p. 234): §V.185, *V.218, †III.673 *San Zeno altarpiece* (p. 66): §I.390, *I.460, †I.318

Memling, Hans, §III.620, *III.735, †II.825 (*The Reliquary of St Ursula*, p. 183)

Michelangelo, §II.18, *II.21, †I.437; §II.33, *II.39, †I.449; §II.594, *II.701, †II.286 (*Resurrection of Christ, with Nine Guards*, p. 141); §V.287, *V.339, †III.759; §V.335, *V.395, †III.800; §VI.310, *VI.364, IV.518 (*Damned Soul*, p. 323) *Creation of the Planets* (p. 83): §I.509, *I.602, †I.416

Mignard, Pierre, §III.650, *III.770, †II.850 (*Louis XIV, King of France, Crowned by Victory*, p. 186); §III.671, *III.795, †II.868

Millet, Jean-François, §IV.373, *IV.438,
 †III.315 (*The Angelus (L'Angélus)*,
 p. 221)

Monet, Claude, §IV.241–42, *IV.283–84,
 †III.205 (*Water Lilies (Nymphéas)*,
 pp. 19, 211); §IV.243, *IV.285, †III.206
 (*Rouen Cathedral*, p. 213); §V.349,
 *V.411, †III.811; §VI.99, *VI.117,
 †IV.349

Moreau, Gustave, §I.322, *I.380, †I.263
 (*The Apparition*, p. 61); §II.387, *II.457,
 †II.114
 Jupiter and Semele (p. 111): §II.323, *II.382,
 †II.61
 The Young Man and Death (p. 179):
 §III.601–2, *III.713, †II.810

Morghen, Raphael, *The Last Supper* (after
 Leonardo da Vinci) (p. 34): §I.46,
 *I.54, †I.40

Munkácsy, Mihály, *The Last Day of a
 Condemned Man* (p. 259): §V.431,
 *V.509, †III.880

Nattier, Jean-Marc, §V.624, *V.796, †IV.168
 (*Portrait of Mathilde de Canisy, Marquise
 d'Antin*, p. 269)
 *Portrait of Marie-Anne de Mailly-Nesle,
 Marquise de La Tournelle, Duchesse de
 Châteauroux, as Eos*, (p. 205): §IV.124,
 *IV.145, †III.105

Perronneau, Jean-Baptiste, §III.484,
 *III.574, †II.713 (*Portrait of a Man*,
 p. 168)

Piranesi, Giovanni Battista, §I.77, *I.90,
 †I.65 (*View of the Piazza del Popolo*,
 p. 35)

Pisanello [Antonio Pisano], §II.442, *II.522,
 †II.160 (*Female Winter Duck Swimming*,
 p. 119); §III.242, *III.286, †II.511;
 §VI.40, *VI.48, †IV.302 (*Head of a
 Young Woman with Profile to the Right*,
 p. 298)

Poussin, Nicolas, §I.475, *I.561, †I.387
 (*Spring, or The Earthly Paradise*, p. 79);
 §II.398, *II.471, †II.123; §IV.242–45,
 *IV.284–87, †III.206 (*Orpheus and
 Eurydice*, p. 210); §IV.245, *IV.287,
 †III.207 (*Mars and Venus*, p. 215 and
 The Inspiration of the Poet, p. 215);
 §IV.248, *IV.291, †III.211

Prud'hon, Pierre-Paul, *Justice and Divine
 Vengeance Pursuing Crime* (p. 165):
 §III.415, *III.492, †II.655

Raphael, §II.389, *II.459, †II.115; §V.73,
 *V.86, †III.579; §V.176, *V.208,
 †III.666; §VI.56, *VI.66, †IV.314;
 §VI.110, *VI.130, †IV.358

Rembrandt (Harmensz.) van Rijn, §I.289,
 *I.340–41, †I.237; §II.91, *II.107,
 †I.497; §II.439, *II.519, †II.158
 (*Philosopher in Meditation*, p. 117);
 §III.104, *III.123, †II.395 (*The Money-
 Changer*, p. 148); §III.650, *III.771,
 †II.850; §VI.254, *VI.299, †IV.474 (*A
 Woman Bathing in a Stream* (Hendrijke
 Stoffels?), p. 318); §IV.586, *IV.690,
 †III.491 (*The Jewish Bride*, p. 225);
 §VI.267, *VI.315, †IV.485 (*Self-Portrait
 at the Age of Sixty-Three*, p. 320)
 Bathsheba at her Bath (p. 256): §V.431,
 *V.508, †III.879
 The Night Watch (p. 59): §I.307, *I.361,
 †I.250–51; §V.433, *V.511, †III.882
 Portrait of Jan Six (p. 201): §IV.92, *IV.107,
 †III.78

Renoir, Pierre-Auguste, §III.375, *III.445,
 †II.623 (*The Umbrellas*, p. 161);
 §III.375–76, *III.445, †II.623 (*The
 Swing*, p. 163); §III.485, *III.575, †II.713
 (*Luncheon of the Boating Party*, p. 172)
 Mme Charpentier and her children (p. 297):
 §VI.38, *VI 45, †IV.300
 Ball at the Moulin de la Galette, Montmartre
 (p. 305): §VI.99, *VI.116–17, †IV.349

Rigaud, Hyacinthe, §III.671, *III.795,
 †II.868 (*Louis, Duke of Burgundy*,
 p. 191)
Robert, Hubert, §I.136, *I.159, †I.113
 (*The Cenotaph of Jean-Jacques Rousseau
 in the Tuileries, Paris*, p. 43); §IV.65–66,
 *IV.75, †III.56; §IV.66–67, *IV.79,
 †III.58
 View of a Park with a Water Fountain
 (p. 32): §I.46, *I.54, †I.40
Rousseau, Théodore, §V.325, *V.383,
 †III.791 (*Oak Trees in the Gorge
 of Apremont*, p. 251)
Rubens, Peter Paul, §II.131, *II.155, †I.530;
 §II.412, *II.487, †II.135; §II.613,
 *II.724, †II.302 (*The Three Graces*,
 p. 143)

Saint-Aubin, Gabriel de, §VI.24, *VI.28,
 †IV.288 (*The Gossips (Les Nouvellistes)*,
 p. 291)
Sebastiano del Piombo, §I.389, *I.459–60,
 †I.318 (*The Martyrdom of St Agatha*,
 p. 65 ['not unlike the headsman in
 certain Renaissance pictures which
 represent executions, tortures
 and the like'])
Il Sodoma [Giovanni Antonio Bazzi],
 §V.246, *V.290, †III.727 (*St Sebastian*,
 p. 245)

Tiepolo, Giovanni Battista, §II.131,
 *II.155, †I.531; §IV.71, *IV.83, †III.61;
 §IV.138, *IV.161, †III.117; §V.450,
 *V.531, †III.896 (*The Triumph of Zephyr
 and Flora*, p. 263)
Tintoretto, Jacopo, §I.267, *I.315, †I.219
 (*Self-Portrait*, p. 54)
Tissot, James, §V.223, *V.262–63, †III.705
 (*The Circle of the Rue Royale*, p. 239)
Titian [Tiziano Vecelli], §I.46, *I.54, †I.40;
 §I.471, *I.556, †I.384; §II.323, *II.381,
 †II.61; §II.332, *II.392, †II.68 (*Portrait
 of a Lady in White*, p. 112); §II.497,

*II.588, †II.206 (*Landscape with a
 Dragon and a Nude Woman Sleeping*,
 p. 127); §II.578, *II.683, †II.273
 (*A Woman at her Toilet*, p. 139 ['the
 tresses of Laura Dianti']); §V.421,
 *V.497, †III.871 (*Portrait of a Lady*
 p. 253); §V.450, *V.531, †III.895;
 §V.631, *V.744, †IV.133; §V.735, *V.868,
 †IV.219 (*Portrait of Isabella d'Este*,
 p. 273); §VI.38, *VI.44, †IV.300;
 §VI.238, *VI.280, †IV.467
 The Assumption of the Virgin (p. 87): §II.12,
 *II.14, †I.432
Turner, Joseph Mallord William, §III.650,
 *III.771, †II.850; §IV.248, *IV.291,
 †III.211; §V.749, *V.884, †IV.231
 (*The Dogana and Santa Maria della
 Salute*, p. 285)
 The Devil's Bridge, Pass of St Gothard
 (p. 189): §III.663, *III.785, †II.861
 Vesuvius Erupting (p. 33): §I.46, *I.54, †I.40

van der Meulen, Adam Frans, §III.444,
 *III.527, †II.679 (*Arrival of Louis XIV
 at the Camp before Maastricht during the
 Dutch War, June 1673*, p. 167)
van Dyck, Anthony, §V.639–40, *V.755,
 †IV.140 (*Charles I, King of England,
 Hunting*, p. 267)
van Huysum, Jan, §III.242, *III.286, †II.511
 (*Fruit and Flowers*, p. 155)
Velázquez, Diego Rodríguez de Silva y,
 §II.386, *II.457, †II.114; §II.389,
 *II.459, †II.116; §III.668, *III.792,
 †II.865; §III.671, *III.795, †II.867–68
 La Infanta Maria Teresa (p. 255): §V.425,
 *V.501, †III.874
 The Surrender of Breda (p. 185): §III.642,
 *III.762, †II.844
Vermeer, Jan, §I.237, *I.279, †I.195;
 §I.288–90, *I.340–41, †I.236–37;
 §II.46, *II.54, †I.460; §II.124, *II.146,
 †I.525; §IV.124, *IV.145, †III.105;
 §IV.246, *IV.289, †III.209; §V.224,

*v.263, †III.706; §v.450–51, *v.508–9,
†III.879–80; §VI.254, *VI.299, †IV.474
(*Woman Holding a Balance*, p. 319)

Diana and her Companions (p. 70): §I.425,
*I.502, †I.347–48

View of Delft (pp. 8, 237): §III.605–6,
*III.718, †II.813; §v.207–8, *v.244–45,
†III.692–93

Veronese [Paolo Caliari], §II.257, *II.303,
†II.6 (*The Crucifixion*, p. 105); §II.506,
*II.597, †II. 213 (*Portrait of a Venetian
Lady (La Belle Nani)*, p. 128);
§II.5524, *II.652–54, †II.252–53; §IV.54,
*IV.66, †III.49 (*The Wedding at Cana*,
p. 197); §IV.391, *IV.460, †III.330
(*The Wedding at Cana*, p. 224); §v.230,
*v.271, †III.711; §v.718, *v.848, †IV.205

Vibert, Jehan-Georges, §III.597, *III.687,
†II.791 (*A Tasty Treat (L'Éducation
d'Azor)*, p. 177); §III.607, *III.720, †II.814

Watteau, Antoine, §I.289, *I.340, †I.236
(*Five Studies of the Face and Bust of
a Woman*, p. 57); §II.222, *II.262, †I.605
(*The Italian Serenade*, p. 101); §III.199,
*III.235, †II.475 (*Standing Cavalier
Wearing a Cape (L'Indifferent)*, p. 151);
§III.388, *III.459, †II.633; §IV.390,
*IV.459, †III.329; §VI.110, *VI.130,
†IV.358; §VI.238, *VI.280, †IV.467
(*Gersaint's Shop Sign*, p. 313)

The Embarkation for Cythera (p. 20)

Whistler, James Abbott McNeill, §II.261,
*II.309, †II.10 (*Harmony in Pink
and Grey: Valerie, Lady Meux*, p. 107);
§II.386, *II.457, †II.114; §II.445,
*II.526, †II.163 (*Crepuscule in Opal,
Trouville*, p. 121); §II.511, *II.604,
†II.218; §II.573, *II.677, †II.269
(*Symphony in Flesh Colour and Pink:
Mrs Frederick R. Leyland*, p. 137
['a pure "Harmony in pink and
gold"']); §III.652, *III.773, †II.852;
§IV.61, *IV.71, †III.52 (*Arrangement
in Black and Gold: Comte Robert
Montesquiou-Fezensac*, p. 199);
§v.342, *v.403, †III.805; §v.742,
*v.876, †IV.225 (*The Storm – Sunset*,
p. 277); §VI.23, *VI.27, †IV.287;
§VI.99, *VI.117, †IV.349 (*Arrangement
in Black: Portrait of F. R. Leyland*,
p. 307)

*Arrangement in Grey and Black No. 2: Portrait
of Thomas Carlyle* (p. 27)

Harmony in Blue and Silver: Trouville,
(p. 147): §III.23, *III.27, †II.328

Winterhalter, Franz Xavier, §II.133, *II.157,
†I.532 (*Empress Maria Aleksandrovna*,
p. 97); §III.544, *III.645, †II.762

ACKNOWLEDGMENTS

I gratefully bow down to the research librarians who helped me to assemble the imagery and reference works upon which this book was built. That their services continue to be available for just the asking is a gift of incalculable value, a tribute to both taxpayers and philanthropists. I found them in New York City at the Frick Art Reference Library and the New York Public Library. Ann Foster at the Wayne County Public Library in Honesdale, Pennsylvania, and Mary White of Callicoon, New York (who makes mockery of the term 'retired librarian') were steadfast and resourceful in their support.

I would like to express my thanks to Vicky Bijur, Kirk Citron, Jeffrey Harrison, Joan Henry, Francesco Rognoni and Penny Wolfson for their constructive input and encouragement.

At Thames & Hudson, I would like to thank Robert Adkinson, Flora Spiegel, Pauline Hubner, Sadie Butler and Mala Hassett, who made working on this book a pleasure.

Dr Stephan Ethe knowingly put *Swann's Way* into the hands of an impressionable 17-year-old reader whose exposure to the world's possibilities was thereafter immeasurably expanded. I remain touched by this thoughtful gesture.

PICTURE CREDITS